THE LOVE OF LEARNING THE SEQUESTERED NOOKS, AND ALL THE SWEET SERENITY OF BOOKS

— LONGFELLOW.

THIS BOOK BELONGS TO

B-340 © Mary Engelbreit

Maryedith Rasmusson

PAINTING NATURE'S DETAILS *in* WATERCOLOR

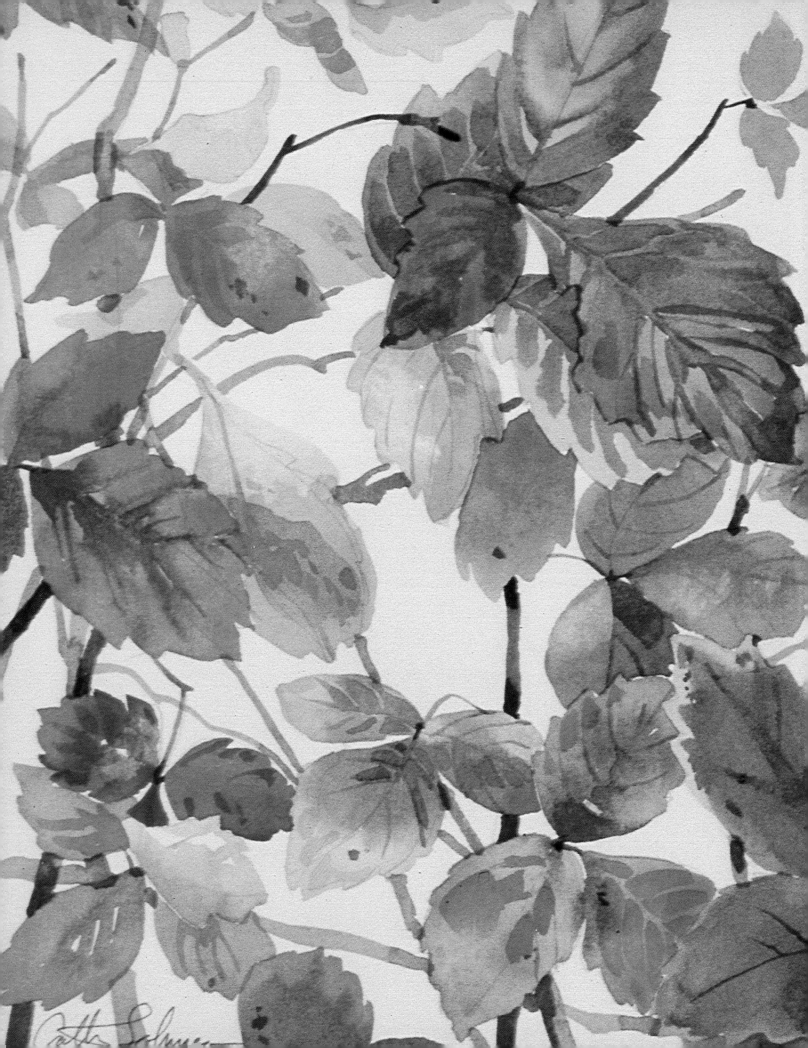

C A T H Y J O H N S O N

PAINTING
NATURE'S DETAILS
in
WATERCOLOR

NORTH
LIGHT
BOOKS

Cincinnati, Ohio

Library of Congress Cataloging-in-Publication Data

Johnson, Cathy (Cathy A.)
　Painting nature's details in watercolor.

　Includes index.
　1. Watercolor painting—Technique. 2. Nature (Aesthetics)—
Themes, motives. I. Title.
ND2237.J6　1987　　751.42'243　　87-10588
ISBN 0-89134-185-4

Edited by Greg Albert.
Designed by Carole Winters.

ACKNOWLEDGMENTS

Writing a book is a monumental undertaking; producing enough paintings to illustrate one more than doubles the difficulties involved. Such a project is seldom the work of one person alone, and I have many to thank for help, support, and guidance.

My thanks to David Lewis, editorial director at F & W Publications, who needed this book just when I wanted to write it, and helped me to put my thoughts in concrete form. Thanks also to Greg Albert, my editor, who has been there for me when I needed answers to a hundred questions.

Mike Ward, editor of *The Artist's Magazine*, deserves a special thanks—without his acceptance and help I would never have understood what it means to share my work and my thoughts on producing it with others. Thanks also to Greg Sharpless, managing editor, who works with me closely on my column—his ideas are invaluable.

To those who have read my column and articles in *The Artist's Magazine* and have responded so generously with praise and thoughtful questions and to those who have attended my workshops and helped me to realize what a lovely fix we are all in when we attempt to capture nature on paper, thank you.

My brother-in-law, watercolorist Dick Busey, has come up with some of the most thought-provoking questions of all; to him and to my patient and supportive sister Yvonne, thanks for helping.

And most of all to my husband, Harris—thank you for being there, and for being patient.

CONTENTS

INTRODUCTION

As children, we shared a fascination with the small, accessible, bite-sized bits of nature we could explore for ourselves: the microcosm of life in a puddle, with the beautiful forms of damselflies, tadpoles, and cattails; or the miniature desert in a patch of dry ground. We explored creeks, tree-root castles, and rocky ravines dotted with fossils and lichen. This world still awaits us—and now we can share it with others through our paintings.

It takes a certain amount of nerve to write a book about painting intended to be read by other artists. After all, who am I to tell you how to paint?

In fact, I hope you will take my advice with a healthy grain of salt. The paintings included here are a reflection of *my* way of looking at the world. They aren't supposed to be copied, but rather used as examples of how one artist chose to solve some of the problems watercolor presents to us. You'll see my struggles and failures along with my successes. I'd never attempt to tell you that watercolor is easy—for me or for anyone else. But it *is* challenging (as well as frustrating and infuriating!), fun, exciting, and endlessly fascinating. What more can we ask of our chosen medium? It's a lifetime learning process.

We never "master" watercolor. A controlled watercolor is—at least to me—one deprived of its life, its liveliness. We do better to climb aboard for the ride, steer it a bit here and there, and hang on for dear life.

The particular focus of this book—the details of nature—reflects a life-long interest in what goes on under my nose, underfoot, under a rock, underwater; the beauty, the life, the serendipity of the small. We tend to think that "painting from nature" means a grand vista, wide-open spaces, or a landscape in the widest sense of the word. I offer the *intimate* landscape for your consideration. Fresh, accessible—and with the power to touch a chord, a response—these small bits and pieces of nature are as available as our own backyards.

This book will help train you to see the intimate landscapes all around you, and offers suggestions to isolate a composition from a sometimes confusing natural world. Let some detail catch your eye, and study it closely. Make sketches, explore its format and value. You will discover a magical realm only inches from your nose. Water, flowers, trees, light—life itself—all lend themselves to this intimate approach.

I never know whether to think of myself as an artist or a naturalist; I've written books both on art and on natural history. By painting the intimate landscape I am able to grow in both disciplines. The closer we study the natural world to paint it, the more we learn about it. And the more we learn, the more we *care* about the world around us; we want to protect this fragile earth. It nurtures us; how can we fail to at least *try* to return the favor?

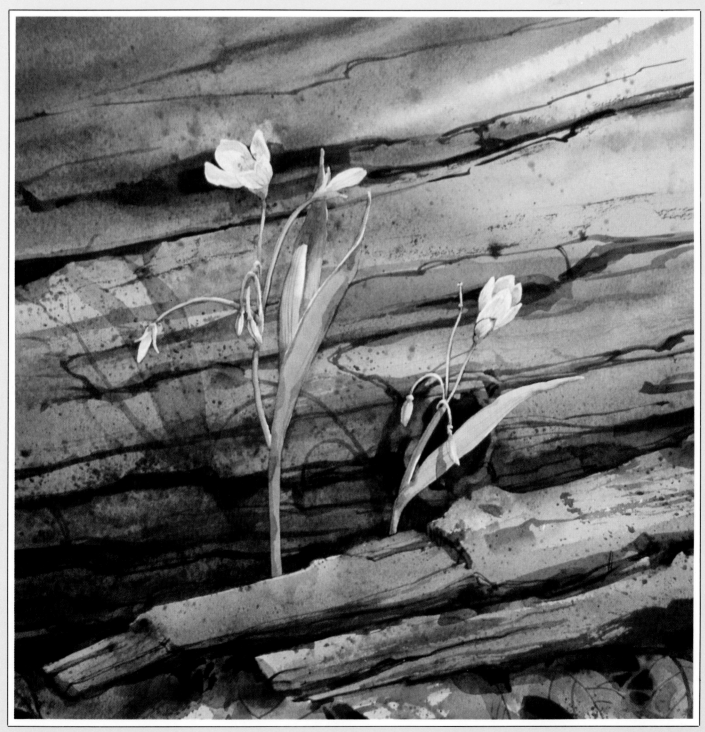

GETTING STARTED

The idea of learning to see may sound strange to you. After all, you've been looking at the world around you ever since you first opened those infant eyes. Literally everything caught your attention: movement, color, new shapes—life. How fascinating it all seemed when we were young: small details were right there on our level: our curiosity at a pitch never equalled during the rest of our lives. "What's *that?*" we'd say. "Pretty!" I can still remember the joy of discovering these miniature vistas. My first drawings were of the fascinating things I saw every day: birds, flowers, trees—even bugs.

But as we grow older we begin to intellectualize, analyze, and categorize. We learn art theory and history, the "rules" of composition and value, the various schools of art. Nature's details are sometimes lost in the shuffle as we form ideas—and sometimes prejudices—about what "serious" art is (and is not).

We *need* to grow beyond this primitive baby stage, however, and exercise our intellect, our powers of analytic thinking, of logic. We certainly profit by the work of the Masters, old and new, but I'm not suggesting that we throw out the baby with the bathwater! We should keep that curious child within us.

We tend to overlook a rich source of subject matter, a very satisfying and fulfilling source: nature's *details*, as worthy of our attention as any broad landscape or thundering seascape. These small, intimate landscapes have the power to touch something deep inside—once we have learned to "see" them.

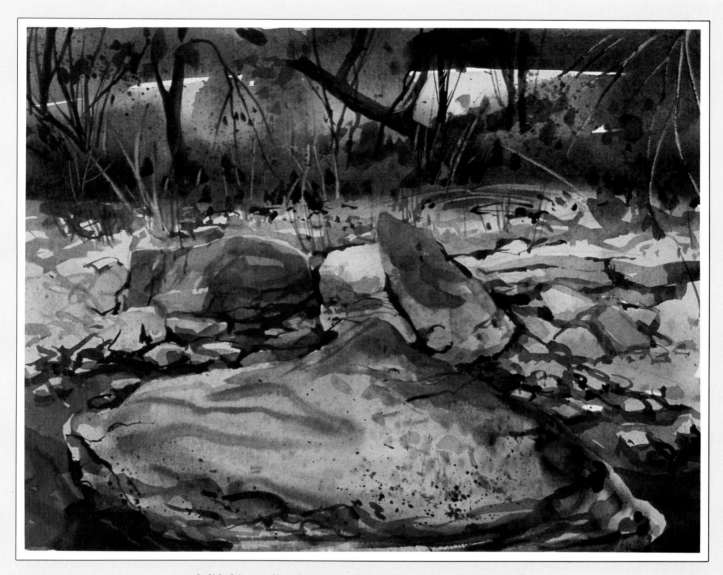

I did this small painting on the spot on the hottest day of the year. I simply sat on a rock across the creek and worked with my feet in the cooling water! The site was within walking distance of my home; one of the joys of intimate landscapes.

SUMMER FORMATIONS
9″ × 12″

VIEWFINDER

If you prefer a more concrete approach to finding subjects, try these tricks. Make a viewfinder by cutting a rectangular frame from a piece of cardboard, or use an empty slide sleeve. Take it with you when you go "prospecting"; look all around, close and far, high and low. Move in as tight as you like—zero in on a painting subject, and isolate it from the confusing clutter all around. Consider a number of approaches. After your viewfinder isolates a composition, pick a format (horizontal or vertical), edit the extraneous, and find a jewel.

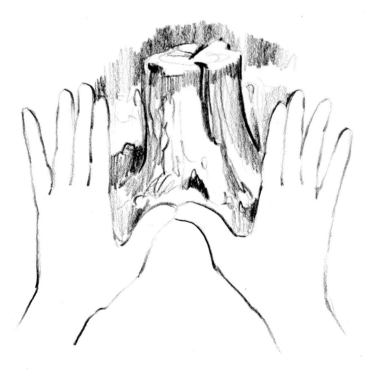

If you forget your viewfinder, use your hands to "frame a shot"; hold them out as shown, like a movie director. It's a good trick—and you won't have to worry about leaving your hands at home!

It took one of the Masters, by the way, to open my eyes to this intimate landscape as a painting subject—although my curiosity as a naturalist focused my attention on small details for years. Albrecht Dürer's *A Small Piece of Turf* set off bells and whistles in my head. Once I saw this careful, lovely study of an unprepossessing tuft of grass and weeds, I was set free to paint whatever—and *however*—I wanted.

At Home and Abroad

One of the nicest things about painting these details is their availability. We don't need to take a painting vacation in an exotic place to find subject matter (although that's always a delight, too). Subjects abound close by—look around your backyard, garden, or local park. Consider the potted plants on your windowsill; be on the lookout for small slices of everyday life.

To pick your subject, look around you slowly. Consider everything, but choose nothing just yet. Then close your eyes. Something will come to mind. Something has made an impression. Respond to it in your imagination. Why has this particular subject touched you? What did you notice about it, what elicited a response? Perhaps it was simply a special beauty, a sparkle of life or movement. Perhaps a particular angle captured your imagination, a play of light and dark.

Sketch it if you like but it's not necessary to do a complete drawing; just let your pencil explore what you see. Don't even think of this as a preliminary sketch for a painting (although it can be); sketch it for its own sake. Some of my most satisfying work has been this kind of childlike exploration with my pencil. It doesn't matter whether or not I eventually end up with a completed painting, but that in *drawing*, in taking time to respond, I learned to see what was before me.

I have an old John Pike "Wonderful Perspective Machine" that I use on occasion to better "see" what I'm looking at. It's a piece of blue Plexiglas

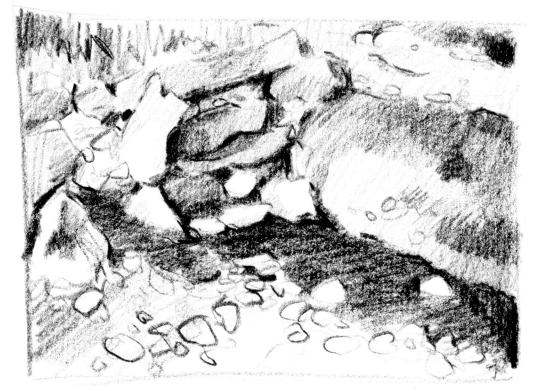

These rocks at the edge of a tiny stream near my home might have been too confusing to contain within a sketch without my border. Using the border helps me think compositionally.

with a watercolor-paper-shaped rectangle marked off with magnetic tape. The "live area" is scribed with lines dividing the viewing area in quarters both ways to help with accurate drawing, and three thin, movable metal strips that will adhere to the magnetic strips are included to help you see perspective. It's a handy tool when things get confusing. Perspective is not often a problem when painting nature's details, but accurate drawing—and finding that composition—may be. (The blue tint helps simplify values.)

I often contain my sketches within borders. Before beginning to draw, I make a rectangle of pleasing proportions on my page, then sketch inside these lines. This helps me to translate what I see to the flat plane of my paper. Using the border helps me think compositionally.

Even your camera may be useful to isolate a composition. Whether or not you actually take a picture, simply looking through the viewfinder of a single-lens reflex camera will help you to see and to spatially organize the elements of the intimate landscape.

Your sketchbook itself can even act as a view-finder, too. The edges of the paper form natural boundaries; picture the image there before touching pencil to paper. Some artists like to make tiny thumbnail sketches—no larger than $1'' \times 2''$ first. Some make "phantom lines" on their paper without actually marking it, to plan ahead of time how much of what is seen will be included. Imagine your format, *see* the viewfinder in space before you, and then simply draw what is contained there.

Often it helps to look more at the subject than at the paper. Become involved with what you see and don't worry too much about what goes down on paper; a 3 to 1 subject-to-drawing ratio is about right for me—I spend three times as much time involved with my subject as with my drawing. I can later refine the sketch as much as I like. After years of painting and sketching these details, I've learned to see them everywhere; it's only a matter of practice, of seeing from a fresh perspective.

Don't forget to have fun. Look for nature's hints and suggestions; exaggerate; use your imagination. It isn't necessary to sketch faithfully or paint exactly what you see as you make value and composition studies. *You* are the artist; feel free to be a bit playful.

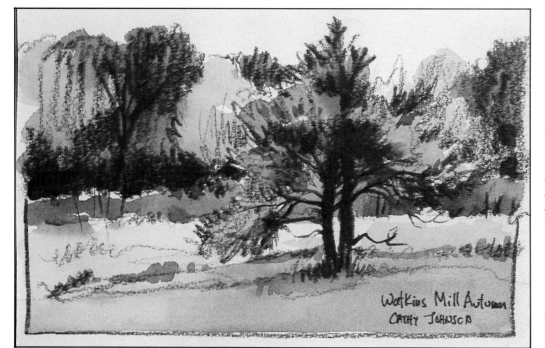

This small color sketch (left) was done on a 3″ × 5″ Notchy Post Card—these come in a spiral-bound pad and are of good watercolor stock—it's a fun size to work with in the field. The card's margins helped me choose what would be included.

This sketch of light-struck tree shapes (below) was done on a 9″ × 12″ sheet and contained within a border.

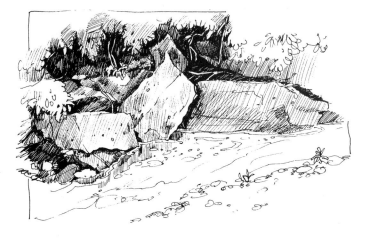

I planned out the asymmetrical placement (above) before I touched pen to paper. The concentration of detail by the large rocks caught my eye, and I played it up in my sketch.

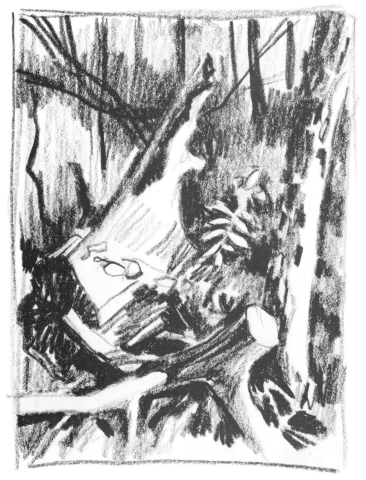

The Sketchbook as a Tool

My favorite and most indispensable art supply is my sketchbook. It's a place for planning future works, a journal, a workbook, and a learning tool. I can record my daily activities or explore new territory within its pages. I can experiment with styles, format, values, subject matter, and even different mediums. Colored pencils, felt-tips, even watercolor washes end up in mine—who says you have to use only pencil or charcoal to sketch? Once, when I had remembered the book but forgotten to take something to draw with, I found the remains of an old campfire on the creek's edge. Instant charcoal! How appropriate—I could now draw nature with a piece of nature!

As that incident suggests, however, it is most important to have your sketchbook *handy*. I keep several sizes for general use. At home in the studio I often use a 9″ × 12″ size or larger. I can use any portion of the page or the whole page for a single drawing, combine drawings, or isolate a sketch with a border.

On walks, on the road, or in the car, I most often carry a 5″ × 7″ book, hardbound to withstand the rigors of extended outdoor use. Mine has been dropped over a cliff and thrown to safety as I sunk thigh-deep in a fresh sandbar, and it was little the worse for wear. Hardbound books have a lighter-weight paper than do spiral or other pads, so they're less useful for watercolor washes. But, because they are so versatile, I prefer them for most uses anyway. The better grades have a good tooth, neutral pH (that is, are neither acid nor alkaline), and a pleasant texture. Be sure to *look* at and feel the paper surface before buying it; I once bought a bound book with slick, semi-ribbed paper that was good for nothing but grocery lists!

The smaller sizes are easier to carry with you (they'll even fit in a pocket to keep your hands free for climbing, if you like!) and are less obtrusive than larger, spiral-bound pads. You're less likely to startle the wildlife you may be trying to sketch by open-

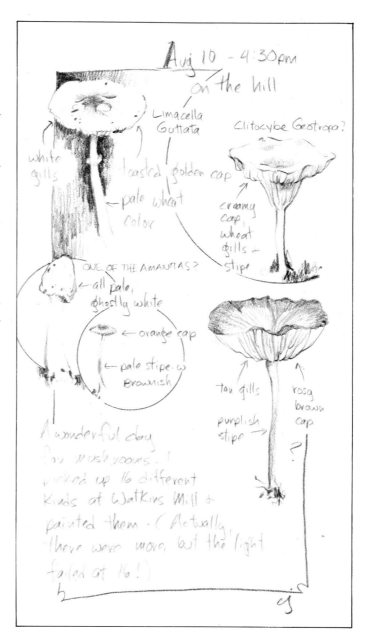

This field journal and the one on the following page show the type of notes I take to remind myself of settings and circumstances. On August 10, I found a veritable mushroom fest in a single day. The sketches and notes helped me identify most of them from field guides back home, reminded me of the date I might expect to find them again, and told me the weather conditions under which I found them.

15

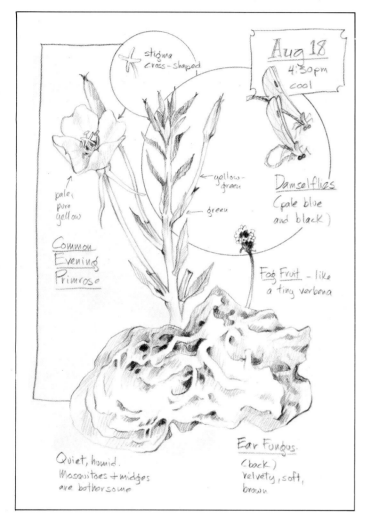

In the journal entry from August 18, my focus was rather general. I included insects and flowers as well as the ear fungus at the bottom of the page, but I still made notes to help me remember more than the visual elements.

Courtesy of Prentice Hall Press

ing a small hardbound book rather than by flipping the pages of a large sketchbook. (You're also less noticeable making "notes" in a small book if sketching in public.)

I often carry an even smaller sketchbook in my purse; "Be prepared" is a good motto for artists as well as Boy Scouts.

Field Sketches

Field sketches have as much to do with *learning* as they do with *drawing*. These are usually annotated, always done on the spot, and extremely useful, even if they never turn up in a painting of nature's details. You need to have an understanding of nature, and a *love* of nature to paint with accuracy and feeling. I've seen too many passionless works of subjects from nature that left me wondering why the artist bothered at all. Field sketches *involve* us with nature. We become acquainted, then friends and lovers. That can't help but show up in our work.

You may include notes about other finds not shown in your sketches; list wildflowers blooming or birds seen or heard. Note your feelings and mention the weather. I often note time of day, date, weather conditions, and location as part of my field sketches; my favorites become miniature time capsules which may include a quick habitat sketch, details from nature, and written notes that take me back instantly to that time and place. How can that possibly help when painting a specific scene? By recalling the original mood, I can more accurately portray the scene to reflect that mood. By evoking a feeling, these detailed notes elicit an emotional response that helps me express the mood as I paint.

Other times, rather than noting everything in its immediate environment, I concentrate on a single plant or animal. Zeroing in and isolating a wildflower, for instance, lets you really get inside its life cycle, understand its budding and flowering. Botanical illustrators often include drawings of the

young sprout, the plant, the flower, the seed pod and its individual seeds.

In a landscape painting, such accuracy has less importance; in an intimate landscape the details *become* your subject. Field sketching helps you to see those details, remember them—and *then* depict them faithfully or, if you choose, abstractly.

Detail Studies

You may want to draw or sketch details for later use. By nature, sketching is fast and not overly concerned with details. An overall sketch of your intended subject may be more involved with format, value, and composition; in order to "bring it back alive" you may want to devote a part of a page or a separate sheet to a single detail. Even if your finished painting won't be that detailed, you will at least have accurate research material to draw from.

My memory is faulty, at best, so my notes help me fix these details in my mind to keep this information usable. Be as specific as necessary when noting color and details; using specific pigment names may help.

Composition

Your sketchbook is a perfect place to plan format and composition. Does your subject lend itself better to a horizontal or vertical format? Sometimes answers are obvious, but at other times they depend on your mood and intent. Often, a horizontal format denotes a calm, pastoral mood. We often think of a panoramic subject handled in this way, but when painting intimate landscapes our "panoramas" are quite small. Still, this is a useful format; I think of Andrew Wyeth's *May Day*, a beautiful small painting of wildflowers against a dark background.

Don't feel constrained by what's already been done; format shapes needn't be determined by the proportions of a sheet of watercolor paper. An extreme horizontal might best express the mood of

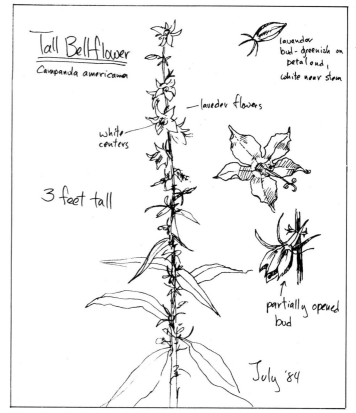

My rather botanical sketch of this tall bellflower was completed at a single sitting, so I did not include earlier or later stages of plant growth. It did help me to more fully understand the budding and blooming stages.

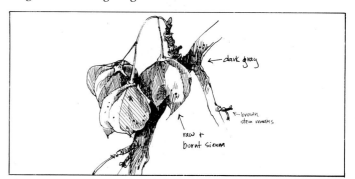

This detailed sketch of bladdernuts gives me clear, close-up information on the structure of these papery fruits and how they grow on the stem. If I were to include them in a larger work, I would be able to capture the shapes correctly and believably—even in a few strokes.

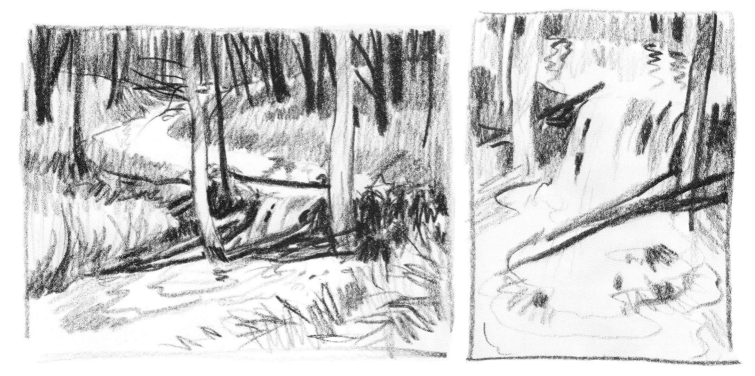

This small waterfall—actually a beaver's dam in the building stage—works well with a horizontal format. From another angle, or if I were closer up and directly by the dam, a vertical format might be a better choice.

one of these tiny panoramas; a narrow vertical format might best express the impact of a tall, slender flower. You may even want to break from these traditional shapes. (Some artists choose a circular form; I've seen some that were quite effective.)

The vertical format not only works well to capture a tall or slender subject (a single tree, a flower, a long-legged heron); it can also be more dramatic. What does your subject demand? Try out both formats with your viewfinder to see which works best.

Composition sketches should be more than mere academic exercises, they can even be fun. The Golden Mean rule for compositional placement is an ancient one—as the sketch shows, lines are drawn to divide the length and width into thirds; the center of interest would be placed at one of the intersections. An alternative is to simply place your center of interest somewhat off center, without worrying about exact measurements. The subject's placement, how it leads the eye through the picture plane, the elements of design and balance, repetition and variation all play a part in composition. My small beaver dam sketch uses the stream as a design element to lead the eye deep into the picture; the varied shapes and sizes and disparate rhythms of the upright trees stop the eye here and there to keep the viewer's attention from leaving too soon.

One of my favorite compositional elements is negative space. These areas of "*non*-subject" can make (or break) your composition: keep them varied in shape, and make them interesting; they will not only help you draw more accurately, but will also give the eye a pleasing place to rest.

Occasionally, I like to center my subject; rules were made to be broken, and the Golden Mean is certainly no exception. Artists of the twentieth century have seen to that. A botanical subject works well as a centered composition. It is still important, however, to vary shapes, keeping those negative spaces in mind.

Sometimes an asymmetrical approach is effective, too. Nature is always in motion: birds fly, fish

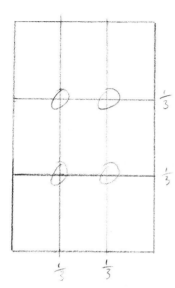

Placing the center of interest at one of the intersections helps ensure an interesting composition.

I did this study, Rocks at the Point, on a misty day while sitting on the creek's bank. I worked quickly with large brushes; the moisture in the air kept the washes from drying too quickly. I liked the soft, wet-in-wet effect. A tiny (1" × 2") thumbnail sketch on the cover of my watercolor block was all the preliminary work I did for this one.

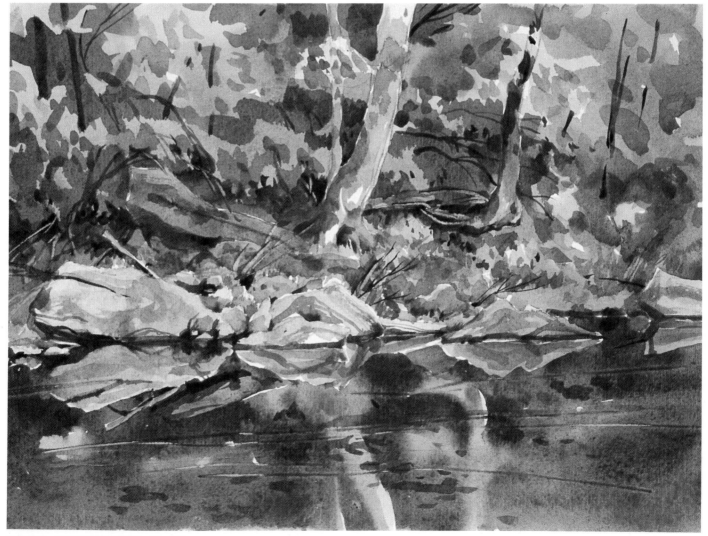

ROCKS AT THE POINT 9" × 12"

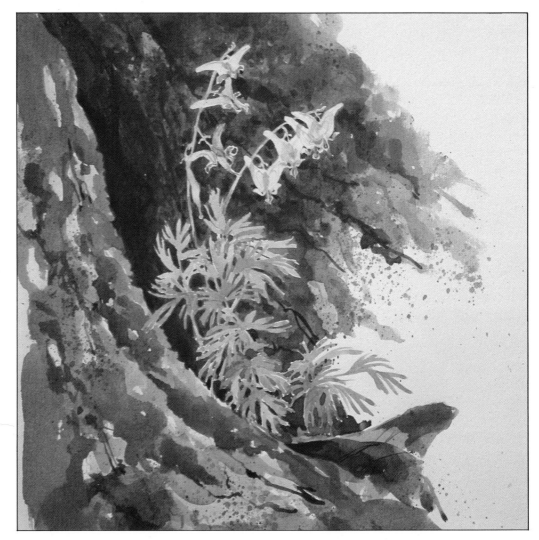

Dutchman's Breeches *was very carefully executed. I drew a quite complete "roadmap" for myself: a pencil drawing directly on the watercolor block. I then proceeded to paint, using no liquid mask to block off the flower forms; I simply painted around them. This system worked well because I painted this fairly dryly with no wet-in-wet work. I was in control the whole time.*

swim, frogs leap, even the plants sway when the wind blows! One way to express the illusion of motion is to place your subject nearer the edge of the page facing outward, as if nearly gone. Try it; it may work better for you than a "safe" and traditional composition.

Value Studies

Light and dark values help hold our work together, direct the eye, express mood. A good value pattern can make sense of your picture plane; a poor one can shoot the whole thing. Experiment with small sketches to plan values; these can be as abstract or simple as you like; remember you're exploring—not executing a finished drawing. I like the effect of strong contrasts and sharp accents; you

may prefer a more diffuse pattern. Values, whether high or low key, help you define a mood; how can you use them to express your feelings about your subject? Thumbnail sketches will help you decide.

Working on the Spot: Beyond the Sketch

I often take my watercolors to the woods to paint on the spot. It gives me a wonderful excuse to do what I love best—run away from home!—and often results in works I especially like for their freshness and immediacy. These *can* be viewed as studies for later works, but often they're able to stand on their own.

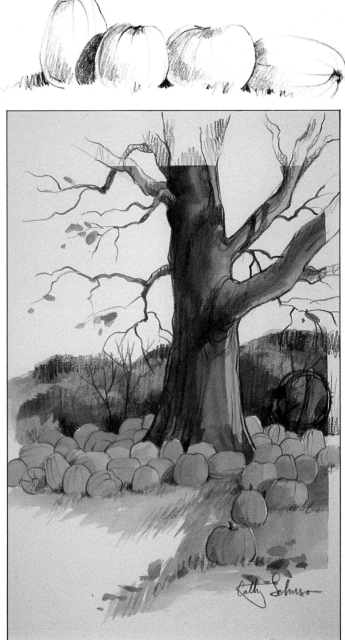

From Sketchbook to Painting

This demonstration shows how sketches are useful in the evolution of an idea for a painting.

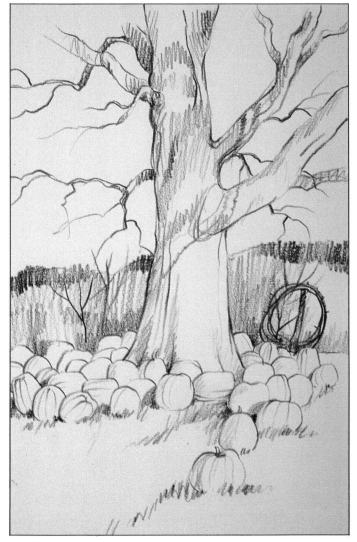

Sketch

I sketched this in a neighboring farmer's pumpkin patch; he piles his produce under an old oak tree to keep it from being damaged by the early frost. The effect is riveting. I sketched the scene using a vertical format, then did detail studies of the pumpkins themselves to remind myself later of their varied shapes and sizes.

Stage One

A quick watercolor wash directly on top of my colored pencil sketch helped fix colors and color values in my mind.

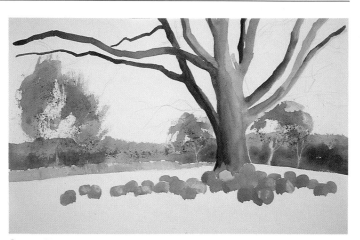

Stage Two

Stage Two

Later, I decided a horizontal format suited the subject better. This began as a demonstration painting for an arts group; stage 1 was as far as I got the first night. I've laid in the varied orange pumpkin wash and the warm, cadmium orange, burnt sienna, and ultramarine blue oak tree, as well as the distant hills and some tree canopies using the side of my brush in an almost dry-brush fashion.

Stage Three

I've begun to develop limbs and trunks, using a rigger or liner brush on the large oak limbs and a small, pointed palette knife to paint the smaller trees. I often paint with this tool; before using it with watercolor, be sure to remove the lacquer coating by burning it off, sanding, or using lacquer thinner; otherwise the color will just bead up and run off.

Stage Four

Now I've laid in the first washes for the grass, begun developing the big tree's shape and texturing, and added some small limbs with my palette knife. I used ivory black and yellow ochre for the subtle shade; a straight-from-the-tube green would have competed with the brilliant orange pumpkins.

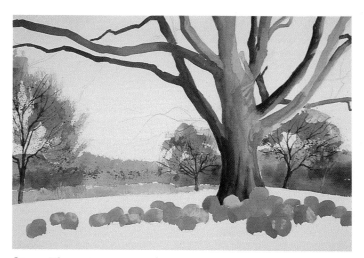

Stage Three

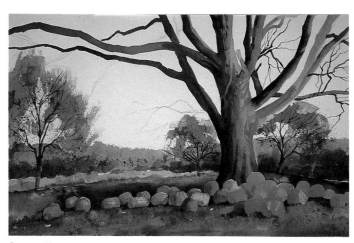

Stage Four

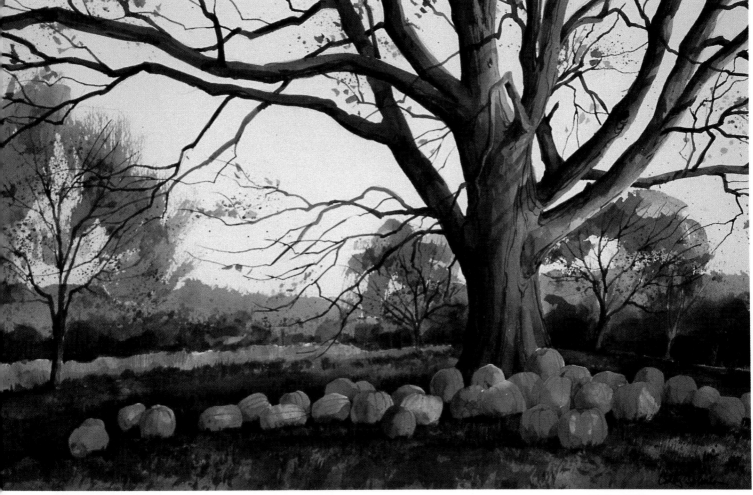

Stage Five

Small details in the trees and in the pumpkins, value adjustments in foreground and background, plus a spattering of dead leaves complete the scene.

HARVEST

PAINTING THE LIGHT

Light gives our planet life. Without it, whole systems would break down; photosynthesis would cease, and plants would stop providing sustenance for animals and humans. Even algae, lichen, and bacteria need light to function. Perhaps that's why in the beginning there was light—without it we wouldn't exist.

Light is the subject of all paintings in one way or another. Think of the cold hours just before daybreak; forms are flattened, cookie-cutter shapes without depth or dimension. As the sun begins to rise, shapes take on volume; as light touches reflective surfaces, they spring to life.

What we see as color is really the effect of the visible light spectrum. Our eyes perceive those colors that fall between the ultraviolet and infrared rays. A good "tool" for any artist is a simple glass prism; although pure light's colors are different from those pigments we can buy, it helps to see and understand what makes up the colors we see around us, the colors light brings to life. Of course, a prism isn't a tool in the same way a brush is; it's a tool for the mind and imagination. It gives us a sense of pure color to aim for—or at least be aware of. Understanding how our eyes perceive color can help us use it with clarity as we paint.

The moments just after sunset are beautiful; I've tried to capture them in this sketch, After Sunset. *The distant trees are lit up by the dying sun that has just dropped below the horizon; all other forms begin to take on an analogous blue-gray tint. Simplified shapes in the middle and foreground with very little detail let the sky and the glowing water of the tiny stream stand out as my subjects.*

AFTER SUNSET *9" × 12"*

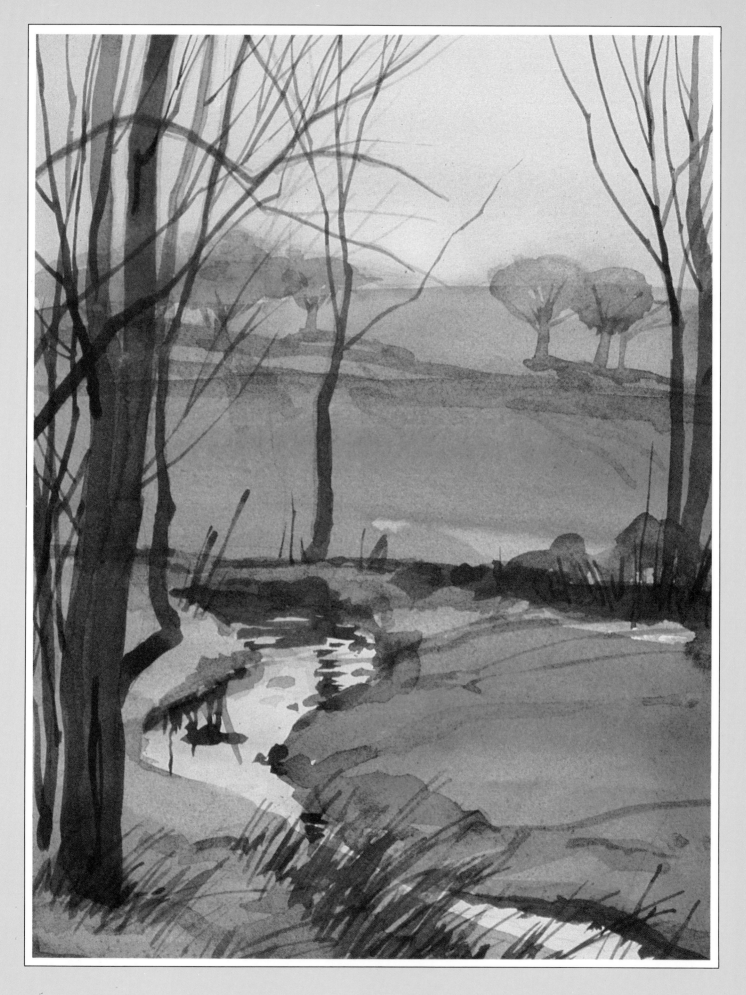

Look at these almost abstract sketches of light and dark placement and composition. Some follow the rules of the Golden Mean; some do not. Traditional composition is often the safest way to go; if the rules don't allow you to express what you want, feel free to experiment and break them if you will.

Organizing Values . . . for Depth, Drama, and Composition

Use light and its effects to organize your picture plane. Rough sketches will help to plan your composition, organize directional thrusts, and consider how to create the illusion of depth. Often, a simple ratio of 1/3 light to 2/3 dark or vice versa will give good results, if the composition is well planned. Look for fresh ways to call attention to your center of interest; place it high or low, or more than a little off center; perhaps it will be only a small ray of light in the midst of a large dark area.

The strong value patterns of a well-planned painting do more than give it a pleasing appearance: they lead the viewer's eye to your planned center of interest, help move the eye through the picture plane; give a sense of depth and volume; and make your painting come alive. These are the actions of light—in the world and on our paper.

Changing Light

Study the light as it changes throughout the day. You may not know the best time to render your subject until you see it in all lights—or until you are familiar enough with the effects of light to choose. The slanting rays of early morning and late afternoon light are dramatic; midday sun is great for mad dogs and Englishmen, but may be too flat for interesting painting. An overcast sky gives subtle all-over lighting; the clouds soften light in much the same way a portrait photographer's umbrella reflectors do. Rim lighting or backlighting may give just the effect you are after; make rough sketches to explore the possibilities, then decide which is best for your subject. You may even want to paint the same subject in several types of light.

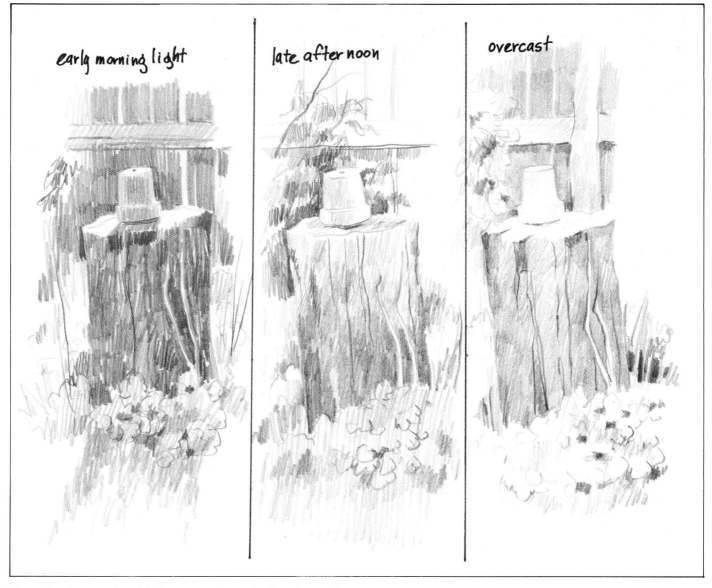

early morning light

late afternoon

overcast

These sketches are of an old plum stump in my backyard, at early morning, late afternoon, and with a hazy overcast. Which one best suits YOUR mood?

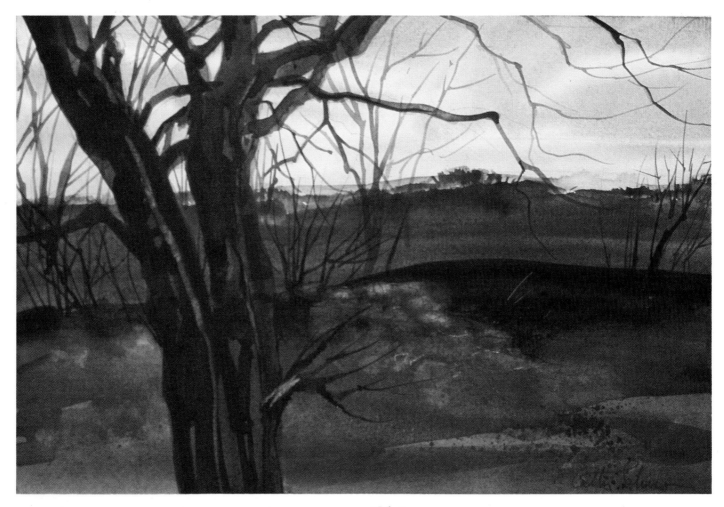

I've tried to avoid the danger of a cookie-cutter flatness in Tree of Heaven *by keeping my sky subtle and allowing my foreground to have some variation in form and color, even if it is quite low key. This is similar in mood to* After Sunset *on page 25, but was in fact illuminated by early morning light in the eastern sky instead of at sunset. The light sky and dark tree form make a dramatic contrast.*

TREE OF HEAVEN
9" × 12"

Chiaroscuro

Dramatic contrasts of light and shadow can be extremely effective. Vermeer was a master of this sort of light; look at his juxtaposition of dark against light and light against dark to define forms. Use these contrasts in your own work for rich effects—but be careful! This is tricky business. It's all too easy to end up with a cadmium orange sunset and black palm trees, leaving you with a cardboard set for a play, perhaps, but not much of a painting.

In St. Francis of the Herb Garden, *I've used contrasting values in a more traditional way. Notice the dark of the statue's shoulder and arm against the warmly-lit fence. From above, the head receives some soft, reflected light and stands out against the shadowed fence boards. This counterpoint play of dark and light moves back and forth throughout the picture. Again, a rough sketch helped me plan light placement—the value pattern.*

Nature's "Stained Glass"

A stained glass effect occurs when sunlight passes through a translucent object. Look at the light where water is shallow; the stream bed or ocean bottom is flooded with the cool glow. When backlit, leaves and flowers (and even our own fingers, held up to strong light) glow as if lit from within.

This was the challenge I faced when I attempted *Redbud Leaves* (on page 30), with their lights and shadows, direct and indirect light, and the deep shadows beyond.

Sometimes the problem with such a subject is in believing what you see. Can those sun-struck lights *really* be so pale? Is that light really so golden; are the shadows *that* rich and deep? If you believe it, and paint what you *see*, the effects can be striking.

The Light Fantastic

There are times when light performs tricks we can scarcely believe; Houdini in a sunbeam. The bright reflection on a lake's surface seems to leap up to meet its source, the sun. Light seems to bend around a form. As we walk past a patch of dew-covered grass, our shadow seems to wear a halo of

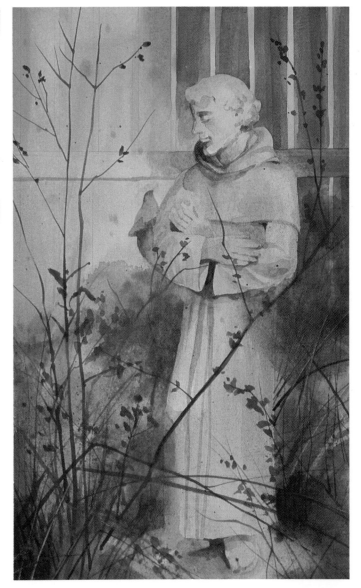

The painting threatened to become a portrait of a concrete statue; I had gotten too self-consciously stiff with my handling. I sprayed clear water over much of the foreground and the lower areas of the statue and floated in freer washes to reestablish a wet-in-wet feeling for these areas.

ST. FRANCIS OF THE
HERB GARDEN
18" × 10"

A tiny thumbnail sketch helped me to believe what colors I saw as well as to organize my thinking on the picture plane. Even such a tiny sketch (roughly 1¹/₂" × 2¹/₂") is sufficient to plan a painting; detail is nearly nonexistent and light values come to the fore.

prismatic colors concentrated around the head (perhaps that's where early artists came up with that familiar visual image.) Light strikes fire from insignificant dust motes as it streams through the branches of a tree, or rings the sun (or the moon) to foretell foul weather. Have you seen sun dogs in winter? They are short, rainbowed bars on either side of the sun, pale, beautiful—and rare. Rainbows themselves would be impossible without light reflecting on moisture in the air—usually during a rainfall.

It's a magical world, one we notice after learning to really see nature's details. These images are tricky to paint; how many poorly done and garish rainbows have you seen? But give them a try—if you should capture the lovely truth you may help someone appreciate the beautiful world we live in. The ancient Celts revered God by revering nature; perhaps we can learn from them.

Reflected Light

Shadows are not all one color, flat and uninteresting. Look closely; you'll see that light reflects and bounces back into the shadow forms. Look under the eaves of a white house in strong sun; you may find warm ochres or siennas reflected there, or

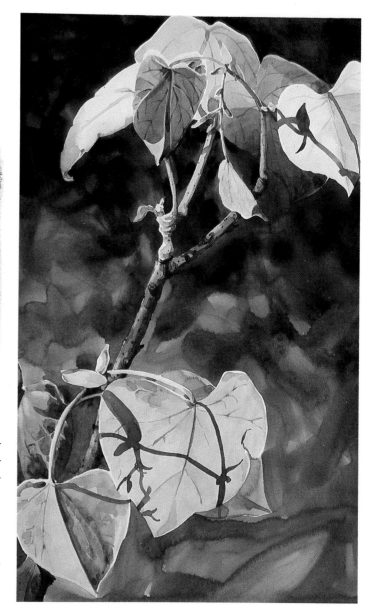

In translating my sketch to a half-sheet watercolor, I maintained that strong value pattern.

The upper leaf cluster was especially rich in reflective and refractive forms; it was like a translucent umbrella in the light. Some planes received direct light, others were backlit, and still others were in shadow. Careful attention to values gave this subject the feeling of bright spring sunshine. Dark shadows thrown by stems and twigs formed interesting shadows on those bright leaves.

Careful observation is the key to success with a simple subject like this. The angular shadow shapes, the curled or curving leaf forms and the values of the light forms make it real. It isn't a traditional choice of subject; we'd more often expect to see this treatment with flowers, but the variations in the leaves were too tempting to pass up.

REDBUD LEAVES IN STRONG SUNLIGHT
15" × 22"
Collection of Betty Bissell

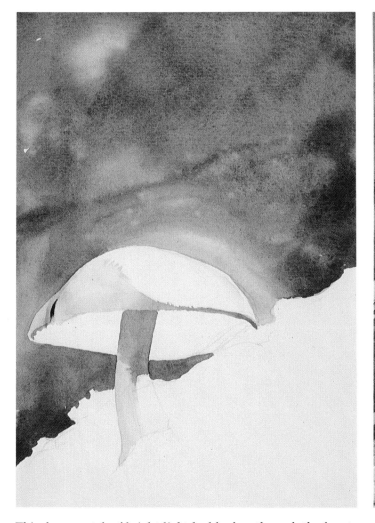

This day, a patch of bright light had broken through the forest canopy, striking a pale mushroom's cap. The mushroom itself was only a light tan-gray fungus, common to our oak and hickory forests, but the light pulled a bit of legerdemain and imparted to it an unearthly glow.

It was a difficult subject to paint believably, but I had to give it a try; I loved the way the sunlight glowed scarlet-orange as it bounced off the mushroom. I painted the background and the glow all in one go, wet-in-wet; I first laid in the pure, bright wash of the glow to keep it from being sullied by the darker green wash. While the edge of the glow was still almost wet, I painted in the green, loosely and with bits of texture created by blotting and spattering. I added a little blue to the upper corner to suggest the sunlight filtering through the tree canopy—where else could that glow have come from? When I had this section down on paper and was satisfied with it, I could move on to less dangerous ground.

In the second step I added the rough bark and the wonderful,

warm shadows under the mushroom's cap; it became a bit of natural "stained glass" when the light shone through it. I used the same colors as in the glow, but added a bit of burnt sienna for substance. I've also introduced these colors in the reflected lights on the stem and on the bark under the mushroom's cap. This is really a painting about light—my favorite subject.

WOOD SPRITE
11″ × 15″
Private Collection

greens; if a tree or vine grows closely enough. And remember when you were a child and held a buttercup to a friend's chin to see if she "liked butter"? The golden reflection in the shadows under her chin proved, once and for all, that she did. These lovely reflected lights also appear in flower forms, intimate landscapes, and found still lifes. Include them with watercolor washes and your painting will spring to life. I often introduce the pure reflected color into a wet shadow wash and let it seek its own boundaries.

A Shadowy World

The opposite of light is dark, but this is not a negative, frightening netherworld. Shadows define shapes; they give a sense of form or direction, mood, or time of day to what we see. Snow shadows sparkle with life as the tiny individual flakes catch the sky light even in the shade. Think of them as miniature prisms; a bit of fine spatter with pale primary colors captures this effect. Keep it subtle, though—if it gets out of hand and looks as if someone had thrown confetti on your snowbank, blot— quickly!

Demonstrations

Because light is so varied and such fun to paint, I have included more than the usual number of demos with this chapter. Perhaps they'll help you see new painting possibilities.

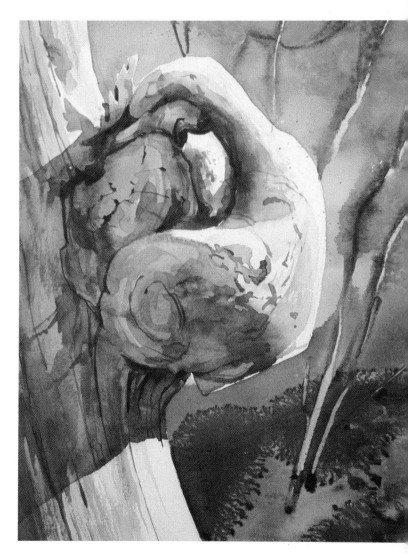

You can see the subtle effects of color in shadow in Tree Gall; *a bit of warm burnt sienna livens up the cool blue-gray shadows and captures the feeling of strong sunlight on the tree trunk, bouncing back up to the nearby gall. (Look for these reflected lights in* Can Spring Be Far . . ., *Chapter 6, and in* Wood Sprite, *page 31.)*

TREE GALL *9" × 12"*

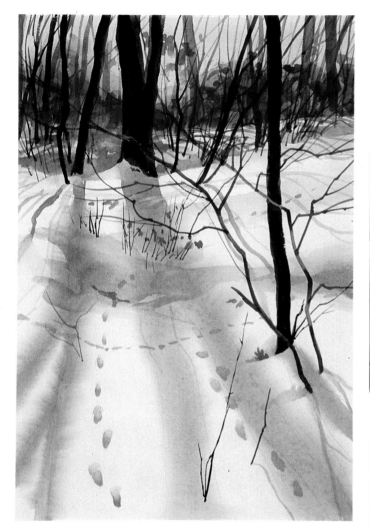

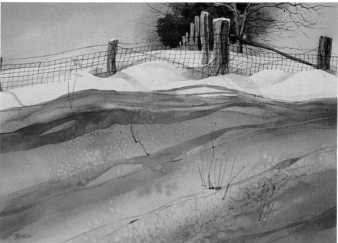

Snow shadows are endlessly fascinating subjects; they run the whole gamut of cool blues and blue-grays. At times it's almost difficult to believe our eyes. We ask ourselves—can the snow **really** be that blue? When my truck was stuck in this formidable snowbank I had ample time to explore the variety and richness of these monumental snow forms. Cobalt blue, ultramarine, thalo blue—all were useful in expressing the nuances. A sprinkle of salt in the foreground captured the icy sparkle. A nice hot toddy was a well-earned antidote to these chilly blues!

SNOW WALL
15" × 22"
Collection of Mr. and Mrs.
Phillip Graham

Sometimes shadows themselves are your main subject, as this small sketch demonstrates. I used the long shadows on the snowy hillside to lead the viewer into the picture, but they also impart information in a number of ways. We can tell the trees are on a hillside; that the sun is somewhere directly above and behind them; and that some little creature has followed a path into the warmly-colored brush on the hill. We can tell there is another plane near the top of the hill—see the horizontal shadow just behind the big tree? Use shadows to give information about nature's details as well as to suggest roundness or volume.

SHADOW PATH
9" × 12"

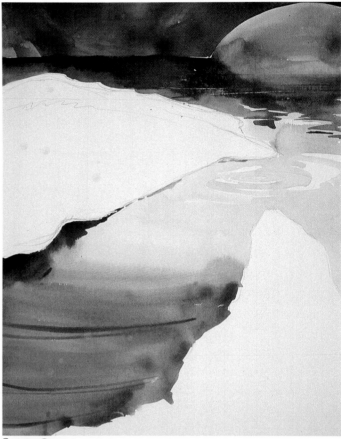

Stage One

Light-Struck Water

I did one of my small on-the-spot postcard studies of the old bridge and the new gravel bar deposited by the most recent high tide. I used the grid system to get the correct spatial relationships between the bridge, the gravel bar, the big sand bar to the left, and the tiny cove of light-reflecting water. But instead of drawing the grid directly on my watercolor and colored-pencil sketch, I used a tracing paper overlay—I hated to spoil the original. These postcard-sized sketches make wonderful additions to my field sketchbook—and sometimes I even send them to friends.

Stage One

Once the images were transferred, I painted the water and the bridge first to make sure I didn't blow that important wet effect—but I did. That green really got away from me. Rather than throw the whole thing away and start over, though, I decided to try a fix; I took the watercolor board to the sink and directed a strong stream of water right at the offending area. While it was still quite damp, I added a subtler brown-green more characteristic of the creek.

Stage Two

Since I was happier with the results I decided to press on to stage 2. You can see the preliminary washes on the cool-toned gravel bar and the warm sand bar. A rich mix of ultramarine blue, burnt sienna, and brown madder alizarin made up the gravel bar, mixing as much as possible on the paper itself. I am happier with my work if I can come close to the desired effect with the first wash or two. Some artists get wonderful effects with numerous subsequent washes—I get mud. I like to retain watercolor's freshness, and I do that by as little overglazing and manipulation of washes as possible.

I like the spiky, angular effects of reflections and hanging tree branches; a rigger or liner brush is the perfect tool to capture them. I keep my touch light and calligraphic here, letting the brush dance over the paper's surface almost on its own. The result is a slightly oriental effect. Hold your brush loosely, not clamped in your fingers like a pencil—you'll like the results.

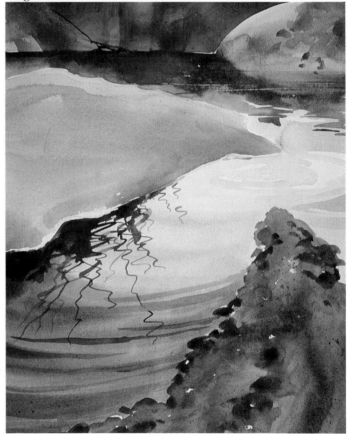

Stage Two

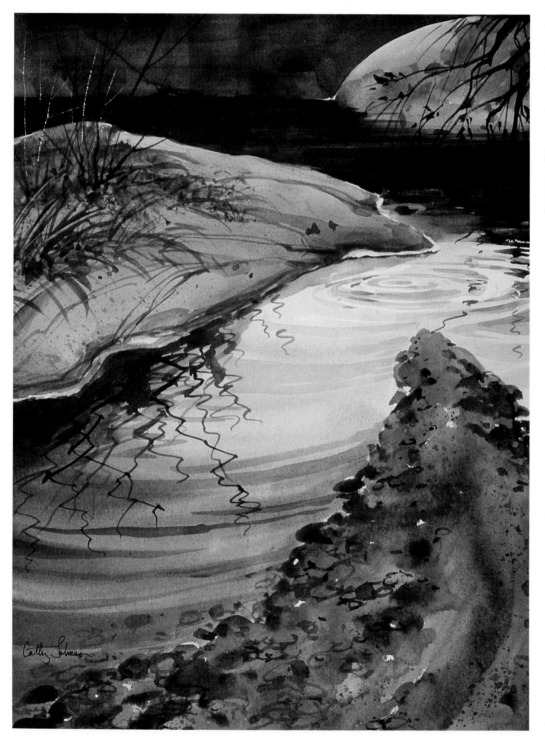

Stage Three

In the finished painting, I've darkened the sand bar and the distant water to be more like the sketch. I've also recaptured the attention on the light-struck rings of water where the small fish was feeding—at the expense of some of the freshness, I'm afraid.

FISH RISING
15″ × 22″
Private Collection

Stage One

Winter's Light

The effects of light are again the subject in Winter's Light—
*those cold blue shadows were irresistible. A winter walk yielded
a felt-tip pen sketch I liked; when I got home I added a bit of pen-
cil work to fix the values in my mind.*

Stage One

*In order to capture the prismatic effect of the light on snow in
stage 1, I used John Pike's old trick: first, I wet the entire sheet
and flooded in* pale *washes of the three primaries, letting them
mix as they would. When the paper just began to lose its shine, I
added the soft shadows of distant trees with a mix of cobalt blue
and ultramarine. A judicious use of salt in the damp wash added
that icy sparkle. (Some places were protected with liquid mask.)*

*You can see that I didn't worry about where the cool shadows
went on the upright tree trunk. I knew I could cover what I
wanted to with a darker wash when the time came.*

*I painted the background in quickly, wet-in-wet, then scraped
light trunks out of the damp wash with the handle of my flat
aquarelle brush. (The corner of a credit card would have done as
well.) If I had scraped before the wash lost its shine, the paper's
fibers would have been bruised, causing them to* absorb *more
pigment. I would have had dark trunks in the distance—which
would have been effective, too.*

Stage Two

*In stage 2, I added the dark of the upright trunk and the fallen,
craggy stump. I wanted the stump's interesting shape to capture
the viewer's attention, so I reserved warmer hues and wider val-
ue contrasts for this area. Mossy greens were flooded into the
wet wash with sap green and Hooker's green deep.*

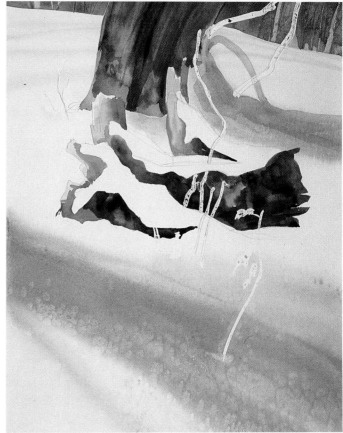

Stage Two

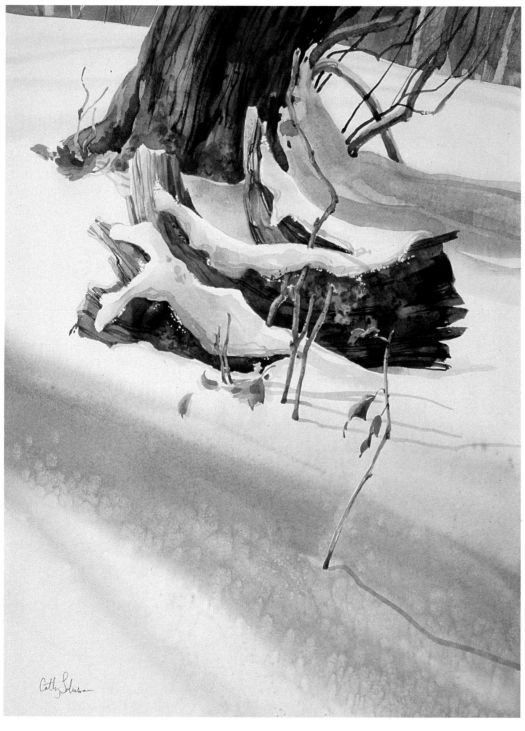

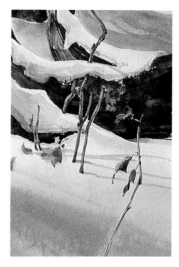

Detail

You can see the effects of scraping lights into the edges of the snow cap here, and the color variation in the twigs pushing up through the snow. Use color to express life. Uniform dark brown twigs would have been boring, a sign that the artist was taking the easy way out.

WINTER'S LIGHT
15" × 22"
Collection of the Artist

Stage Three

Next, I added the pale blue shadows on the snow on the stump itself; I softened the edges by touching them with a brush dampened in clean water. I paid particular attention to the underlying stump's roundness, and what direction the light shone on it.

When this dried thoroughly, I removed the liquid mask and painted the small twigs with their stubbornly clinging leaves of brown madder alizarin. I varied the colors for interest and to impart a sense of life to the twigs. Their shadows are sharp-edged because they are close to their source— even in an already shadowed area, as in the soft blue foreground shadow, enough light will be present to make a darker, sharper shadow on close objects. Scraping completed these small details on the edges of the stump's snow cap.

Perhaps you noticed that I changed the background tree's shape. Its blunt entry into the ground lacked rhythm, so I added the large root to the left and a few fallen leaves.

Glowing Morning Light

Sometimes light is as rich and golden as butterscotch. Everything is bathed in its glow. This usually occurs in early morning or late afternoon, when the sun's rays are filtered through a thicker concentration of the earth's atmosphere.

Stage One

To capture the effect, I gave my entire paper surface a wash of cadmium yellow, cadmium orange, and raw sienna. The shadow in the lower left and foreground included these colors plus a rich addition of ultramarine blue. Salt and spatter, with a bit of blotting, added texture to this preliminary wash.

Stage Two

I protected the bridge's carefully drawn uprights with liquid mask, and used drafting tape to mask the straight areas. Here and there, I also protected lacy branches and weeds as well.

In stage 2 you can see the loose washes of rich green painted over the protected areas. I used sap green, burnt sienna, cadmium orange, thalo green, and burnt umber in this passage, plus a bit of thalo blue for the patch of sky. In this photo, the mask has been removed from the bridge and the weed in the foreground but not from the tree limbs. A tip: liquid mask can damage brushes, so use a disposable brush or protect the bristles with soap before using it.

Stage One

Stage Two

JOHN'S BRIDGE
15" × 22"
Collection of Nancy Elmore

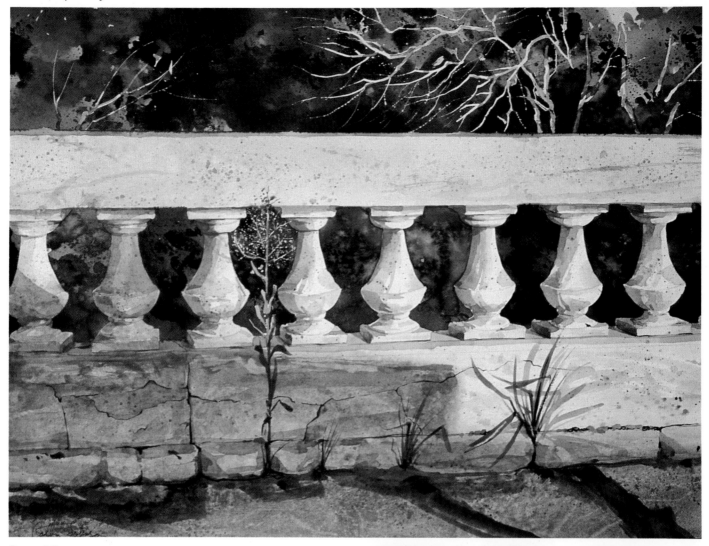

Stage Three

I was now free to use as many glazes and washes as necessary to add detail and form to the bridge. I retained the freshness by letting each wash dry thoroughly before adding another. Shades of ultramarine blue, burnt sienna, and touches of cadmium orange completed the painting.

Detail

The detail shot lets you see the texture of the old stone bridge which, though man-made, really had become a part of nature. This painting is owned by the woman whose father built the bridge many years ago; he met her mother while working in the tiny town of Prathersville and made her his wife.

Detail

RENDERING TEXTURE

Now that you are looking more closely at the world around you, you are probably noticing textures you had never really seen before. Rough, smooth, furrowed, rounded, mounded, pitted, pebbled, or puffed, textures surround us, and watercolor is the perfect medium to explore them.

How do you capture the effects of rust or weathered wood? When you begin to take note of nature's details, fresh challenges arise on every side. Use familiar techniques, such as wet-in-wet, drybrush, or successive washes—or invent your own to match the subject.

Your eyes are only one way to learn—your other senses can help familiarize you with texture, too. Lie down on a mossy bank—it's soft, cool, and inviting. A springy bed of dry oak leaves or of bent, dried grasses is also pleasant. (The rich autumn scent may even find its way, subconsciously, into your work.)

Feel rough rocks with your hands; close your eyes and explore. Try a weathered fence post, soft, mounded snow, or puffball mushrooms as smooth and round as miniature buns fresh from the oven. We are tactile beings—notice how a baby explores its world with hands and fingers as well as eyes or even tastes things to see what they really are. I realize I go a bit further than most, but I try to be one with nature before I dare try to paint it. I taste the wrinkled lichen or the cool, gritty stone. If you prefer, just let your sense of touch supplement your sight—I guarantee you will have a greater understanding of your subject. Who can imagine the depth of those crevices in a cottonwood's massive flanks without following their lines with a finger?

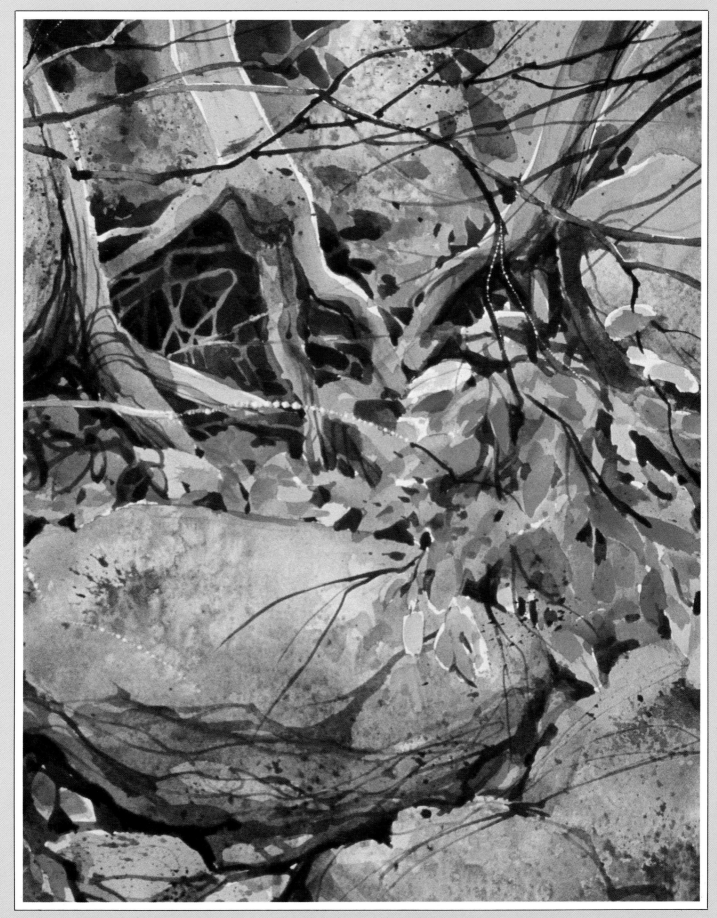

DETAIL OF TREES, ROCKS AND ROOTS

41

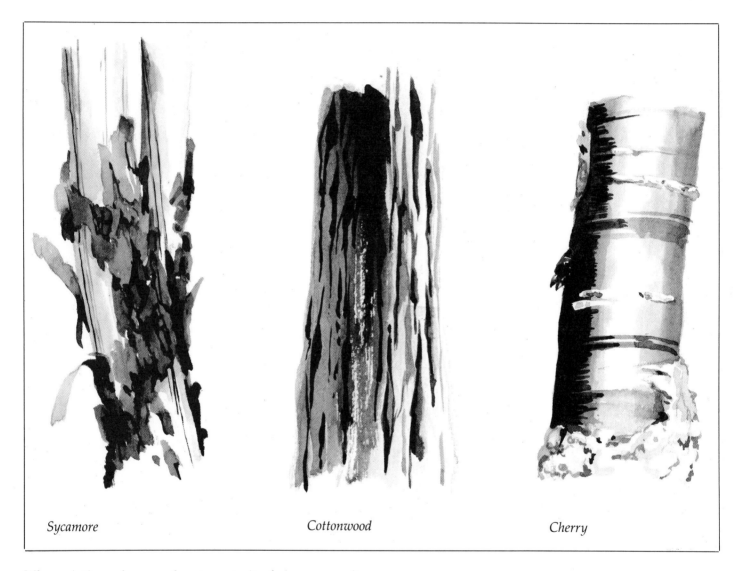

Sycamore

Cottonwood

Cherry

When painting a close-up, almost a portrait, of a tree you won't be satisfied with a generic "bark" texture. You'll begin to notice more than that. Is the tree a sycamore, with its pale underbark and flaking surface, or is it a stretched-tight-looking beech tree? Does it have deep furrows like a cottonwood or the glossy look of a cherry tree? My sketch represents only three of the myriad possibilities. Try a combination of techniques here; a wet-in-wet underwash and an almost drybrush overwash for texture can be very expressive (the cottonwood was done this way). Or build successive washes as I did on the sycamore bark. Just be sure to notice the differences, the personality or "gestalt" of the tree, and tailor your technique to match.

Bark Studies

You may want to make a series of sketches or small watercolor studies of different bark types to keep on file. Any good field guide on trees will help you identify the tree you've chosen as a subject; make a few marginal notes as to season, tree size, color, and any other details you happen to notice. Were there lichens or moss on the bark; engraver beetles or other tunneling creatures; shy moths hiding under loose bark; woodpecker or sapsucker holes? These notes may seem incidental to painting, but they familiarize you with your subject, which helps you to better depict it. They will also serve as memory jogs to recall the image more clearly when it's time to paint. You will begin to *know* your subject in a much deeper way.

Trees and Foliage

Painting the many varieties of trees and foliage could keep you busy for years. Notice how other artists have handled this challenge: Jamie Wyeth, perhaps, or John Pike, or one of the wildlife artists. Artist/naturalist Keith Brockie carefully delineates textures with a wonderful freshness. Or look at Rein Poortvliet's techniques; he is best known for the gnome books, but he has also written and illustrated others, including *The Living Forest* (New English Library, London, 1979), which focuses closely on some of nature's details.

The type of tree makes a great difference in how you paint it. An oak is rugged and gnarled; a willow, graceful. In deep woods where trees must compete for available light, younger ones may rise for many feet without branching—they save their energy for the light in the canopy. If you want to paint a tree in a crowded forest, look carefully. An old tree may have received more light before the forest filled in around it, or it might be naturally branched or gnarled, heavily textured even to the roots. A younger tree that has had to stretch for sun-

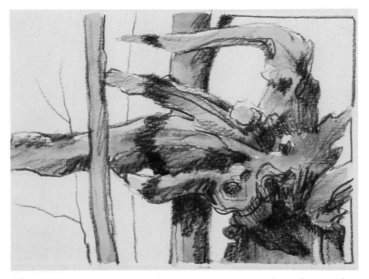

This little sketch is a study in contrasts: rough and smooth, warm and cool, massive and spidery, twisted and straight. It was done on a watercolor postcard stock, sketched with a dark colored pencil. I added the watercolor washes later at home. Working this way helps me develop my color memory as well as an awareness of the wonderful variety of textures.

UPROOTED
4" × 6"

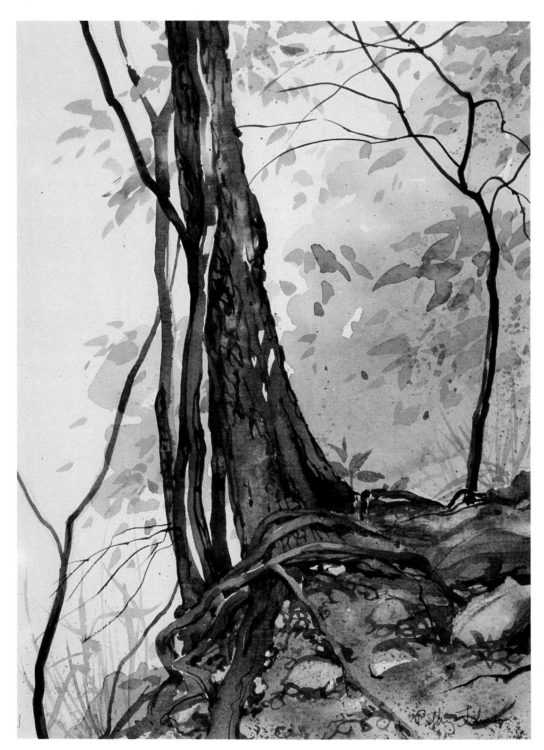

ROCKY HOLLOW TREE
9" × 12"
Collection of the Artist

I was struck by the wonderful tactile aspects of this tree overhanging the limestone bluff at a small fishing lake. Its roots clinging to the loose rocks like snakes, and the sun-struck, dappled bark were irresistible. While my husband fished for our dinner below on the water, I came home with a "catch" of my own. Be prepared with your own "fishing tackle"—take along at least some painting gear wherever you go.

I used a wet-in-wet technique for the background foliage; I wanted to focus on the tree itself and on the twining smaller saplings at its base.

I used a warm underwash with a shadowed base to establish the main trunk's color, and the point of land it was on; most of this went in wet-in-wet, also.

When it thoroughly dried, I covered nearly the entire tree with a shadow wash of ultramarine blue and burnt sienna, beginning to work in a bit of texture here and in and around the roots and rocky earth. I painted the fine details in the bark and pebbles with a nearly dry brush.

I added a few individual leaves with single strokes of a #7 watercolor round. I painted the grasses, leaves, and tiny sprouts last, using the fine point of my Raphael folding brush with an almost calligraphic stroke. I like the faintly oriental feel of this little painting—this was one I was **happy with!**

In the sketch below left, a small creek has washed the soil away repeatedly whenever the water has risen, but the tree is still clinging to the bank—and reaching toward moisture. In the sketch below right, the old behemoth has given up its hold and fallen into the lake. The roots have rotted away somewhat, but you can sense their groping strength.

Depending on the type of rock I am trying to paint, I can employ a variety of techniques, alone or in combination. In this quick sketch, I did a wet-in-wet wash, letting burnt sienna, burnt umber, ultramarine blue, and a little brown madder alizarin blend freely in the shadows. While it was still wet I scraped some fissures into the side and spattered it with the same, but more intense, colors. I added cobalt blue here as well.

light is smoother and straighter. Look for these differences in texture and form and play them up.

Roots also make interesting subjects. Normally hidden under the soil, where they may spread as far in any direction as the leaf canopy itself, exposed roots give us a sense of the strength and tenacity of these largest of plants.

I know of trees that have seemingly defied gravity by their clinging roots, or have given up their hold on an arid forest ledge to expose great, twisted root systems that resemble beached and rigid octopi. These make terrific painting subjects—always available, too.

Rocks, Sand, and Gravel

Much of the earth is covered with rock; in fact, the soil itself is composed of fine rock particles broken down through an eternity of heat, cold, wind, and water, then mixed with organic plant residues. As you zero in on these details you will notice a great variety of shapes, colors, and textures. Many watercolor techniques are helpful in expressing this variety. Suggest sand with a bit of varicolored spatter. A small stencil brush can produce just the right textural effect; save large droplets from the tip of your #12 round brush for pebbles or small rocks. Blot here

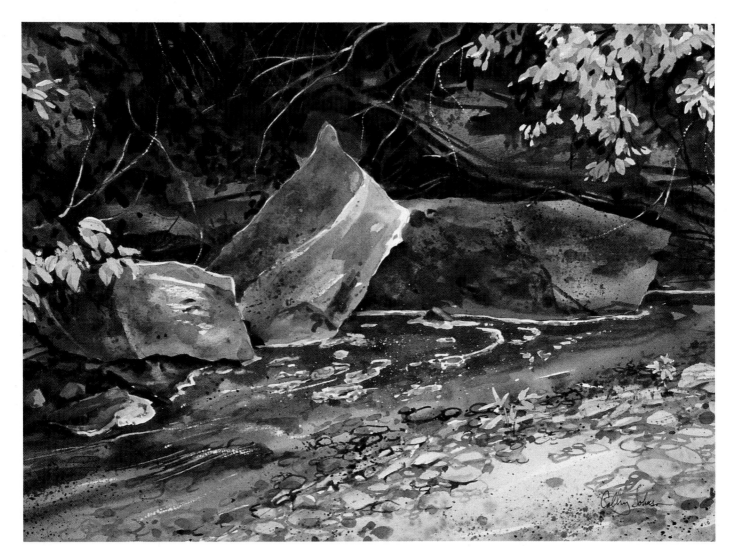

ROCKS IN THE STREAM *15" × 22"*

In this painting you can see the three textures I discussed—the big limestone rocks, mossy and weathered; small pebbles; and a sandy bank. The pebbles were expressed mainly by painting over the underwash with a sharply pointed round brush, almost drawing rather than painting to describe the rounded forms and the shadows between them. Later I added some color variation to help differentiate them.

These large, multi-faceted rocks are entirely different in character from the glacier-rounded granite boulder. They formed under great pressure, then cracked away from the exposed bedrock through centuries of water's repeated freezing and thawing inside tiny surface cracks. They look almost as if they were cut by a stonemason, and here I was careful to emphasize their angularity. I used wet-in-wet only to introduce a bit of mossy color, especially noticeable in the middle rock. Granular manganese blue worked well here. A minimum of spatter gives a sense of the pitted surface. The darker color of these limestone blocks helps push them back into the middle ground, while the lighter sand and pebbles seem to come forward in the picture plane.

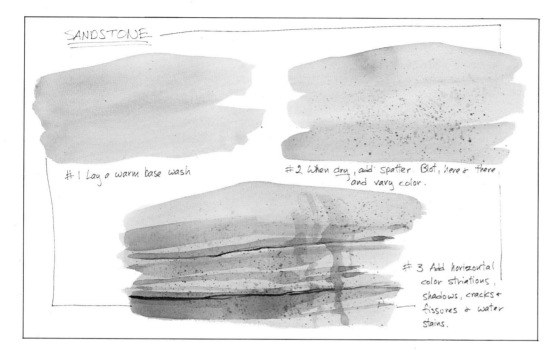

SANDSTONE

#1 Lay a warm base wash

#2 When dry, add spatter. Blot here & there, and vary color.

#3 Add horizontal color striations, shadows, cracks & fissures & water stains.

There are as many ways of painting rocks as there are types of rock formations. What you see in the particular stone will dictate your approach. These are suggestions to help get you started.

Sandstone, as the name suggests, is formed from grains of sand compressed under great pressure to become rock. A warm wash in as near the actual color as possible is a good first step. I have used burnt and raw sienna plus a bit of ultramarine blue.

When that wash is dry, add spatter; blotting gives the dots some variation.

Add further details, such as rock cracks, fissures, and the signs of weathering.

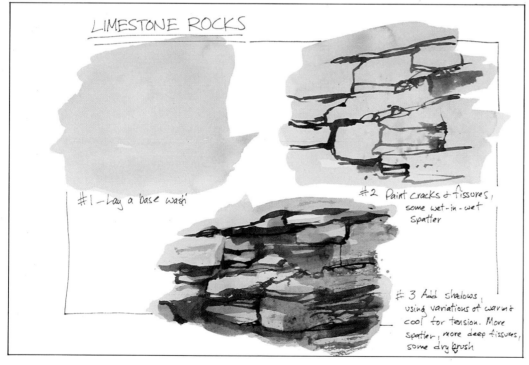

LIMESTONE ROCKS

#1 — Lay a base wash

#2 Paint cracks & fissures, some wet-in-wet spatter

#3 Add shadows, using variations of warm & cool for tension. More spatter, more deep fissures, some dry brush

Limestone is quite different from sandstone in character. It often has more fissures; some limestone looks as if it had been shattered by a great blow.

A cooler wash better depicts limestone's color; try a stronger concentration of ultramarine blue with burnt sienna.

Then paint in dark lines to represent cracks and fissures, using a small brush and a rich mixture of pigment. I used ultramarine blue and burnt umber. A calligraphic approach may help you describe these forms. Spatter here and there for texture.

Finally, add warm and cool shadows, softening some dark lines and accentuating others when the wash is dry. A bit of drybrush used here captures the character of the rugged limestone.

and there to avoid too uniform an appearance, and try spattering into a damp wash with clear water or rubbing alcohol for further texturing.

Erosion and the effects of weathering or moving water determine a rock's shape and texture; you may want to learn a bit about these natural forces to better understand the formation of your subject.

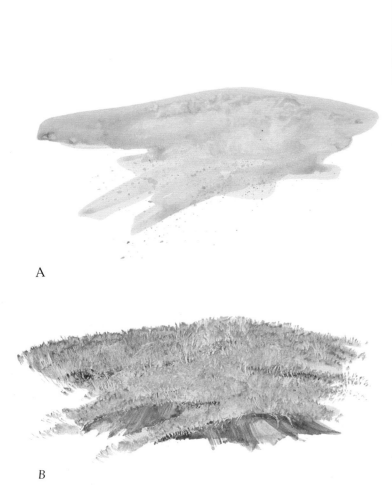

A

B

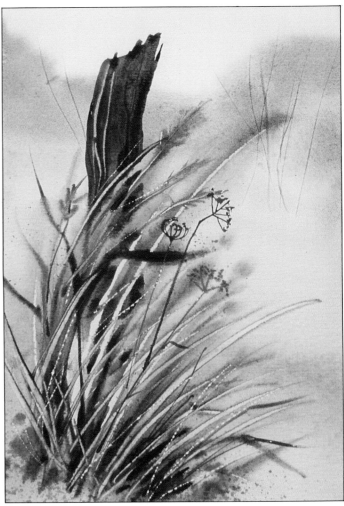

WEEDS AND POST
9″ × 12″

Grasses and Weeds

The texture of grasses and weeds is fun to paint; we can use all of our tools and tricks here and, if careful, will still not overwork our subject. You may wish to concentrate on the rough, varied forms of a weedy bank silhouetted against the sky as in the sketch below, or simply express a grassy foreground for another primary subject.

I don't care much for short, manicured, almost shaved-looking grass (it reminds me of "flat-top" haircuts) but there are times when we may need to include it. You might try it on smooth, hot-pressed watercolor paper or board for a different effect. The absolutely featureless surface lets your pigment and brush create their own lively texture (See A). If you want to create a bit more, work back into this first wash with a barbered fan brush, your fingers, or the side of your hand. Introduce one or more other colors and mix them on your paper, not the palette, as I have done in B. (I'd be perfectly happy with A, by the way—too much texture can get boring.)

I quickly sketched this fence post nearly buried in tall weeds and grasses mostly wet-in-wet, with strong saturations of earth colors (burnt sienna, burnt umber, etc.) so they wouldn't flow too wildly. I also waited till the background lost its wet-wet shine to lay them in. I scraped and spattered as the wash dried to the damp stage, then waited for the whole to dry before adding the post and individual weeds. I wasn't happy with this one—it seems too facile to me. (That's why it's still a sketch and not a painting, as far as I'm concerned.)

A "barbered" brush

GATE POST
9" × 12"
Collection of the Artist

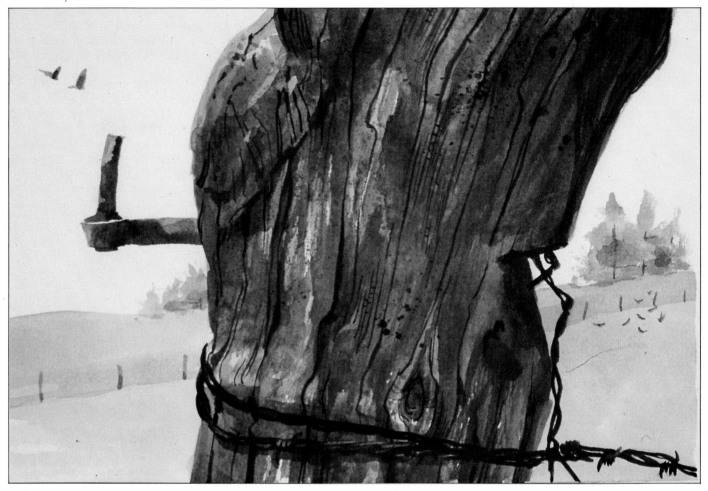

This ancient gate post may have outlived its original use—its gate has disappeared—but it is still beautiful. Sturdy and gnarled, it was chosen for its strength. In Missouri, Osage orange or hedge is a common choice for fence posts. It resists rot, though not superficial weathering.

From the beginning I painted this old survivor with a large, flat watercolor brush in an almost drybrush manner, to allow the paper's texture to express sunlight.

The shadows looked very cool in contrast to the warm, rusty lichen growing on the post's sides; ultramarine blue mixed liberally with burnt sienna gives this effect. I painted lichen spots with a mix of burnt sienna, raw sienna, and a bit of sap green.

I used a small flat brush on the gate hinge pin and let the pigment's natural puddling take over to give it dimension, only slightly manipulating the puddles to guide them.

I added small details with a fine-pointed red sable brush, following the contour of the post and the grain of the wood. The large knot at upper left was once a sturdy branch—notice the grain lines take a different direction here, following the logic in the wood.

Weathered Wood

Wood textured by time is one of my favorite subjects. Old fence posts, weathered buildings, and gnarled stumps come in all shapes, sizes, colors, and degrees of texture. Colorfully patterned lichens grow on aged wood, knotholes develop character lines; perhaps that's what makes wood so endlessly fascinating. Its life shows in its lines, much as ours does.

Demonstrations

Since there are many kinds of texture in nature, I am including four demonstrations with this chapter. Actually, a whole book could be written on this subject alone.

Bark and Foliage

This old stump by the water's edge caught my eye as it clung sil-houetted against the dark woods of the far bank.

Stage One

I used a felt-tip pen to explore the textures that time, water, and weather had caused. I find that this type of detail study provides a good basis for a later painting; it eliminates the temptation to overwork which I might do if I worked on the spot. I am also not locked into reproducing the colors in a photograph. I often make sketches like this one even from my photo research, just to short-circuit that tendency, then put the photo away.

Stage Two

In the painting itself, Rugged Stump, Rocky Hollow, I kept the background deliberately simple to focus attention on the stump and the rough, light-struck weeds around it. I painted around the big weed just behind the stump rather than using a liquid mask; I like the fresher, more immediate effect. The weed was then painted in using very pale washes that I allowed to touch and blend with the still-wet background trees here and there.

I painted the stump itself with successive washes of pale ultra-marine blue, burnt umber, and burnt sienna, maintaining the light-struck upper edge by painting around it. I liked the rich shadow of the root that anchored the stump to the bank—it re-flected some of the bank's warm color, so I introduced brown madder alizarin and a bit more burnt sienna to my ultramarine blue. Look for these reflected lights; remember that shadows are seldom one color, and tend to look dull and uninteresting when painted that way. There is even a tube of watercolor called, if I remember correctly, "shadow tint." If you use it, be sure to flood in other colors to give it a richer feel; by itself it is a boring bluish gray.

I achieved texture by selectively blotting with a tissue while still damp. I was able to lift the contours of the root in this way and give it some further dimension.

I added final details of grain and weathering with a fine brush loaded with a rich mix of sepia umber and ultramarine blue.

RUGGED STUMP, ROCKY HOLLOW
15″ × 22″ Collection of the Artist

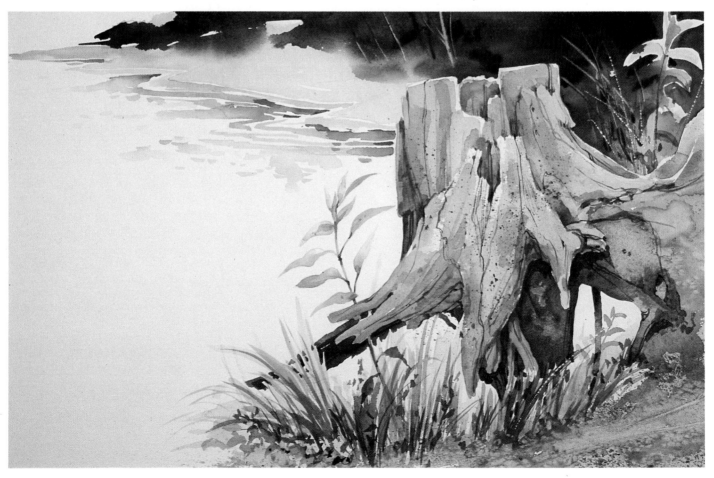

Forest Floor

This painting began as a demonstration of intimate landscape for a workshop I conducted in the Ozarks. You can see how far I got in stage 1 before running out of time. I used liquid mask to maintain the light, thin limbs reaching down over the bank, but I painted around everything else.

Stage One

Rocks received the full treatment: puddling with a flat brush, spatter, and a little blotting here and there. I suggested fine lines with burnt umber and ultramarine blue, and painted the foliage with burnt sienna and a touch of cadmium yellow medium. I added salt here and there while the washes were still damp.

You can see the beginnings of root definition under the middle tree in this first stage.

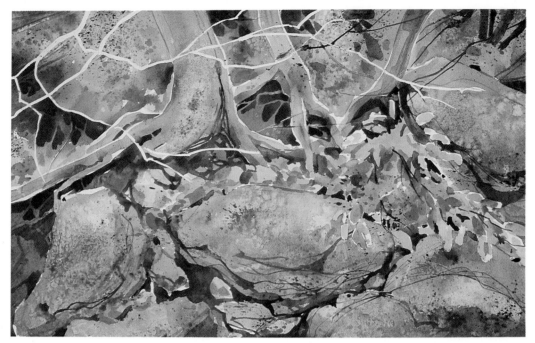

Stage Two

I made the foliage more colorful by adding a little cadmium orange here and there—it had looked too homogenous before, and needed some punctuation.

I further defined the rocks and developed the shadow areas. I like to paint negative spaces around objects; in this case the shadows around and behind the roots became progressively smaller as I worked.

I painted in fine twigs and branches or scraped them out with the tip of my craft knife when everything was dry.

TREES, ROCKS, AND ROOTS
15" × 22"
Collection of the Artist

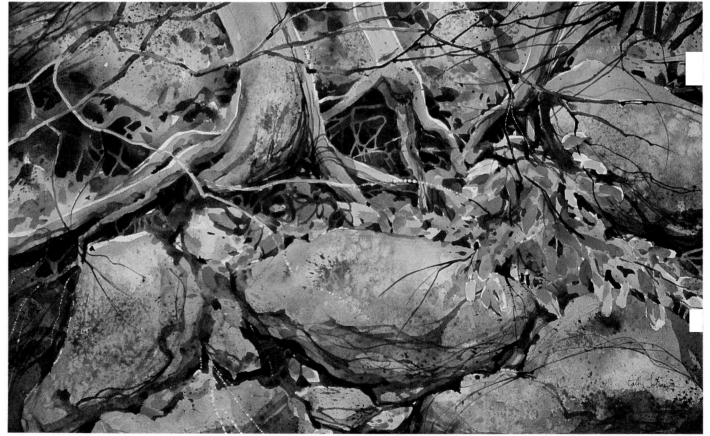

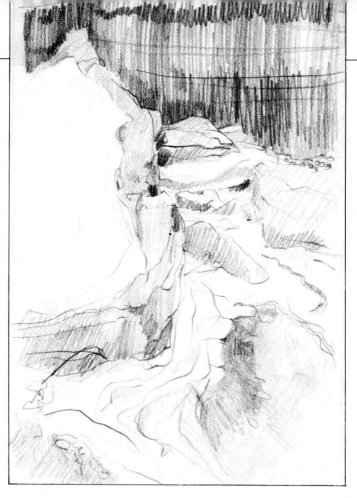

Snow and Ice

I love winter walks. The park where I often paint is nearly deserted, so I can work undisturbed. These massive rocks are upstream from my home near the creek. The long cold began to break a bit and the hard caps of frozen snow were melting back at the edges; the creek had open water again, characteristically winter-dark.

Stage One

I altered this on-the-spot sketch somewhat in the final painting for compositional reasons. As you can see, I extended the large rock's point to overlap the land form on the opposite bank.

This is a real working sketch—you can still see the coffee stains.

Stage Two

I used a rough grid method to transfer my thumbnail sketch to the watercolor board; the sketch itself was no larger than 1″ × 2″, but was enough to guide my placement and to transfer the changes made in the original field sketch.

Once my basic guidelines were in place, preliminary washes went in quickly. The far bank was in shadow, so I kept it fairly simple and used a very cool cobalt blue.

To contrast, I kept the massive rock form very warm. Burnt sienna and ultramarine blue were the main colors. Spraying with clean water while the wash was still damp, and then blotting with a tissue added to the rocky texture; here and there I used the side of my hand as a texturing tool (no wonder I always look as if I'd been working on my car). Unlike the traditional watercolor technique in which you work—safely—from your lightest light to darkest dark, I sometimes like to jump right in with some of my bolder colors and darker values. It lets me see how to key my lights to these dark-to-middle tones, and if I am careful and work quickly, I can still work over the edges of my darks without lifting them.

After first protecting some of the bubbles with liquid mask, I painted the frozen, crystallized ice pool in the lower right with cobalt and ultramarine blue. For a crackled ice texture, I pressed crinkled plastic wrap into the damp wash and allowed it to remain a few minutes, then pulled it away across the surface for a linear effect. I did this twice, with successive blue washes, to give a sense of depth to the ice.

The massive rock's snow cap was painted wet-in-wet with very soft edges by first dampening the area with clean water. Again, I chose cobalt blue for color unity and its icy coldness.

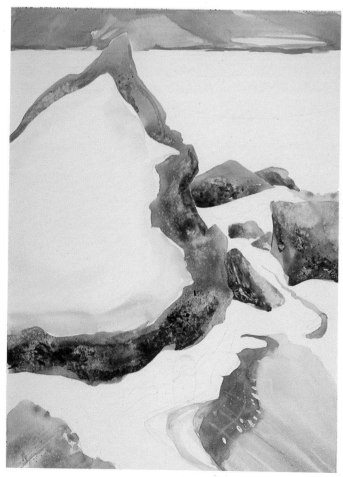

Stage Two

Stage Three

I wanted to protect the rock edges in order to freely paint the dark water all at once. I laid drafting tape carefully over the area and burnished it down with the back of my thumbnail. Because this tape is thin enough to see through, and not as tacky as masking tape, it's not as likely to damage your paper when you pull it away. Still, it's best to be careful and remove it slowly—this is no Band-Aid!

Once the tape was down, I cut along the lines of the rocks and shore with a sharp-pointed craft knife and pulled away the excess tape. Then, to further protect the snow and rocks from splashes, I taped a piece of plastic wrap over all, following the line of the previous tape. You can see the plastic's shine in the photo.

Stage Four

The water technique proved to be elusive. I wanted it very dark but with an even darker shadow or reflection at the top, so I chose indigo pigment. As it happened this was a mistake. I was unfamiliar with this particular pigment—the color wanted to flow into itself and spread out evenly. Still, I liked the effect enough that I didn't feel the painting was ruined. I continued to add small details in the ice and rocks and developed the pebbles exposed by the melting ice in the lower left.

ICE AND ROCKS
15" × 22"

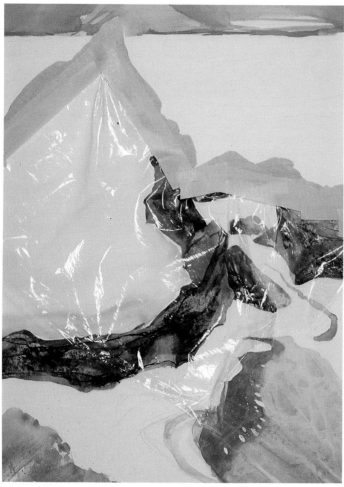

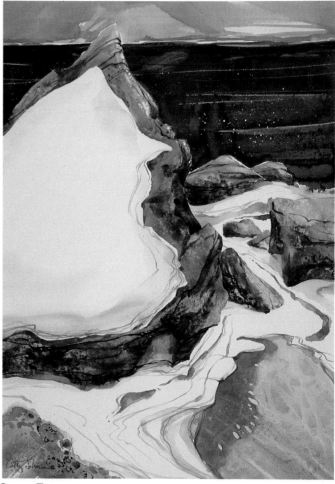

Stage Three

Stage Four

Contrasting Textures

These smooth, glossy mushrooms set against the dead log's cool blue-gray and the rough grass was too eye-catching to resist. This combination illustrates an effective use of contrasting textures.

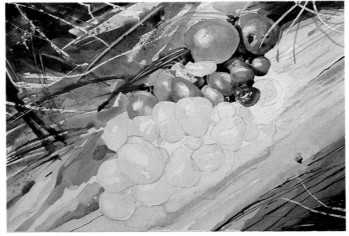

Stage One

Here you can see my careful pencil drawing to delineate forms and the first warm underwash of cadmium yellow medium. Even at this stage I was careful to maintain highlights. Although you can reclaim whites with a number of methods (lifting with a damp brush or sponge, scraping, cutting, etc.) the effect never looks quite as spontaneous and fresh. I like to preserve my whites where I can; the other methods I tend to think of as "fixes" rather than actual techniques. (This is true except when working on hot-press or plate watercolor paper, when lifting is to me a legitimate part of the technique.)

Stage Two

At this stage you can see the beginnings of the mushroom forms as they will finally appear. Cadmium orange, raw sienna, and burnt sienna are my colors; the mushrooms themselves were so vivid that I mixed color samples on a separate sheet so I could experiment until I hit on just the right color combination. Value patterns and composition may make a painting, but when encountering such a wonderfully rich color in nature, I make every effort to duplicate it if possible.

I've protected some of the weeds and grasses with liquid mask, and scratched other lights into the damp wash.

The blue shadow is a fairly strong value made up of cobalt blue and burnt umber—heavy on the blue. In other parts of the log I've introduced burnt sienna and ultramarine blue for variation.

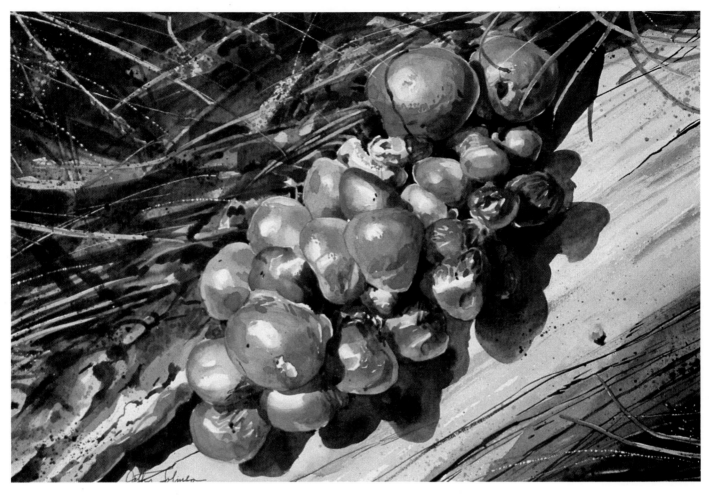

Stage Three

In this final step you can see the modeling of details in the fungus and the grasses. I've repeated some of the puffballs' color in the grasses for unity. The dark shadows really make them stand out and give them a sense of depth and roundness.

This was a rather contemplative painting. I took my time with the rounded forms of the mushrooms, softening edges, and building up colors until I was satisfied with the final effect—other times I like to be more spontaneous. You don't have to stick to one method or style for every painting; let your mood and the subject dictate the approach.

GOLDEN PUFFBALLS
11" × 14"

WATER PATTERNS

Endlessly moving or still and reflective; clear and sparkling with light or roughly tumbling over a miniature waterfall, water patterns on this intimate scale are fascinating painting subjects. For centuries artists such as Winslow Homer, John Marin, and Albert Bierstadt have captured the grandiose proportions of the sea, great rivers and mist-shrouded waterfalls. But when we take a closer look at nature's details we can find a whole new dimension to the subject on a smaller, more comfortable scale. Certainly Niagara Falls are impressive, but for day-in, day-out pleasure, I'd rather sit by the little riffle upstream in the creek near my home listening to the gurgling and chuckling of its miniature "rapids." I've painted them more than once, dabbling my feet in the water like a kid—keeping cool and comfortable at the same time! For most of us the smaller lakes and rivers are more accessible on a day to day basis than Niagara Falls or the pounding Atlantic Shore.

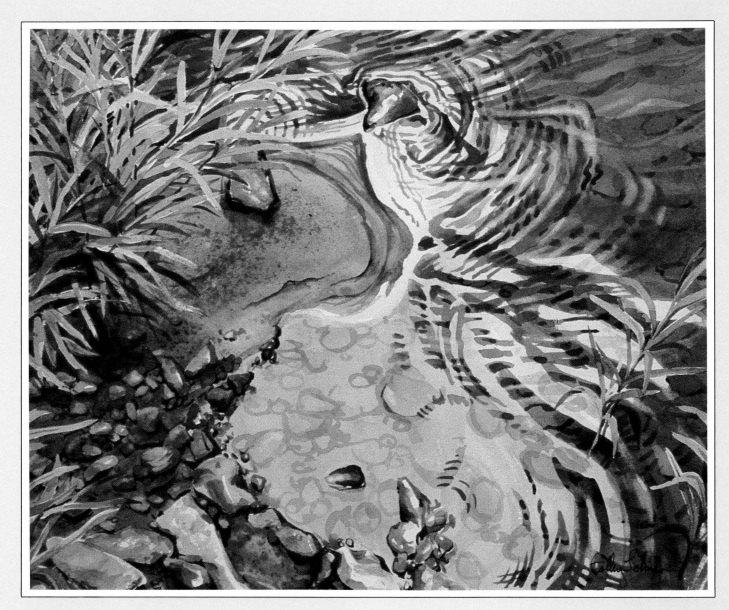

SAND POINT *10″ × 12″*

In Sand Point *I've studied the tiny wavelets lapping against a small sand peninsula left by the latest high tide. Even the half-submerged pebble disturbs the water's sensitive surface.*

I made a careful pencil drawing of my subject directly onto the watercolor paper, paying close attention to the random pebbles and the nice shape of the sand point. I then protected some of the weeds and pebbles with liquid frisket. Once that was dry, I painted the light water and sand as my first step. I knew that if I blew the sand point I'd have to toss the whole thing, so once this section was laid in I could breathe easier.

Notice that where the sky reflects on the water there's a certain opacity—I could barely see the little rocks under the surface, even though the water was no more than an inch deep. I just indicated their varied shapes with the tip of my brush once the wash of pale thalo blue had dried.

The water itself is mostly transparent at this time of year; it looks brown because you can see right through to the mud and pebbles below. I was careful to mix a nice, rich algal brown, with raw and burnt umber and a dash of Hooker's green deep, and followed my pencil "map" of wave shapes, painting from the relatively simple upper right corner down to the loose waves around the shoreline and point. I softened some edges with a brush loaded with clean water, then blotted quickly.

When that dried, I removed the frisket from weeds and pebbles and painted them in, paying attention to the wonderful diverse shapes and colors, trying to maintain a shiny, wet look.

Darkest accents came last—and it was fun to see the wave patterns really become wet-looking as they got their secondary washes. I still paid attention to the cause of these secondary patterns. That's what makes this little painting work.

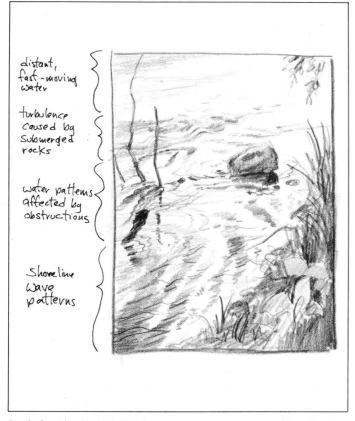

distant, fast-moving water

turbulence caused by submerged rocks

water patterns affected by obstructions

Shoreline wave patterns

Look for the logic behind water patterns; every effect has its cause

Organizing Patterns

Water patterns vary from lake to river, even within the same body of water. A submerged rock causes interesting, undulating shapes, which affect reflections on the water's surface. The shape of waves lapping against the shore differ from those breaking around a protruding object. Still water *does* run deep (unless it's a quiet, protected pond or stagnant swamp!); here, the reflections will become your primary subject. When bubbling over shallow rocks or water-polished pebbles, the surface will be broken and sparkly. To know what makes each pattern, learn the logic behind the water's movement.

The sketch, top right, shows some common water patterns and explains their causes. The distant, fast-moving water has little to mar its surface—you may see only a few indications of current. A few feet away, in shallower water, the surface is wrinkled and active. Long streamers of water flow downstream away from obstructions. Even a small twig causes a change in this expressive surface; a rock displaces proportionately more water, making the patterns broader and deeper. As waves break against the shore, they resemble miniature ocean

surf. Look for these patterns—to help you "see," make an annotated sketch like this one to explain what is really happening. Later on, such memory jogs will help to interpret your subject more believably.

Freezing Motion

Water patterns can be confusing at first—the continual motion makes water seem almost impossible to paint. But if you watch over a short period of time, though the patterns may change somewhat, the object that causes them does not. The same pattern—or one similar to it—will appear again and again. Sketch it quickly, then work on your sketch each time your original pattern reappears. This is also a perfect place to make use of the sketching tool popular with artists for decades—the camera. A relatively fast shutter speed freezes the action of the water, making it "a snap" to study at leisure. A slow speed will make a soft blur if water is moving rapidly—an interesting effect to attempt wet-in-wet if you're brave enough!

Turbulent Water

This is the most challenging water pattern to paint. Even if a waterfall is quite small—no more than a foot in height—there's still a *lot* going on. Painting such a scene without overworking is the problem here, but again, a basic understanding of what *causes* the pattern is the answer. Simple observation is the key.

Still Water

In very still water, reflections may be perfect mirrors of their object (upside down, of course) but that isn't always the best way to paint them. A bit of variation in line and direction "says" water to the viewer's eye. Look to capture that watery effect without making a confusing statement; if your painting looks just as good upside down, your audience will feel disoriented.

Graded washes help to give the feel of distant, still water; you will almost always be able to discern some slight movement in the water, either from an underground source or from the motion of the air. Wet-in-wet wave effects help break up a too-still body of water.

WATERFALL
15" × 22"

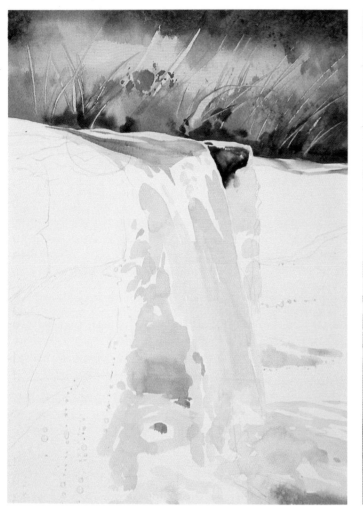

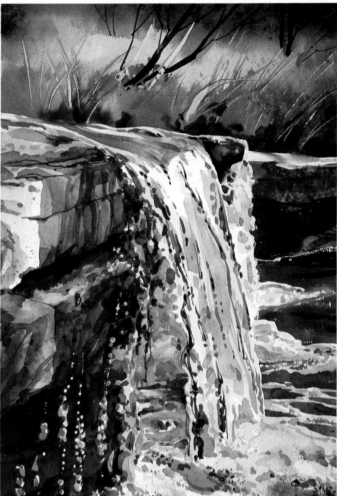

I painted the background wet-in-wet first, with a rich mixture of thalo green, cadmium yellow, thalo blue, and a touch of brown madder alizarin at the base of the tufts of grass for a bit of warmth and contrast. I scratched into this wash while it was still damp to make individual grass blades and weeds.

I wanted to focus attention on the area where the water breaks over the rocky ledge. This is my center of interest and the area of the greatest value contrast, so I left the white paper to act as the water's shine.

Even though this is moving water, it still reflects both the blue unseen sky and the green bordering forest. I introduced these color notes at the top of the falls with some intensity, using the thalo green, thalo blue, and a bit of Hooker's green deep. Down in the waterfall itself, where the water lightens when mixed with air, I used the same colors but in a weaker concentration.

Again, I paid attention to details: what caused the shapes in the water; the color where the rocky ledge dipped and receded, then thrust out like an assertive chin at the area of greatest contrast.

For the rock forms I used warmer colors than were actually present in nature to help separate them from the cool greens and blues of the water. Although nature is my primary teacher, I feel that in the interests of a good, readable painting I have license to change what I need to. If I wished to make a slavish copy of nature, I would do better with a camera. I used ultramarine blue, sepia, and burnt umber in the shadowed areas. Rocks were spattered, scraped, and blotted while still damp to give them the rugged texture characteristic of Missouri limestone.

At the near edge of the falls the water moves slower—the stream breaks in two directions, though still knitted together at the top with droplets. I used successive washes to capture this effect.

Between the two streams you can see the roiled, muddy water—it's amazing how many colors and shades appear in one little waterfall! Liquid frisket protected the droplets on the lower left; I tinted them after I removed it. I like the background and the center of interest best—I started to overwork the shadow areas, and they got a bit dull. I hope your eye doesn't linger there long! (Oddly, it's the area of this painting my husband likes best.)

Reflections

Unless it is an extremely overcast day or the surface is whipped into an overall choppy pattern by the wind, water is a very reflective surface. The water's motion or the degree of wind determines a reflection's shape and direction in a secondary sense. Of course, the overall shape depends on what is being reflected on the water. Most generally, reflections are opposite (like your face in a mirror), darker, and somewhat less distinct than their object. My quick sketch, right, shows what I mean. Reflections are more distinct closer to their object; they are affected by water patterns further out. (See Rocks and Trees at the Point, for an example of reflections painted on the spot.)

Cast Your Nets is one of my favorite paintings of the creek in the mist. I waded up the stream in my sneakers (the water was cold—that's what made the mist!) to get close enough to see the reflections and the carefully constructed spider web over the busy "insect highway" of the creekbed. The sun barely touched the water with a bit of warmth; the resulting angular reflections were wonderful to paint. Often, the problem with painting a scene like this is in not being bold enough. A bit of spattered frisket retained the sparkles in the distant water and allowed me to paint freely. I then used a graded wash of thalo blue and alizarin crimson in the water, allowing the foreground to break into a delicate, wavy pattern. The second wash included the far light-struck bank and its reflection (upper right), and the dark, shadowed woods and their reflection (upper left). A strong mixture of Hooker's green deep, ultramarine blue, and a bit of burnt umber gave me a rich, dark color, and I let it play out into dancing reflections as I moved forward in the picture plane.

When this dried, I removed the droplets of frisket and washed back the reflected sun in the water with a small, clean natural sponge dampened in clear water, and blotted the excess pigment. I painted more warmth into the sun's corona with diluted alizarin crimson. The dark twig overhanging the water and its squiggly reflection came next, painted with a liner brush. When all was thoroughly dry I scraped the spider web in place, careful to follow my observation of how the spider had anchored and woven his asymmetrical masterpiece. Be careful not to get too mechanical here! Spider webs are sometimes perfect circles—the late summer web-weavers bear this out—but this one was rather more interestingly shaped. The scraped lines give the feeling of dew-beaded strands.

Be ready for special lighting conditions or other natural occurrences that may make an unusual painting. Fog, mist, rain, sunrise, sunset—all make lighting more interesting than during the flat glare of midday. Very early one morning I woke to find a mist rising from the creek. I grabbed my painting gear and camera and set off before breakfast. It was a magical time—the rising sun tinted the mist with peach and alizarin; strands of dew sparkled on every spider web. So far, four paintings have resulted from this one impulsive escape to the creek.

CAST YOUR NETS
11" × 14"

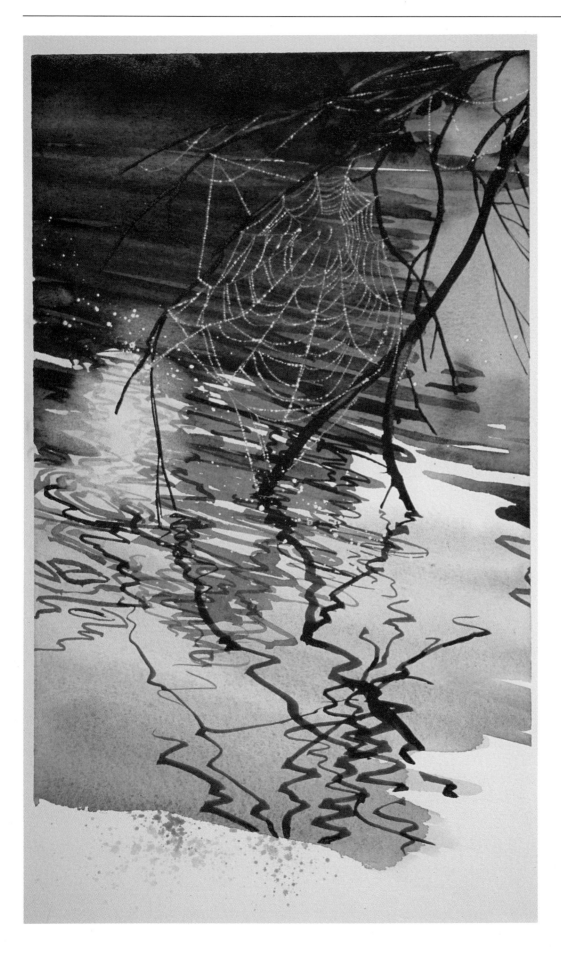

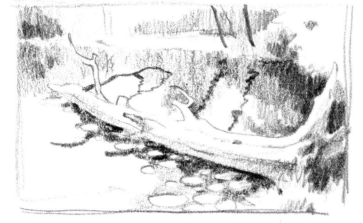

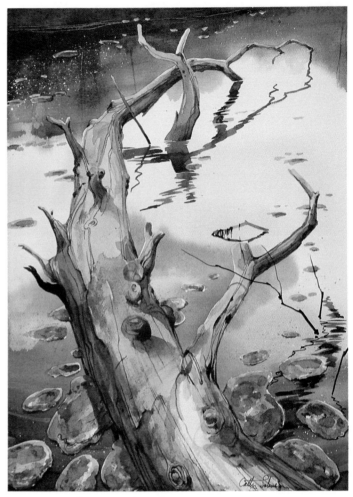

One calm day I stood on the trunk of this old fallen tree; the far trees reflected indistinctly in the distant water, and the limbs of the once tall oak reflected like negatives in the water below. I remembered that the lake was spring-fed and therefore had some slight movement all the time, and took a bit of artistic license.

A couple of small pencil sketches helped me decide on a format. The broader horizontal vista was nice (top right) but almost too placid, so I chose the more dramatic vertical to draw the viewer deep into the picture plane (center right). In fact, the long tree trunk was a temptation I couldn't resist; I had to climb out on it as it pointed like a knobby finger into the depths of the lake, just to see how things looked from there. I think this small adventure found its way into my painting.

I protected the tree and floating moss pads with frisket so I could lay the pigment in boldly, after first wetting the whole board with clean water. I usually apply this first water with a spray bottle, then spread it with a wide brush to avoid getting my watercolor board too wet and having to wait until it dries to the right point. Hooker's green deep, mixed here and there with sap green and ultramarine blue made my first brave step "into the water"—gravity pulled the paint into believable reflected forms when I tipped up my board.

A rich mixture of ultramarine blue, thalo blue, and a bit of burnt umber gave me my reflected summer sky in the foreground, then once the frisket was removed, I painted in the rest fairly directly in successive washes. I tried to remember that reflections are more distinct close to their object and more wavy further away. I was pretty happy with the results.

FISHIN' HOLE
15" × 22"
Collection of Mr. and Mrs. Leonard Johnson

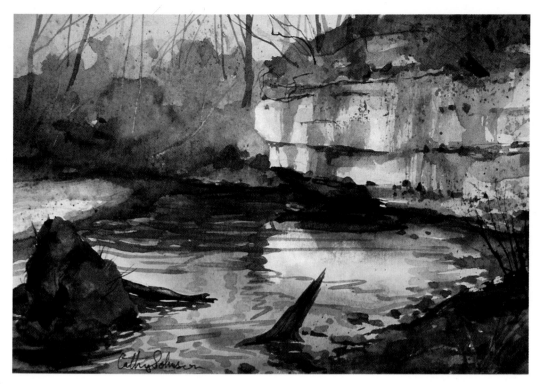

TROUT SPRING
9" × 12"

I painted the warm-colored distant bank first, using cadmium orange in my mixture of burnt sienna and ultramarine blue. I left the limestone cliff white at this stage; I wanted to dash in the water next to see if the painting would be worth continuing.

I wet the water area with a rich mixture of cadmium orange to reflect the warmer colors higher up on the opposite bank (invisible in the view I was painting). Ultramarine blue, burnt sienna and a strong dose of manganese blue helped represent the mineral-rich water of the spring where it flowed out from under the cliff. Manganese is a very sedimentary color, so it tended to stay put and not blend too much in the wet wash.

When these two areas were dry, I painted in the cliff, the sandbar on the left, and the dark foreground, using spatter and successive washes to suggest texture.

The whole area was actually in shadow; the sun hit only the tree-covered bluffs above and lit them up like a forest fire. I was able to keep the foreground shapes pretty dark to give the feeling of depth I wanted. I added dark shadows, reflections, small trees, and twigs last, when everything dried thoroughly.

This was tricky to paint. I might have liked it better had I worked larger, but like the subject itself, this painting responds to light. I like it at night under artificial light; in daylight it looks garish. At any rate, remember—don't let a tricky subject keep you from attempting at least a study. We learn especially from our failures, and I may try this one again some time.

On the Surface

Sometimes the surface of water itself makes an interesting subject. The sky, clouds, shadowed sides of the waves, distance, light, and perspective all combine for a fascinating study. I recently saw a wonderful pastel painting of a similar subject at sunset, with the surface patterns broken by a few ducks swimming to shore. It was smashing! Look for these patterns yourself—perhaps you'll be in the right place at the right time.

Color

Achieving the right color can be a real challenge: it defines the water patterns. While teaching a workshop in the Ozarks last fall, I had a few hours to visit Ha Ha Tonka State Park. A cold-water spring rushes out from under a limestone bluff; close to the source it's as aquamarine as Morning Glory Pool in Yellowstone. On the hill above the spring, the setting sun's glow cast unbelievable colors into the autumn leaves in the water. The closest shore was already in shadow.

Because water is endlessly fascinating to me, I had to try it, though I knew it was a dangerous subject. Don't let anything keep you from *trying* a challenging subject—I keep a circular file for those I miss.

Water in Motion

This small dam spans the creek just upstream from the foot-bridge near my house. I sat on the dam early one morning to do this on-the-spot study of the rushing water.

Study

Without full studio paraphernalia, I had to rely on painting around and scraping out my whites, but the sketch gave me a good feel for the water's action. (It also convinced me of the wisdom in bringing a nice thermos of hot coffee!)

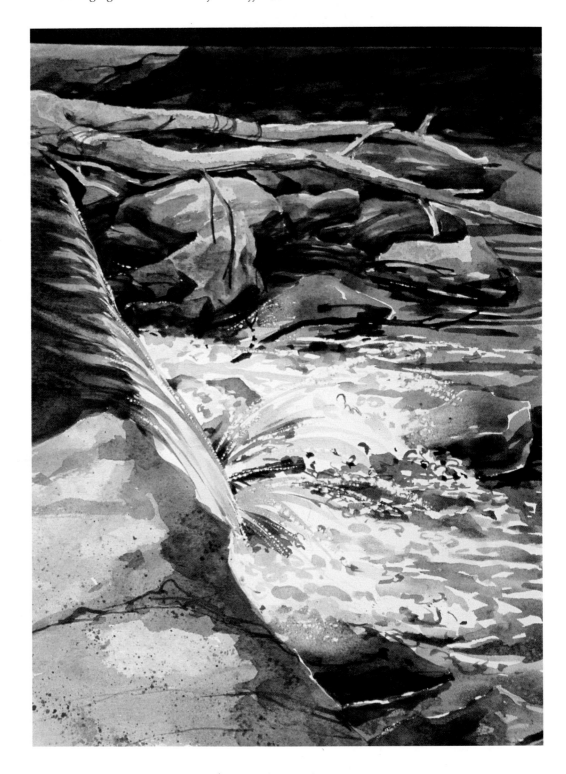

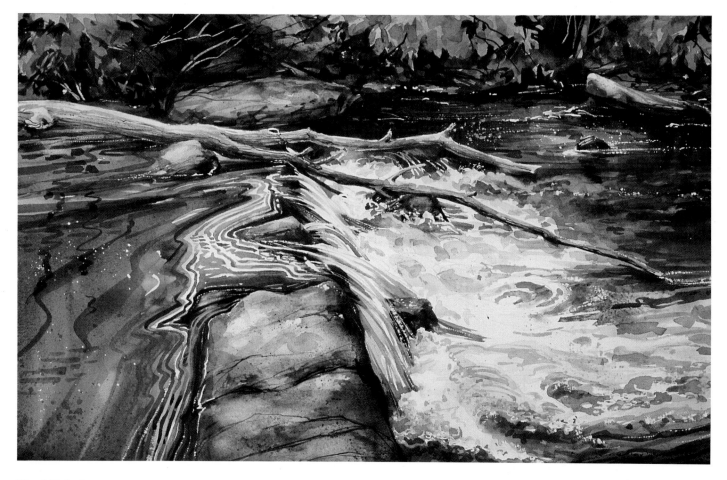

Final Painting

In the large painting I played with liquid frisket and salt to retain some of my whites and give a feeling of frothy water. I roughly sketched in the dam and the patterns in the water below as well as the wonderful linear effect of the water as it fell. The small whirlpool below was especially expressive.

I painted fairly traditionally here—light to dark. Some of the darks on the dam got too dark so I washed them back with clear water and a bristle brush.

Some of the small twigs were scratched into the damp shadow wash, regaining their light shapes. I liked the strong abstract qualities of the composition—but I may still work on this painting; I was in a "brown phase," and now think it could use more color.

STILL POOL/WATERFALL
15" × 22"
Private Collection

Organizing Patterns

Here, the subjects are the moving water and low early morning light. Again, a strong abstract composition forms the backbone. This was another painting that resulted from the misty morning that produced Cast Your Nets *(page 61). The small thumb-nail sketch helped me organize my thoughts before starting in on the clean sheet of watercolor paper.*

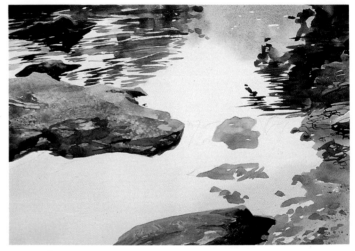

Stage One

Once I decided on positioning and composition, I sketched the rocks directly onto my watercolor paper. I spattered a bit of liquid mask in the distance (a nice trick to give the effect of light on water or distant air bubbles floating on the surface.) A few touches of liquid mask here and there maintained the lines of the current.

Then I wet the entire surface, using my water sprayer and a clean brush to avoid overwetting. I mixed ultramarine blue, burnt sienna, and a bit of sap green to make the soft reflections of the far hills, and added a blush of alizarin crimson in the left side of the painting to suggest the early morning glow.

Stage Two

Next I painted the rocks, getting as much color variation as possible without losing the sense of "rockiness." The blue sky reflects in the upper surfaces—a bit of thalo blue was used to capture the effect. I used ultramarine blue, raw and burnt sienna, and a bit of brown madder alizarin for the rocks' variable colors, and when the pigments lost their wet shine, I sprayed them with clear water for texture. Here and there I blotted the droplets to further texture the rocks (I could have used a bit of salt here, too.)

Notice the warmer color in the closer rocks. Even though in intimate landscapes we often deal with distances of only a few inches instead of yards (or miles), it's still a good trick to remember that generally cool colors recede and warm ones advance. I qualified this statement because with thought and foresight you can manage to break this rule quite happily if you like. In this instance, I chose to use this "rule" as it stands, and the foreground rock is just a bit nearer to our eyes by being warmed with burnt sienna.

When the rocks were dry, I added their deep shadows with a rich mixture of ultramarine blue and sepia, then, using a flat watercolor brush, laid in the water's far reflections with Hooker's green deep, sepia, and a bit of alizarin crimson.

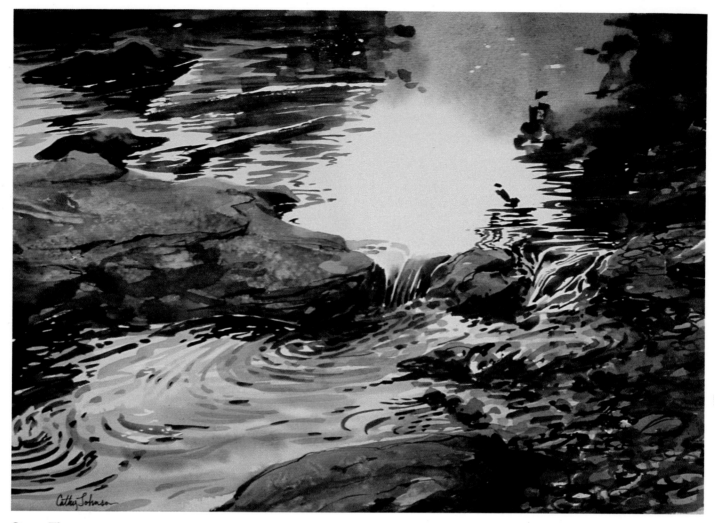

Stage Three

Finally, I rewet the foreground water and worked wet-in-wet on the waves. When that was dry, I carefully modeled the small rif-fle as it fell the few inches over the rock ledge, and the dark shapes in the rippled foreground. I used a rich mixture of the same background reflection colors applied with a round water-color brush.

Since the action of falling water is really the center of inter-est, your eye is led to that point by values and direction, but the waterfall itself has to merit the attention.

I softened some edges with clear water in my brush while they were still quite wet; I could have blotted while damp or softened edges with a bristle brush and water once they had dried, but I am generally more satisfied if I get the fresh blending effects in the first attempt. Scrubbing and lifting sometimes leaves a mud-dy residue, which I try to avoid.

When the water fully dried I continued to shape the rocks and pebbles in the lower right with a #7 round brush, reserving some whites to maintain a look of wetness.

RIFFLE
15" × 22"

OVERALL PATTERNS

Look down; look up—zero in. Use your viewfinder to isolate patterns from the rest of nature; you may discover a way to express the complexity of natural systems without making yourself go mad in the process!

It isn't necessary to always have a center of interest, especially an obvious one, neatly placed according to the Golden Mean. A fresh outlook gives new life to your work. Nature may be a calico of overall patterns; look at a section of grassy turf, spangled with wildflowers; a close view of leaves at the forest's edge; tree bark; small waves on the water; white chenille clouds in the sky; the cut ends of logs in your woodpile.

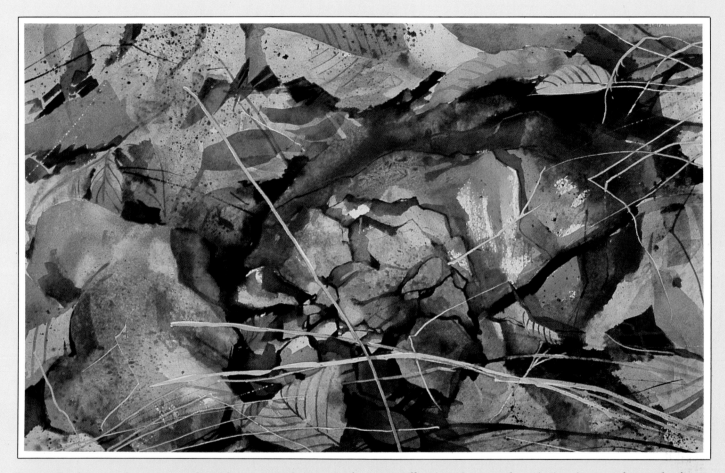

Forest Rock *was to become a study with no particular center of interest, with plenty for the eye to discover throughout. I chose to begin with a wet-in-wet wash, toning the entire background and then painting in details as the paper went from wet to damp to dry. Only a bit of preliminary work went into this study: protecting the fallen grasses and weeds with liquid mask.*

As I worked, however, the subject seemed to take on a life of its own; the paper accepted washes in a particularly happy way, and pigments seemed to have their own plans for the future that didn't include my carefully crafted format of patterning.

By the time I finished, the painting had developed an interesting rhythm, a kind of swirling energy that amazed me—

especially since I was only painting inert rocks on the forest floor. I let the painting *tell me what to do and when to stop; leaves that I intended to paint simply disappeared. Others that I meant to render fully were only suggested. And the small bright leaf at the center of the offset vortex insisted on becoming the focal point.*

I could have forced the finished product to fit my preconceived plan, but it would have killed the spirit of watercolor.

FOREST ROCK
15" × 22"

My small postcard-sketch could have been completed as an overall pattern, but instead I chose to delete areas, creating a vignetted composition. In another mood I might have zeroed in even closer or added the other rocks and leaves that were actually present.

I once designed a pair of needlepoint cushions for a New York publisher using overall patterns; one of spring wildflowers, the other of autumn leaves. A Taos artist whose work I admire had done several full-sheet (or larger) studies of the dark, shiny wet pebbles at a creek's edge—nothing more. They were incredibly effective.

Use all or part of your findings as subjects; if you don't really want to repeat your subject patterns *throughout* the picture plane, then add a bit of variation. Vignette an edge, if you like, or give a sense of depth by the amount of detail you choose to include.

Be forewarned, though; in most cases painting overall patterns takes more than the normal amount of patience! It can become a contemplative work, if you like; or you may opt to try different techniques. A pointillist approach may reinforce the pattern concept. You may choose a more abstract approach, or even decide to paint an entire composition with only one brush. There are many approaches to this concept, all worth trying. And, if your painting takes a different direction midstream, go with it. Trust your own creative instinct.

Leaves

Leaves lend themselves well to this kind of pattern handling, and can make an interesting study if you choose leaves of only one species. A whole concerto may result if you prefer a patterned study of fallen leaves on the forest floor! Look near the edges of a stream in the fall for the best variety: local trees will have added their leaves to the mix; faraway leaves may have been carried there from the next county. In early autumn the colors are bright and fresh and as varied as the leaves themselves: reds, maroons, yellows, golds, oranges, greens. Later in the fall and into the winter, colors become more subtle. In late November you may paint a symphony in brown.

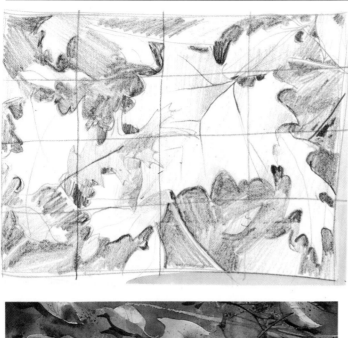

This rough sketch was done as a demonstration in a classroom situation, but even though I was working at great speed, I felt I had enough to go with. (You'll notice on the right-hand side I had begun to suggest depth in the underlying leaf litter.)

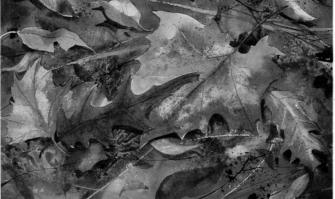

My first attempt, also a workshop demonstration, went wrong. I didn't pay enough attention to my sketch, in either format or composition, and the leaves look too strung out in a horizontal line. The leaf shapes are too inaccurate to be realistic and not free enough to be abstract; they also seemed to be pasted onto the background like a collage. They needed to be integrated.

LEAVES
15" × 22"

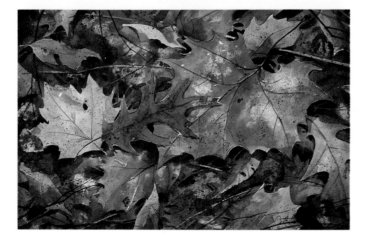

I liked the idea enough for another try. This time I drew the shapes more carefully, and paid better attention to both distribution and rhythm.

It was a rainy day, and the leaf litter underneath my primary subjects was gray—almost black in places—and damp; it reflected the cool light of the sky. The recently fallen leaves were lighter, crisper, and more varied in color. I used all the earth colors on my palette, as well as ultramarine and thalo blue (no actual black pigment, however, even in the darkest areas).

I also had fun using a few "tricks." On my first attempt I used liquid mask on the biggest leaves; it was tedious to apply and remove—perhaps that's why I lost interest in including all the leaves! I wanted to be free to texture the background without worrying about the leaves, but in the second attempt I decided to forego the liquid mask altogether and let background and leaves blend here and there. Notice the lost-and-found edges, especially in the smaller leaves and the medium-sized one at lower right.

As I painted the background (with burnt sienna, ultramarine, burnt umber, and a bit of thalo blue), I textured it by blotting, scraping, spattering and applying paint with wadded plastic wrap. I painted in some of the leaves at the same time, allowing their wet edges to blend. When this dried, I finished by painting the larger leaves (also textured) and the small details in the background. I was much happier with this painting.

COMMUNITY
15" × 22"

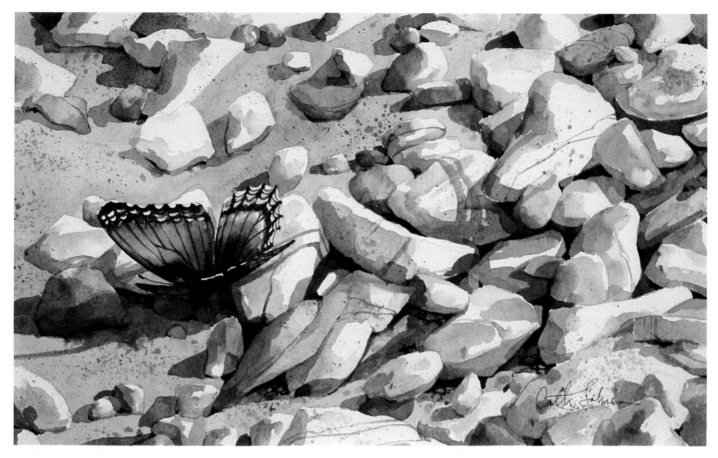

Rocky Patterns

The shapes and varieties of rocks or pebbles in an all-over design may catch your attention—use them as your subject or let them act as a counterpoint, a backdrop, as I have done in Butterfly/ Rocks. *The Red-Spotted Purple butterfly had just landed and began to suck moisture from the sand between the pale pebbles on the shore. I placed him off-center and facing out of the picture plane to give the feeling that at any moment he might fly away (which he did, after a few seconds).*

I painted the butterfly first; if I hadn't liked the way he turned out there would have been little point in finishing. I next painted the sandy areas and then the pale local colors of the individual rocks.

I gave a sense of depth and volume to the rocks by painting their shadowed sides. When that wash dried, I added their cast shadows, somewhat deeper in value than the shadows on the rocks themselves.

Finally, I added the deep crevices between the rocks and details of tiny cracks and fissures. A bit of spatter textured the rocks without overworking them.

If I had been painting wet rocks rather than dry, I would have used the technique shown in the diagram at right and used in Sand Point *(page 57). I'd keep the rocks darker overall, with only a wet, shiny highlight of white.*

This technique could be adapted to suit any rock pattern you may find, with or without a center of interest like my ephemeral butterfly. I wanted to keep him from standing out too vividly from his background, by the way; I liked the slightly camouflaged effect.

BUTTERFLY/ROCKS
11" × 14"

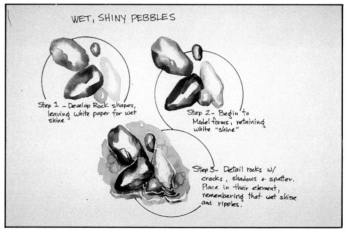

WET, SHINY PEBBLES

Step 1 – Develop Rock shapes, leaving white paper for wet shine

Step 2 – Begin to Model forms, retaining white "shine"

Step 3 – Detail rocks w/ cracks, shadows + spatter. Place in their element, remembering that wet shine and ripples.

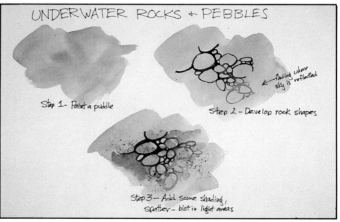

UNDERWATER ROCKS + PEBBLES

Step 1 – Paint a puddle

Step 2 – Develop rock shapes

← fading where sky is reflected

Step 3 – Add some shading, spatter – blot in light areas

A Pattern of Repetitive Shapes

This study was a workshop demo, but I only completed the first stage. Although one student adamantly insisted that the painting was finished at that point, I was fond of my sketch and wanted to explore it more fully.

Stage One

A dark gray colored pencil was used for the sketch, originally planned to be only a close-up of cut log ends in an overall pattern. This particular wood pile was stacked in two ranks, and I liked the effect of this small distance, only suggesting the second pile behind the first.

This sketch is a good example of what on-the-spot observation can do; I had assumed the wood pile would be more uniform in shape as well as in the sizes of the logs, as you can see in my sketch of an imaginary wood pile. There is a very large fireplace at this old hotel, though, and it was able to take huge rounds (almost like Yule logs!). Because some of the wood had been cut from a hollow tree, I had a wonderful variety—large and small, hollowed crescents, round to oval shapes, solid wood and rotting holes—in short, a much more interesting subject than I had originally imagined.

Stage Two

This stage shows the initial wet-in-wet wash of burnt sienna, raw sienna, touches of burnt umber and ultramarine blue with touches of yellow ochre and cadmium yellow medium. I began to develop some of the log shapes after the first wash dried.

Stage Three

Stage 3 shows the nearly-completed painting, with foreground logs developed and background ones only suggested. But I neglected to notice that my shadows had moved in the course of the afternoon's work.

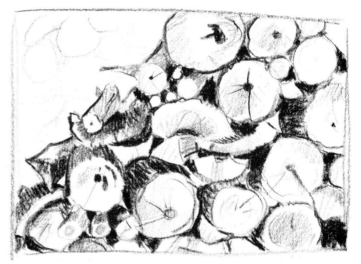

Stage One

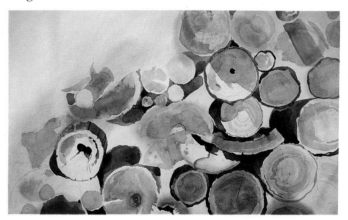

Stage Two

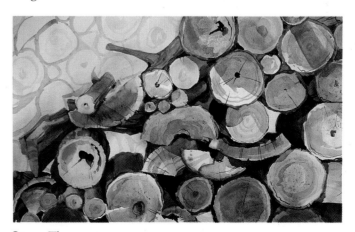

Stage Three

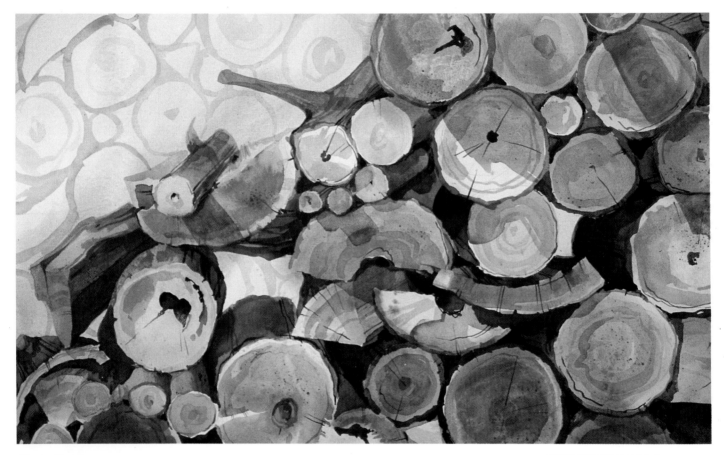

Stage Four

A bit of adjustment in stage 4 let me maintain the logic of my lighting; notice the small log resting on the crescent at left. I washed back its shadow with clear water and then restated it where it belonged. Other minor adjustments throughout the wood pile let me call this one finished, but I have to admit it was hard to go beyond stage 1. I liked that look, too. Suggestion is a very powerful tool, and someday I may wish I had stopped there. What do you think?

WINTER WARMTH
15" × 22"

A Pattern of Silhouette Shapes

I had a number of decisions to make when I painted this one. Would I give it a natural background, silhouette it against black, or leave it with a white ground for a rather botanical feeling? I decided to let it tell me what to do—and in the end it remains clean white.

Fragrant sumac is a nonpoisonous plant with bad press. The three leaflets and bright fall colors do give it a superficial similarity to poison ivy, but it can be picked and handled (and sniffed—it's delightful) without harmful effect. Be careful, though—fragrant sumac produces fuzzy red berries in the spring while poison ivy may be identified by pale, waxy whitish berries later in the season. If in doubt—don't touch.

Stage One

In stage 1, I have just begun painting the leaflets, mainly using wet-in-wet washes on a small scale. Colors were mostly cadmium yellow medium; cadmium orange; cadmium red medium; and Hooker's green deep. I blotted some washes as I went along for variation and definition.

Stage Two

Stage 2 shows further development, both in number of leaves and details added. I varied colors and intensity to give a feeling of depth, however shallow, to my picture plane. Here and there I began to develop glazes and further define details. The bright orange-red leaf at lower right is an example of this.

Stage Three

I deliberated a long time before completing stage 3. I needed to decide on both the background treatment and the amount of detail. After several days of deliberation I decided to use a sheet of translucent paper as an overlay and painted in part of the background: a naturalistic wash of blue-gray with a bit of wet-in-wet of the same colors as the leaves. The other part I painted black.

I still couldn't tell the final effect; the translucent paper diluted the effect, so I finally cut away the leaf areas themselves, leaving only the naturalistic background. Bingo! I saved a painting, right there—the white was definitely the effect I was after. The blue-gray killed the brightness, and gave everything a dull sameness. Now I was free (mentally!) to finish the painting, adding warm-colored leaves on the left, connecting stems and small twigs. Oddly, this effect is more "natural" than the naturalistic effect I had experimented with.

FRAGRANT SUMAC
11" × 14" Collection of Betty Bissell

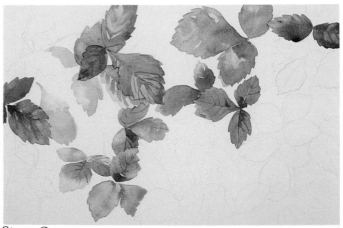

Stage One

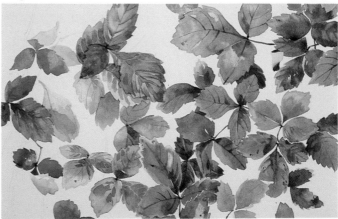

Stage Two

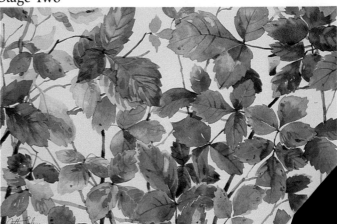

Stage Three

Forest Floor Close-Up

This painting is the most truly overall pattern of all the paintings in the chapter. I attempted to distribute elements with some regularity, but not to the point of boredom or an unnatural stiffness. It was actually a combination of two miniature vistas; bloodroot leaves, false rue anemone, waterleaf, sorrel, and Dutchman's-breeches' foliage have all pushed up through the leaf litter.

I took advantage of natural puddling and texturing to avoid overworking a tricky subject—something this detailed could be ruined by too much pickiness. I chose a hot-pressed paper to keep myself from finicky fiddling; the paper's glassy surface will not allow smooth or overly controlled washes, thereby playing up the freshness of watercolor.

Stage One

I protected the white rue anemone flowers and buds with liquid mask and began laying in the leaf forms, allowing natural puddling of the pigment to help define leaf shapes and depth. The beginnings of the brown background (mostly burnt umber) in the lower left show how I intend to handle this—slowly and carefully! My favorite Strathmore Kolinsky #5 red sable round was a big help here—it has great control and holds a reasonable amount of paint.

Stage Two

I have completed the background, and have begun to texture somewhat by a kind of "fingerpainting" in the wet pigment. Again, in the lower left I've started adding some darker accents to the background wash to give a feeling of built-up leaves.

Stage Three

Now I have added more texture to the background in the form of glazes and a bit of spatter. Some shapes suggest the margins of oak leaves, others are simply abstract shadow shapes. I've begun defining some of the leaf shapes with glazes and details and have removed some of the liquid mask. At this point, however, the effect is still too staccato, too flat.

Stage One

Stage Two

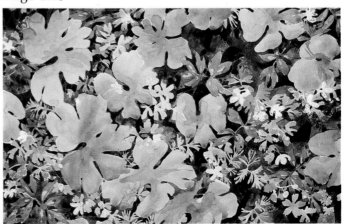

Stage Three

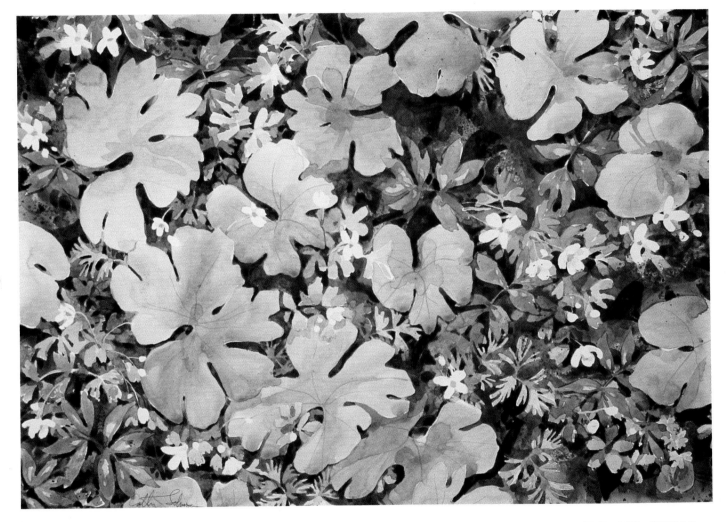

Stage Four

Finally, shadows come into play. Light, quick (and careful!) glazes of ultramarine blue and a bit of burnt sienna push some areas back and bring others forward. Only a little more detail is added to leaves, and flower detailing is kept to a minimum to avoid spoiling the freshness. As a last step, the tiny flower stems are painted with a reddish-brown color.

FOREST FLOOR, SPRING
15" × 22"

PAINTING PLANTS AND FLOWERS

Plants and flowers are among my favorite subjects to paint; perhaps it's because they'll stand still for me! While birds and other wildlife make great subjects, unless you are quite good at stalking, it is difficult to get close enough to *see* the details, let alone have time to paint them. Flowers, plants, and trees, on the other hand, are easy to get close to, and as long as you catch them in season you will have days or weeks in which to work.

Once, I set myself the challenge of painting all the wildflowers as they bloomed on my hill. I took my daypack to the woods every day, and painted the bloodroot, trillium, and Dutchman's breeches as they bloomed. As an exercise, it was great fun, and even though I soon fell behind and gave up, I do have Bloodroot and Spring Beauties *to show for the attempt. (See others in Chapter 1.) The clasping leaf is a sign of a very early spring; later, after the flowers have gone, the leaf flattens to an eight-inch-wide umbrella. Details like this help your work ring true.*

Since I painted this in the woods, I wasn't able to shoot step-by-step photographs, but this is the general progression.

First, I carefully drew the bloodroot flower and leaf shapes to make sure I captured the wrap-around effect. I delineated other flower and leaf forms at the same time. Since I generally carry no liquid mask with me in the field, I first painted the main flower forms, using fairly direct and mostly semidry washes. I allowed some puddling in the large leaf form to suggest shadow and volume. Grass blades were painted calligraphically, using a single brush stroke to suggest their graceful forms.

I also painted the fallen limb in the background with an oriental stroke, allowing the side of my brush to skip over the paper on the left for texture. Mossy greens were flooded into this area while still damp.

A rich green-brown, made up of burnt umber and Hooker's green deep, was carefully painted in around the flower shapes and tiny stems, using a fine-pointed Kolinsky sable, which I also used to add the final details to the flowers. I liked the unfinished negative spaces and decided to leave them alone.

BLOODROOT AND SPRING BEAUTIES
5" × 7"

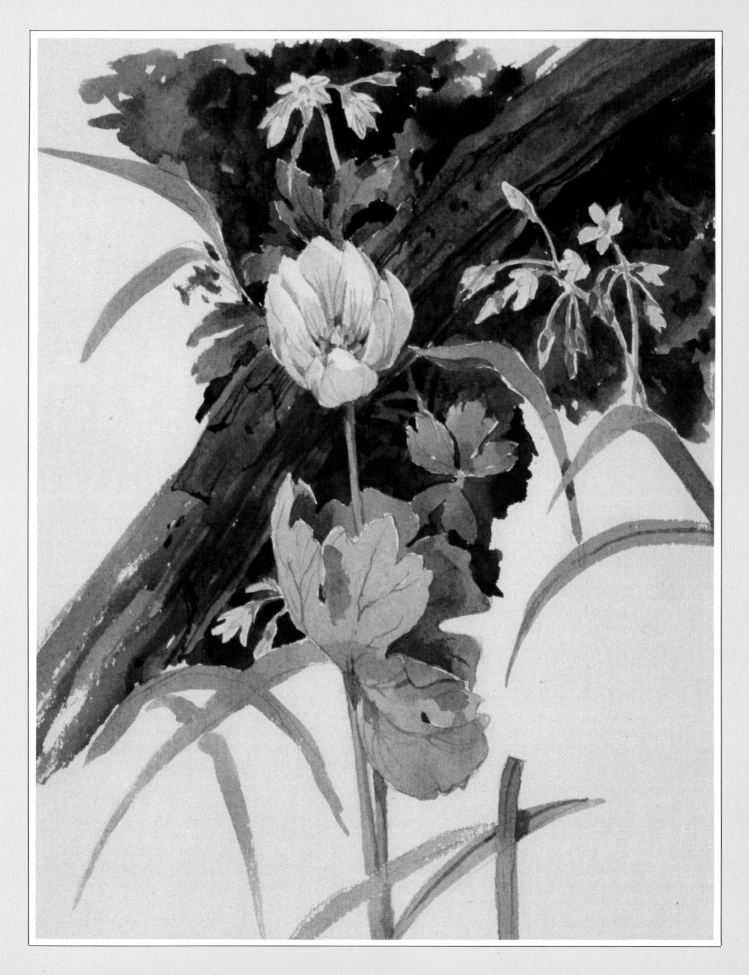

Seeing

Look beyond the normal, the everyday, the expected for your painting subjects. Notice the negative shapes, the rhythms, the reflected lights. Close in on your subject for a new, almost Georgia O'Keeffe style. Consider the "portrait" approach, or the botanical style with its clean white background for emphasis. Look for varied shapes to add interest; painting details gives you this luxury that would be just so much overworking in a larger landscape. I like to study plants closely in my field sketches; if I want, I can add one to a later painting for emphasis. (If you do this, though, try to make sure the plant or other added details would be at home where you have put them. No matter how much you admire their fat brown "tails," don't add cattails to a desert scene.)

Look for geometric forms and interesting juxtapositions when planning your paintings. Sometimes it's difficult to believe what we are seeing, and we may need a key to help us get the shapes right. If it helps, think of overall flower shapes enclosed in geometric forms; some flowers are a simple circle (daisies, wild asters, sunflowers), some a cone (lily family members), others a dome (peonies, zinnias, dandelions), and still others might fit in a triangular shape. Try making rough sketches that would bound the outer perimeters of your flower shape, then draw the actual flower inside. This will help keep the shape from getting away from you and becoming too large or distorted. (I often use this trick when painting tree shapes to keep them in control.) The drawing, top right, reprinted from *The Artist's Magazine*, shows what I mean. If more complex flower forms are involved, break them down into separate parts. For example, you may find that part of a flower like a daffodil may fit a circular or oval shape while the rest would be represented by a cone or tube.

Notice that in the top sketch on page 81 I've included as much color as I could to define individual

It often helps to think of flower shapes as simple geometric forms.

petals. In nature, white is seldom a stark, flat white. Flower petals, snow, and even buildings are affected by lights and shadows, time of day, overall lighting, and reflections of nearby colors. Look for ways to emphasize these reflected colors; play them up. A livelier painting results. I never use black as a shadow in nature; it's simply too flat and dead (oddly, the only place I normally use black is in the lively blacks of an animal's eyes. Painting, like life, is full of contradictions!) Make rich darks by mixing complementary colors (i.e., red and green, purple and yellow) or the subtle neutral earth colors with blues (for instance, burnt umber with ultramarine blue or burnt sienna with cobalt). If you are painting a subject with local color as opposed to a simple white, you can use these darks or grays mixed with a bit of the local color in shadow areas. It even works with flowers.

Paintings of plants and flowers can look sickeningly sweet if we don't take care. Keep your colors

clean and vibrant, subtle, or rich and full to avoid a pastel sweetness that reads as simply weak. And if the subject *is* pastel, look for ways to present it in its natural habitat, with weeds, twigs, warts, and all.

As was the case with *Bloodroot and Spring Beauties*, on page 79, I began *Sweet Williams*, on page 82, by first painting in the small flower forms before proceeding with the background or the large dead stump. When they were done to my satisfaction, I laid a wet-in-wet wash in the background area, giving it texture with some spattering before moving on to the dark shape of the stump. I used drybrush and blotting techniques to give the stump its rugged look, and then added small details with a fine brush.

Wildflowers, Plants, and "Weeds"

Weeds are simply plants which no one has yet found a use for—and since a vast majority of our wild plants have a use of one sort or another (edible, medicinal, fragrance, or dye) very few actually deserve the name "weed." I may not *plant* lambsquarters in my garden, but the fact that it grows there doesn't make it a weed. Not only is this plant a fine edible (along with many other common yard and garden "pests") but, as are most plants, it is also fascinating to draw and paint.

Trees

Normally, I would expect to write a chapter on trees alone, but since this book's focus is more intimate, I've chosen to include them with their smaller cousins. Root patterns, stumps, bark (see Chapter 3, page 43), vines, thorns, twigs, plus odd shapes and directions are trees on a smaller, more comfortable scale.

Your sketchbook is a handy place to jot down ideas while you're in the woods—or anywhere you find an interesting tree shape. Note the differences

It isn't necessary to use precise shapes—a rough approximation is usually sufficient to keep your shape in bounds; and it acts as a kind of framework and as a gesture sketch all at once. In the sketch, above, a fairly regular circle, #1, becomes a looser flower shape, #2, and then blooms out in a natural form, #3.

In this sketch, I have simplified the scene to concentrate attention on the stumps rising from the swampy backwater. If this later becomes a painting I will keep the white areas as they are; it's not necessary to paint everything you see. You are the artist—an editor of sorts. Delete or add as needed to make a good painting.

The dark, rotting stump in Sweet Williams *provided just the background I needed to make the flowers stand out, but the stump, sprouts, and twigs save this small painting from sweetness.*

SWEET WILLIAMS
9″ × 12″

in species; though they both have loose bark, a shagbark hickory's peeling bark looks very different from a fir's. An oak tree has gnarled, twisting branches; a willow, more graceful curves.

When you are painting nature's details, the challenge of foliage is, admittedly, somewhat different than when you are painting a normal landscape situation. Where, in a broad vista, a bit of scumbling, spongework, or wet-in-wet reads as "foliage," an intimate landscape calls for closer observation. Our flashy tricks may not be as useful in these situations. Observation, then, is the key. *See* what you are looking at. It's amazing what symbolism a crumpled leaf may carry, if we simply see it as it is.

Using Your Sketchbook

Keep your sketchbook with you at all times; you never know when you'll spot an interesting flower or plant. A quick sketch will not only capture a likely painting subject, but careful observation and drawing will help you to identify plants from a field guide. Written notes may help with this. Even if you are not interested in learning the names and habitats of wildflowers or plants for their own sake, you may want to title the finished painting with the correct name. It's embarrassing to mislabel a painting—believe me, I've done it! I find that field sketching, especially of wildflowers, herbs, and other plants, has become as involving and pleasurable an activity as painting itself. The dormant naturalist in me came to life by observation and drawing. The sheer pleasure of learning, with no other end in mind, is half the fun.

Many of these field sketches find their way into later paintings and illustrations, though. *The Local Wilderness*, published by Prentice Hall Press, was almost entirely illustrated with my field sketches or with more detailed drawings based on field observation.

Record all those small details to help your work ring more true as you paint nature's small treasures.

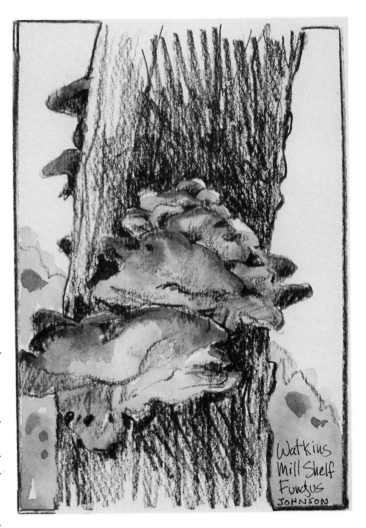

Various fungi (as well as lichens and mosses) make different and challenging painting subjects. Sketch these forms as you find them; you won't believe the fantastic variety. This small watercolor sketch is of a shelf fungus. Other forms are the more familiar "toadstool" shape and the sought-after morchella esculenta, or sponge mushroom. Exercise your drawing ability on these nonflowering plants, then explore them in watercolor.

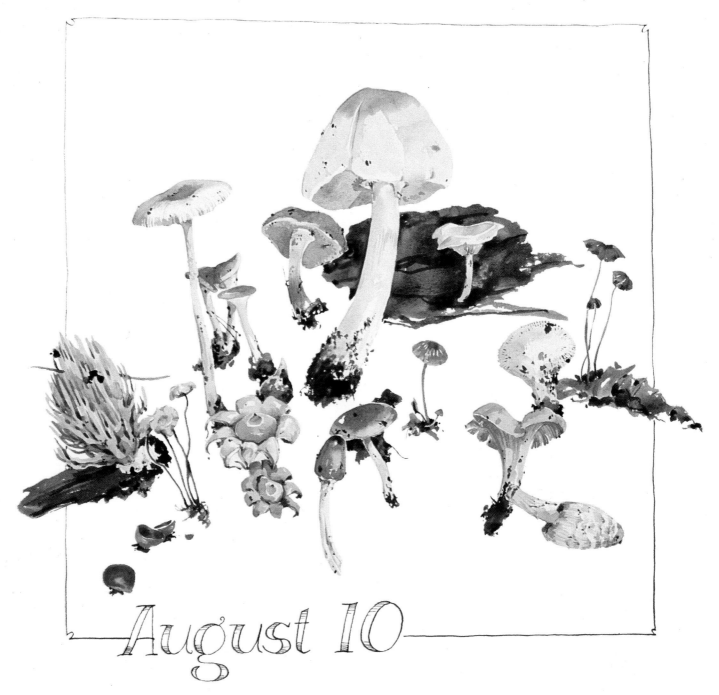

August 10

One hot August afternoon I found and painted all these varied mushrooms (in fact, I found several more, but the light faded before I could include them in my composition). These were done with a rather botanical handling, with careful attention to the details of the fungal forms against a white background. In some areas, washes were built up slowly in glazes; wet-in-wet was used when possible for freshness. The bright red allowed the Scarlet Cup mushrooms, lower left, to come forward from the picture plane.

Composition or placement in this type of painting becomes especially important because there is nothing else to lead the eye into the picture plane. Before beginning, I planned an overall roughly oval form. I placed the largest mushroom just off center and allowed the brightly colored forms to make color accents into secondary triangles. Repeating a geometric form within a composition imposes a sort of order on an otherwise somewhat scattered array of separate objects. Look at this painting closely—see if you can find all the triangles within the overall shape. All the relative sizes here are correct, and nearly everything is lifesized. Someday I'll go back and identify all of the mushrooms and carefully write in their common and Latin names.

AUGUST 10
16" × 20"

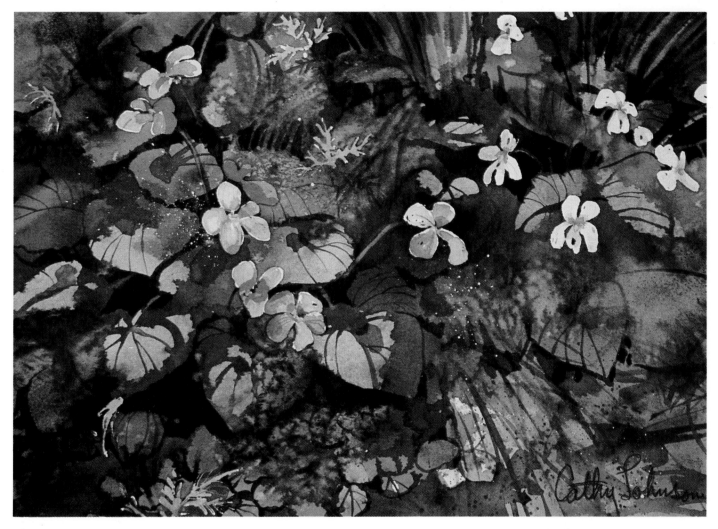

These violets grow by my back porch. To capture their exuberant growth, I used a wet-in-wet technique, using liquid mask to protect only the flowers themselves and a few fern-like leaves. A light spatter of liquid mask was added, too. Then I wet the entire sheet and washed in a rich mixture of sap green and Hooker's green dark, with a bit of sienna and burnt umber in the lower right. I kept the paper quite wet during this stage. Salt, spatter, and a little scraping-out in the upper right areas suggest the beginnings of foliage forms. I continued to work in this area while the wash dried, delineating the violets' heart-shaped leaves. When this was well dried, I removed the liquid mask and painted in the white and lavender-colored flowers with a small #4 brush. The spattered liquid mask, when removed, suggests pollen in the air.

BACKYARD VIOLETS
11" × 14"
Collection of Mr. and Mrs. Claude Adam

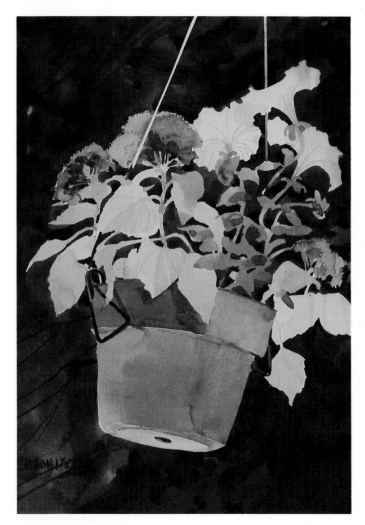

Even a potted plant can make a good painting subject. I used no liquid mask at all to paint Petunias and Friends, *but did cut thin strips of masking tape to protect the plant hangers. I painted around all of the flower and leaf forms with a deep wash of Hooker's green dark, burnt umber, and ultramarine blue.*

The rich burnt sienna of the clay pot, mixed with a bit of ultramarine to add a little sedimentary texture in the shadows, makes a nice warm contrast to the cool colors of the leaves and flowers.

In this painting and in Backyard Violets, *page 85, the strong contrasts of light and dark helped describe the quality of the light. The sunlight cast deep shadows, making the flowers seem to pop out of their setting. I accentuated this effect with a wide value range as I worked. Often, what first catches my eye in a painting subject is this sense of strong contrasts; look for them in nature and look for ways to put them to work.*

PETUNIAS AND FRIENDS
11" × 14"

Availability

Flowers and plants are available to all of us. These "details" spill out of your window box, fill your backyard, pop up in your lawn, and grow along every roadside. The park near my home is dotted with thousands of wildflowers from as early as late February to November, giving me subjects to paint almost year 'round. If you add to that interesting root shapes, vines, thorns, and withered, wintry fruits clinging to bare branches, I could paint on the spot all year.

The Portrait Approach

A found composition, with changes only for aesthetic reasons forms a "nature portrait." I include the background, other plants and natural objects, as well as the subject itself. *Wild Columbine, Sweet Williams,* and *Backyard Violets* are all examples of the portrait approach. You may use a still-life approach, of course, if you prefer more control over your subject and its arrangement. But when I paint a portrait of a flower, I like to paint it with the things it is "comfortable" around, just as I would a human subject.

The Botanical Approach

Attention to correct botanical forms plus the removal of distracting background details—and sometimes including notes on size, shape, season, Latin names, and uses—make a botanical painting. Seed cases, seeds, and roots may be shown. Botanicals have a fresh but timeless feel; some of our earliest flower paintings were done in the botanical style.

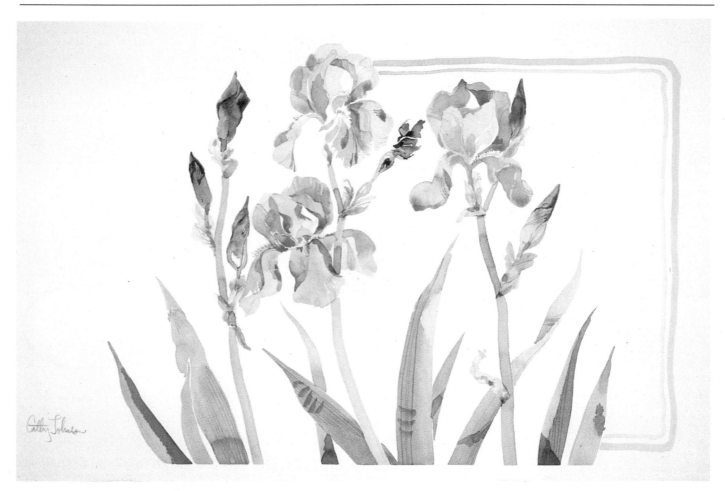

Iris in Sun *is a botanical painting, with the subject vignetted
against a white ground and bounded with a loose border—
hardly an object found in nature! This was painted on the spot,
as an exercise in brush handling. Each of the petals, buds, and
leaves was done as a single stroke, at least in the base washes;
manipulation of the brush accounts for the varied shapes. I used
a large #12 round brush, in a somewhat oriental technique. Try
holding your brush vertical to the paper and vary the pressure
on the hairs to change line width. Let each stroke stand as you
put it down to retain freshness; some puddling will occur, giv-
ing a sense of dimension to the forms.*

*Some colors can be allowed to flow into others for unity. In the
bud areas, I charged my brush with a soft green or lavender
green, then touched the tip into a strong mixture of alizarin
crimson and ultramarine blue. The purple tip touched the paper
first, then the body of the bristles was brought in contact with
the paper. Learn to use your entire brush rather than just the
tip—otherwise you'll be tempted to draw with your brush in-
stead of paint. (If you're using a calligraphic style, of course,
that approach is fine; otherwise, use the whole brush.)*

IRIS IN SUN
15" × 22"
Collection of Susan Bollinger

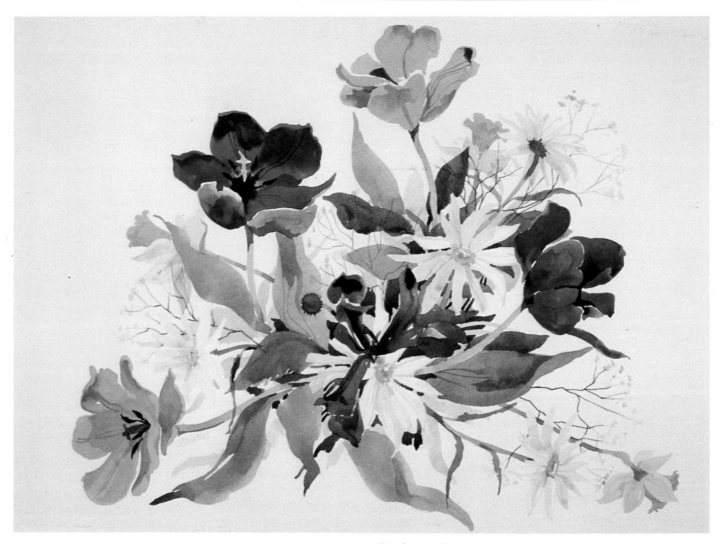

These exuberant spring colors, after a long winter of subtle colors, inspired my handling of Bouquet. *My garden yielded these flowers that almost demanded I use the saturated strength of liquid watercolors. These are dye colors, very strong when used directly from the bottle. I usually dilute them somewhat with water to improve their washing ability, but often find them useful to paint the bright, strong colors of flowers. I am careful to choose permanent colors; some are quite fleeting.*

I used a direct painting method, with only the barest of preliminary drawing as a framework. As in Iris in Sun, *I used a calligraphic brush technique—I painted each flower form in one sure stroke. (As you can see, my exuberance resulted in a scarlet splat right in the middle of my composition. I liked it! It stayed.) Dutch iris, red and yellow tulips, daisies, daffodils, and baby's breath (from the florist) made a nice composition, based on an overall triangle shape.*

BOUQUET
15" × 22"
Collection of Mr. and Mrs. Keith Hammer

Color Contrasts

We tend to think of florals as weak and wimpy, old-fashioned and pastel, but they needn't be. Use your brightest, richest hues—or go subtle and almost monochromatic. Be bold; be sophisticated—paint what you feel as well as what you see.

The Monumental Image

Imagine a plant so big, so commanding, that you almost become lost in its depths, surrounded by beauty. I think of some of Georgia O'Keeffe's monumental paintings of flower forms. Focusing closely on plants or flowers gives us a whole new perspective. Try this for yourself. Pick a single flower or only a very few, at most. Let them fill your picture plane. Get within inches of them; get to know their shapes, their delicate transparency, the very cells that make up their petals. Explore the shapes of pistils and stamens; look at their shadow shapes. This approach can be a fresh and startling one.

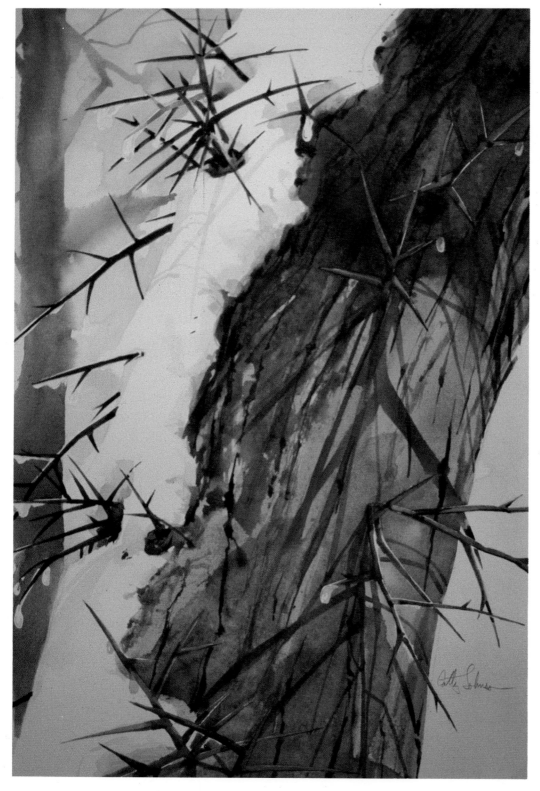

Subtle colors work well to capture other seasons; this is not a floral, of course, but it is one of nature's details. You might want to experiment with such understated colors to paint a bouquet of winter weeds, fall flowers, or even some of the rich brown-colored orchids.

Winter's subtle colors were as much my subject as the ice-covered thorns and wet snow on this honey locust tree. The thorns were almost startlingly warm-hued next to the cold blues of the ice, snow, and wintry sky. I liked the long shadows they cast and the dripping ice as it melted. I used masking tape to protect the thorns' angular shapes while I painted the bark behind them with burnt umber, ultramarine blue, and a little sap green to express the feeling of the algae and lichen that had formed on the damp surface. Shadow shapes were painted before removing the tape.

These cruel thorns are effective protection against predators that would eat the tree's honey-sweet pods. I found one branched thorn that measured eleven inches long!

HONEY LOCUST
11" × 14"
Private Collection

Flowers I have handled successfully in a monumental way include peonies, roses, tulips, poppies, and daffodils. I like the feeling of becoming relatively small in relation to these immense blossoms. This kind of attention helps us to appreciate the complexity of nature.

Other Subjects

Fruits and berries make wonderful subjects as well; their variety of shapes, forms and colors let us create rhythms, studies, botanical works—whatever we wish.

Sequential Images

Change and growth are integral parts of nature. Plants and flowers lend themselves especially well to sequential studies; from sprout to flower to fruit, perhaps. Get acquainted with a plant over a period of time and you may be fascinated with the visual changes which remind us of the endless cycles of natural life.

One trip to a twenty-foot-long section of a country roadside provided me with the subject matter for Fall Fruits—*these are some important sources of winter food for wildlife.*

I carefully drew their shapes in an informal arrangement. I especially liked the way they wove in and out of each other, tying my composition together with their overlapping forms.

The amazing range of colors found on this one small stretch of road had to be painted to be believed; bittersweet's red-orange fruits and lighter orange outer husks, spindleberry's (or wahoo's) pinks and reds, buck brush's magenta, carrion flower's almost black fruits, and red osier's pale berries with their reddish stems were a mosaic of color in a season rich in hues.

This was a rather contemplative work, as opposed to some of my more impressionistic pieces. I lost myself in the slow build-up of controlled washes, the glazes that added form and color to the leaves and fruits.

Look for forms in nature to study closely; fruits, grasses, weeds, nuts, and other plant parts make interesting studies and are a welcome break from flowers.

FALL FRUITS
15" × 22"

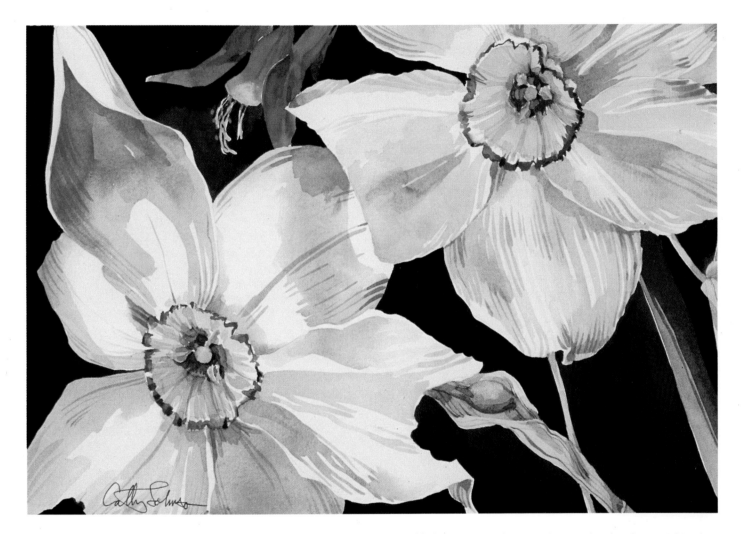

I took an extreme close-up approach with this painting; I wanted to become lost in the fragrant spring flowers, and focus the viewer's attention on their deceptive simplicity. Letting the flower shapes fall outside of the picture plane's borders enhances the feeling of intimacy; the black background further focuses interest.

I included the more complex form of the columbine as a kind of counterpoint to the repeated circles or ovals of the narcissus. The related color notes of the tiny red border of the narcissus' center and the columbine's convoluted petals puts repetition to effective use.

Lightest colors were painted first; then the modeling and veining of the narcissus' outer petals. I used a combination of cobalt and ultramarine blues, burnt sienna, cadmium red and yellow to express the light-filled shadows. Hard edges were softened with a thirsty brush, (one rinsed in clear water and wiped almost dry).

I added the centers, keeping them rather free form within their outer perimeters to give a fluted feel. Cadmium yellow light was my basic wash. Using greens and blues I darkened the centers to give a sense of depth, and painted the edge last with a strong cadmium red light. Here and there, where the yellow was still damp, I blended for softness.

The columbine was more difficult to paint believably. I separated the petals and did the outermost ones first, then painted the middle one alone, so I could better control the blending of the yellows and reds. The colors of the pistils were exaggerated so they would stand out against the dark background, which was added last. It's made up of a very strong mixture of Payne's gray, alizarin crimson, and thalo blue; I could have used black here, but I wanted to maintain a hint of color.

NARCISSUS AND
COLUMBINE 11" × 14"

The Botanical Approach

Near the end of winter I yearn for the color and scent of fresh flowers. These came from my florist. I used a vignetted, almost botanical approach for the red tulip and paper white narcissus.

Sketch

In order to capture the illusion of depth on the flat paper plane, we need to take into account that flowers obey the laws of perspective as does everything in nature. Look at my schematic drawing of the composition; the tulip is tipped forward, inviting the viewer into the illusory (if intimate) distance implied. The individual flowers on the narcissus' stems are on different planes and at varying distances from the eye as well. I've used dotted lines in various circles, ovals, and discs to demonstrate the variety of direction; if we ignore such things our paintings will look as flat as folk art.

Final Painting

To maintain the flowers' clean, fresh feel, I did the painting itself as directly as possible. The tulip's colors are mainly tints and shades of cadmium red medium; there is only a small amount of shadowing done in its depths to give a sense of dimension. The shape and direction are the main source of this illusion.

The narcissus I painted more carefully, one at a time in successive washes, to retain their freshness and identity. Notice that reflected lights, in this case yellows, blues, greens, and even some pinks, give a sense of life and interest.

CAN SPRING BE FAR . . .
10″ × 14″
Reprinted courtesy of The Artist's Magazine
Collection of Betty Bissell

Sketch

Final Painting

The Portrait Approach

This painting demonstrates the portrait approach; the columbine is comfortable in its leafy surroundings.

Stage One

Stage 1 shows my preliminary drawing, with the columbine, its stems and leaves protected with liquid mask.

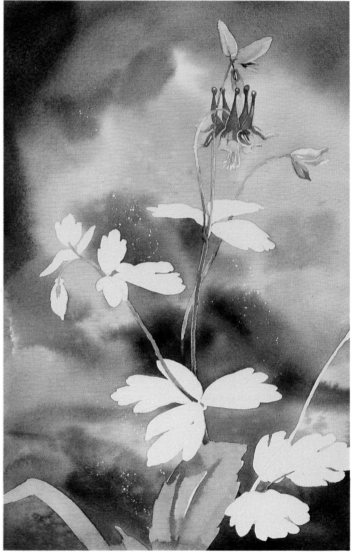

Stage Two

Stage 2 shows the rich, wet-in-wet background wash of greens and a deep purplish shadow made up of brown madder alizarin and ultramarine blue. Some of the forms are beginning to take shape. A soft, out-of-focus background, almost photographic in effect, helps create a sense of depth and also focuses attention on the foreground flowers and leaves. Notice small details like the redness of the stems; all stems aren't *green, no matter what we were taught. Next I added color to the flower itself, carefully shaping it.*

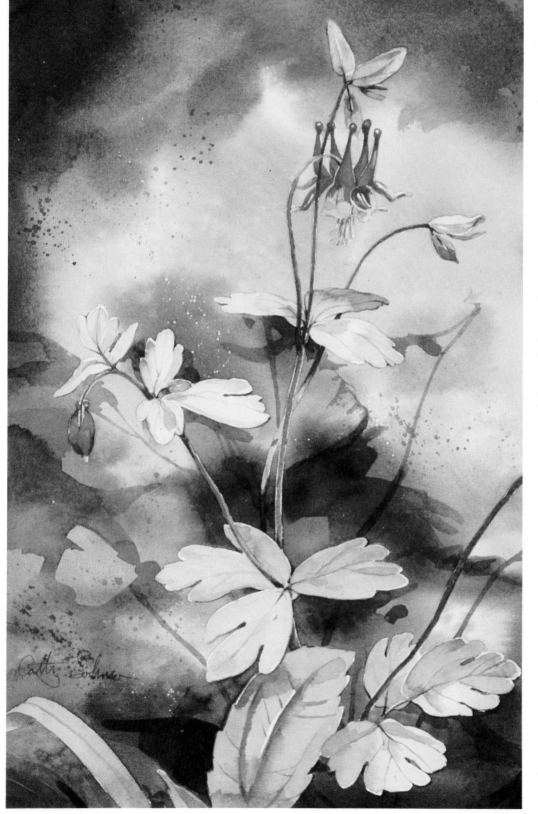

Stage Three

In stage 3, a lot has happened. The upper background didn't provide enough contrast, so I wet it with clear water and quickly brushed in another, darker shadow wash using a light touch to avoid lifting the washes underneath. Then I painted and modeled the leaves and stems and added the bud on the left.

The leaves still didn't satisfy me—somehow the picture was all too flat. So additional background shapes were suggested to make the leaves come forward and give a sense of the various levels and planes. A little spatter added texture and interest without overworking. (Spatter is great for this!)

WILD COLUMBINE
11" × 14"

Sketch

Subtle Contrasts

I liked the shapes of this fallen tree, a giant among the smaller upright trees and miniature wildflowers. The soft overcast day made it a painting challenge, though: all the elements were of similar value, making for very little contrast. In a way it was advantageous because the sunlight and shadows filtering through the tree canopy would have made a confusing subject. This was almost too simple—I needed to add interest.

Sketch

To make sure I actually had a painting subject, I made a quick watercolor thumbnail sketch. This solved several problems for me by giving me some hints on how to handle the final painting. A lighter, simpler background with just a hint of detail would push this area back; cooler mixtures for the trees behind the fallen giant would keep them in their place, too. I also found that a warmer mixture on the closer trees would make them advance toward the viewer.

Stage One

In stage 1, I used liquid mask to protect the tiny wildflowers and leaves growing beside the huge fallen log. I washed in a mixture of thalo green, modified with cadmium yellow light, yellow ochre, and a touch of burnt sienna here and there to keep it from being too acid-green. I used my largest flat brush for this, a 1" aquarelle. While the wash was still wet and making interesting puddles, I added a touch of salt and a spatter of liquid mask right into the damp wash. (I also used this trick on Leaf Lace.)

Stage One

Stage Two

When this was dry, I painted in the tree forms, keeping in mind the lessons I learned from my sketch. I made the background trees much cooler than those in front of the fallen and broken log.

I used graded washes to model the log itself. I wanted the picture to start with a light wash on top, where it reflected the light of the sky, then proceed to a very deep shadowed wash where it nestled among the flowers. I did this to provide contrast and to give the feeling of roundness. At this stage I also began brushing in the lines of the wood grain; they were interestingly twisted around the old trunk like ribbons around a Maypole. I wanted to accentuate the wood's change in color where the huge tree had broken, so the warmer-colored heartwood became my center of interest.

Stage Three

I was careful to maintain a feeling of overlapping planes here to give a sense of volume and distance. The right-hand section of the log was kept lighter, in keeping with its simple, cylindrical shape, while the log that rested on the slope of the hill was deeply shadowed underneath. You can see the difference between the two planes in the detail shot.

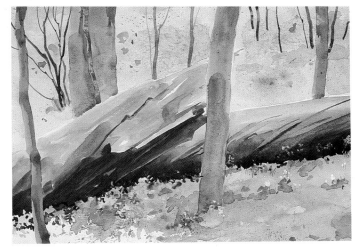

Stage Two

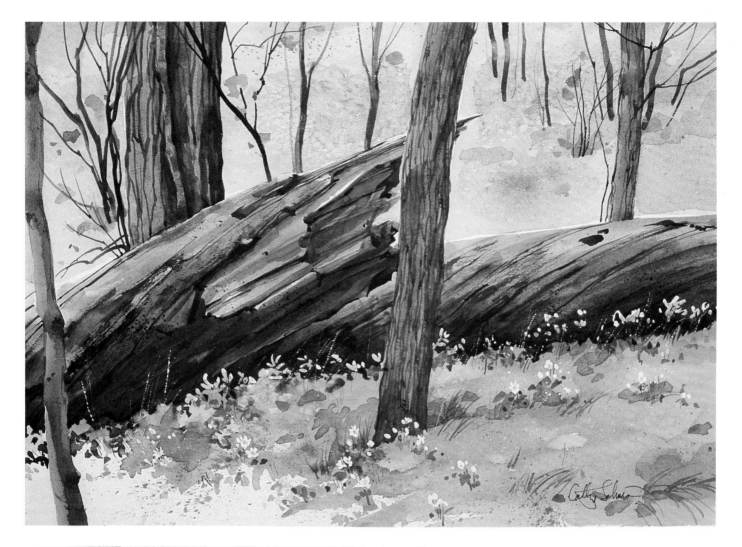

Stage Three

Stage Four

In the final stage, I removed the liquid mask and finished detailing the tree bark and weathering the log. Some moss and algae color had been laid in during the original washes so it would blend; in the final stage, I added drybrush mossiness to accentuate texture. I also used drybrush to weather the log itself. The small leaves against the log were loosely painted, letting some remain white to look light-struck. When the paper was thoroughly dry, I scratched in a few grass blades with a sharp craft knife.

WILDFLOWERS IN SPRING LANDSCAPE
15" × 22"

INTRODUCING LIFE

There are times when your painting seems to call out for some signs of life beyond the movement of wind and water, or the burgeoning of weeds and wildflowers. Hints of animal life can be especially effective details to add. Feeling that something has just passed by or scampered off into the woods adds an immediacy to your work.

I enjoy painting and drawing animals directly rather than from a picture or illustration. It's more fun to watch them go about their business in real life than to see their actions frozen in a book illustration. You can also learn how an animal's body reacts with different movements. When a squirrel sits, what do his paws do? How does he look from the side, front, and three quarters' view? An illustration can't give you this information.

Even the commonest squirrel or coyote shares sentient being with us and deserves our respect and attention. Some of these plucky survivors have learned to share space with us quite nicely, thank you, and make a living on our common ground. A somewhat unlovely family of Virginia opossums shares the basement with my outdoor cats in winter, allowing me plenty of opportunity to get to know these prehistoric "neighbors." Rabbits and raccoons, squirrels and birds are all common backyard visitors; if you're quiet and take the time to let them become accustomed to your presence you'll have plenty of opportunity to sketch them.

DETAIL OF BLUET SPRING

My cat cornered a mouse that had wandered inside last fall; to protect the frightened little creature I caught him in a mason jar; what a perfect opportunity to sketch a live animal in a variety of positions! I did these sketches and shot nearly a whole roll of film, until the poor creature began to get too panicky. I then turned him loose under the front porch and wished him well. I can imagine several future paintings from these sketches—they were well worth my time.

This sketch of an ailanthus tree would be reasonably interesting by itself; but notice how the alert and cautious squirrel provides an immediate center of interest. Plan your composition so the animal (or bird, fish, insect, etc.) is at an interesting point; remember logic, but don't be afraid to deviate from a simple Golden Mean placement. An animal placed far off center and facing out of the composition may give just the sense of life on-the-fly (as it often does in nature) that you are after.

You may even wish to invite the wildlife into your backyard: a bird bath and feeder attract a wide variety of feathered visitors; food scraps, cracked corn, and other grains plus a ready water supply may attract animals to study at close range.

You won't have to lure any insects to your yard to study and sketch; these prolific creatures are everywhere. They're even beautiful once we get past our prejudice about "bugs." If beetles are not your cup of tea, start out with the wonderful varieties of butterflies, moths, damselflies, and dragonflies. As an artist/naturalist I gain as much pleasure in drawing a mud dauber as a Monarch. From past experience I can guarantee you'll find something interesting enough to sketch or paint. It won't even be necessary to zero in or use a viewfinder: creatures, by their very nature, become a natural focal point for our attention.

Get used to sketching animals quickly; gesture drawings and quick drawings from memory are good for this. Why quickly? Animals are nearly always on the move. Unless you develop good memory drawing techniques or are able to capture the overall pose in a quick gesture drawing, you may not get another chance.

This may be a good place to make use of that handy artist's tool, the camera. It will provide you with the film equivalent of a sketch to refer to later. I did a painting of a lake near my home in which I wanted to include the flying form of a Great Blue Heron; a quick shuffle through my photo file turned up an amateurish overhead shot of the big bird—just what I needed. The image was only about a quarter of an inch long in my snapshot, but it was enough to provide me with information about how the heron's neck folded back in flight and how he held his legs.

My best advice for including realistic-looking animals, birds, and insects in your work is to sketch, sketch, and sketch some more. Frequent the zoo, stalk wildlife, visit natural history museums—observe . . . constantly.

BUFFALO &
ROOSTER
JOHNSON

Aug. 3
5:30 pm

These sedentary buffalo I sketched last summer, lazily chewing their cud and strolling slowly along as they cropped the long grass, changed positions before I finished drawing, performing a kind of slow-motion pas de deux.

These quick sketches of a muskrat are gesture drawings, which I squiggled down rapidly with a #2 pencil as he went about the business of lunch on the opposite bank. There is enough information here that I could comfortably include a muskrat in a future painting.

You may want to use an old trick to get the animal's shape right. Try breaking down the overall form into manageable and easily recognizable parts, as I did in this sketch of a black bear. Use circles, ovals, cylinders to help you capture the overall pose, then flesh out your finished drawing. Watch for negative shapes as you do your preliminary sketch; they'll help you to accurately draw proportion and pose.

Field Sketching

Try your hand at field sketching; it's the most absorbing and interesting way to learn about nature's details. Work from real life whenever possible to develop your own understanding of this particular creature's construction, how he works, and what he can and can't do. Later you'll be able to reconstruct, from memory and imagination, a particular pose or action. Look at my painting, *Rock 'Coon* on page 114. I'm familiar enough with the raccoon's anatomy and habits to sketch a reasonably accurate drawing without any model whatsoever.

When I am doing slightly complicated field sketches, I take my backpack. An old Army-surplus canteen and cup act as my water container and bucket. A travelling watercolor box with semimoist pan paints works best for me—when I use up the color in the tiny pans, I simply refill from my tube colors and let the paint dry overnight before heading out into the field. I've built up a collection of favorite brushes for sketching; if I am planning to work small, I take along my folding brush set. The brush unscrews behind the ferrule and fits into the hollow handle, protecting the delicate sable hairs. When I want to work larger, I use Oriental brushes or Sabeline—that way I won't cry if they are lost.

These field sketches of turtles that wandered through my backyard were fun as well as instructive. I didn't finish the Painted Turtle sketches because while I held him in my left hand and painted with my right, he struggled, kicked, and scratched my palm into hamburger.

A few colored pencils and a tiny sketcher's watercolor kit are also among my favorite tools. I do a sketch with a dark warm gray colored pencil, then do loose overwashes of color, usually from memory. A few well-chosen colored pencils in a variety of hues or a small set of watercolor pencils would allow you to capture color in your field sketches without overburdening yourself.

One word of caution; it is o.k. to practice, if you must, by sketching book illustrations. If their source is recognizable in any way, however, they will be a detriment to your finished work. The photographer who worked so hard and waited so long for that particular shot may even be inclined to sue you for copyright infringement!

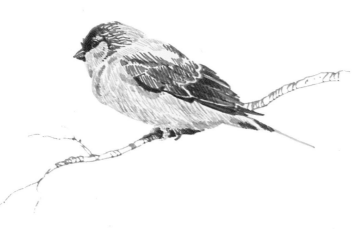

Take along simple tools for sketching in the field; this sparrow was done with a few dimestore felt-tip pens. A #2 pencil and inexpensive sketch book would be all you really need.

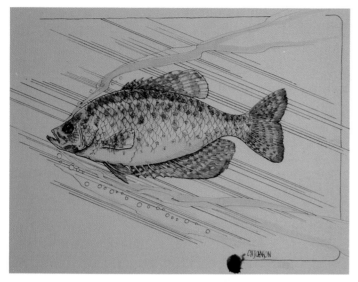

My Black Crappie *is a mixed-media painting. The line drawing was done with sepia ink and the pale, subtle washes were dashed in loosely and allowed to blend freely.*

BLACK CRAPPIE
11" × 14"

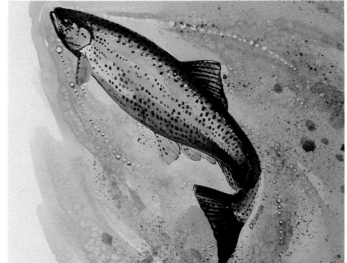

In contrast, Rainbow *is a much more realistic handling, with pure aquarelle as my medium. I carefully delineated the trout's shape to maintain its grace and dynamics. I paid special attention to the skeletal form and how he actually moves through the water. Spatter, salt, and liquid mask "bubbles" help give the water a sense of movement and reinforce the fish's directional thrust.*

RAINBOW *11" × 15"*

Wildlife Art

This is a whole genre in itself, and a very demanding one. The knowledgeable buying public for wildlife art are generally sticklers for detail: habitat, season, foodstuffs, etc., as well as the anatomy, coloring (which may be seasonal), and animals' actions have to be correct. Personally, I don't enjoy working under too many constrictions. Although accuracy of habitat and action is important to me as a naturalist, painting every hair or feather goes against my interpretive and creative grain as an artist. I like to be free to *suggest* as well as to spell out. I'm usually more concerned with using animals to add a spark of life, a bit of interest, or a focal point—producing a finished *painting* rather than an animal portrait. My wildlife is generally only a part of the finished work rather than the work itself. (There are exceptions, of course.)

Fish

Fish are a whole different "kettle of" Their shape, texture, and habitat are so alien from those of warm-blooded creatures. I love their silvery, streamlined bodies and graceful movements. They make good abstract as well as realistic subjects, rich with symbolism and beauty.

Since they are underwater creatures, you may find fish a bit more difficult to study—unless you're into scuba diving. Position yourself downstream of a small riffle to see the close-up actions of a school of small shiners; polarized glasses will help you see through the reflective surface of the water almost as if by magic to discern the larger shapes. Or visit an aquarium (or start your own at home!), or find a good book or field guide. Your camera may be a useful tool here; action shots of fish in mid-air can be gotten no other way, unless you make very quick sketches indeed.

Seriously, this is a good place to hone your skills in gesture drawing or working from memory. Let the fish imprint itself on your mind as it breaks the surface of the water after an emerging mayfly—or your hook. Then sketch its shape as quickly as possible to retain the image. Details can be filled in later from a field guide or book on fishing, if you wish.

Even a fish market can provide you with subjects, "up close and personal." Thomas Aquinas Daly does beautiful paintings of game fish—although I think Tom catches his own! These paintings can be reminiscent of early Flemish works, very beautiful and affecting.

Even in death, fish make interesting subjects. Chardin used them in his still lifes; the latter-day master, Tom Daly, has integrated this image into his works effectively.

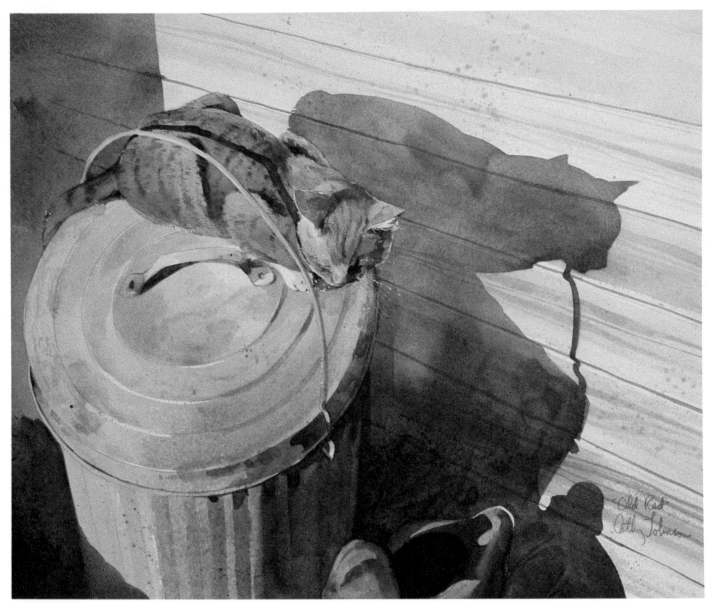

Model Pets

Your family cat or dog (or bird, fish, horned toad, whatever) is a handy model and often more than willing to pose. My cats are all real hams; I've done lots of paintings and sketches of them over the years. Understanding their anatomy has helped me to understand and paint *all* four-legged mammals.

Big Red was one of my best models; his pose on a galvanized trash can inspired me to do this study in warms and cools. Notice the use of spatter for texture and how simply the washes that describe the cat himself are handled.

I didn't want to get too caught up in painting every hair on my old cat; a warm raw sienna and cadmium orange wash was varied only slightly here and there with clear water along the light-struck edge of his body or with a stronger value of the wash to suggest shadows. Then, when that first wash was dry, I went back in to paint his stripes and a few suggestions of anatomical details. The point of my craft knife suggested light-struck hairs and whiskers.

I kept the shadow area fairly simple; I wanted to retain the somewhat abstract feeling of the raking light and cast shadows and I liked the angularity of the cat's shadow on the wall. The wash was varied only slightly with spatter as it dried; a bit more was added when everything was dry.

OLD RED
15" × 22"

July 25

Monarch wings were much more opaque and subtly colored in the closed position, but the black lines were bolder. They were like black threads in stained glass in the open position. He fed from our marigolds for some time while we watched, probing delicately into each flower.

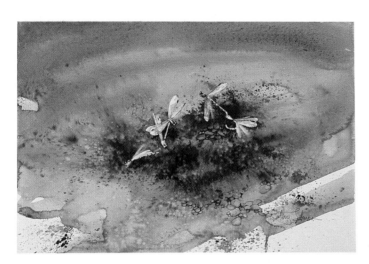

A semiabstract painting resulted from a chance find of mating bluet damselflies at the water's edge. I protected the damselflies' shapes with liquid mask before dashing the water in with a vignetted forward edge. Then I allowed "flowers" to form in the damp wash to suggest mossy forms (using hot-press paper to encourage this effect) and added wet-in-wet areas, spatter, and some salt to give a feeling of the water's submarine coolness.

I often only really see, for the first time, when I sketch and paint something. This was no less true when I sketched this Monarch butterfly.

"Bugs" and Other Fantastic Creatures

The burgeoning world of insects, spiders, butterflies, damselflies, bees, and wasps is virtually untapped as subject matter. What could be a more lovely subject than an iridescent dragonfly with netted wings? I can't imagine a flower that is more beautiful than a butterfly. Why, then, are flowers the subjects of a hundred paintings while that ephemeral bit of winged beauty feeding there is ignored? Take a butterfly hike with a local nature or wildlife group—you'll be astounded at both the beauty and variety. Don't forget to take your sketchbook and camera along! And *take notes*.

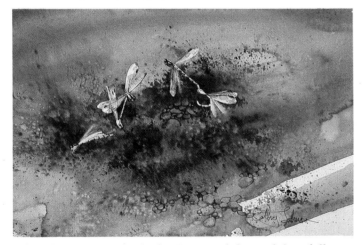

When this was completely dry I removed the mask (carefully, so as not to disturb the washes on the surface of the slick paper) and painted in the damselflies, carefully integrating them with their watery "landscape" so they didn't appear pasted on. I suggested a bit more detail in the underwater rocks and mosses to make the transition flow more smoothly.

BLUET SPRING
15" × 22"

With insects and other small creeping creatures (spiders, crustaceans, etc.) we may just need to cast off our squeamishness and note the possibilities before us. I once had a decided lack of fondness for spiders (actually, stark, unreasoning fear would be closer to the truth!) until I began to draw them from the artist/naturalist perspective. I then began to see their wonderful beauty and variety.

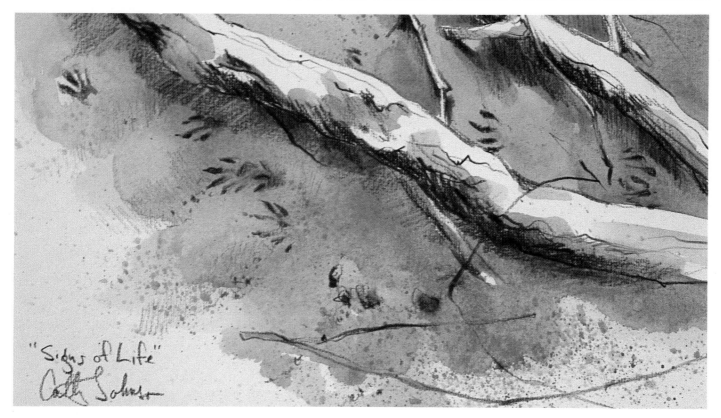

"Signs of Life"
Cathy Johnson

My field study of raccoon tracks was, to me, as satisfying as some of my more complete paintings. I did this by the creek near my home; because all life is drawn to water, it's a rich source of painting subjects. I used a warm gray colored pencil and a quick watercolor wash, one of my favorite sketching techniques.

SIGNS OF LIFE
11" × 15"

Mud Dauber —
Yellow & Black

this is nearly
twice size

Even a long-time neurosis can make a good subject! Here, I've done a field sketch of a mud dauber. Like some dogs, their "bark" is worse than their bite—I've only been stung once after years of studying them closely. (And I've gotten over my fear as a bonus!)

Animal Signs

More often we see where an animal has *been* rather than the actual animal itself. Many mammals are either shy of man (quite rightly) or nocturnal—not exactly conducive to close study. But you can produce an effective painting of these mere whispers and suggestions of life. My cousin, artist Keith Hammer, painted a wonderful scene of only the crossed footprints of herons and smaller birds at pondside.

Worshipping From Afar

We may only see birds or animals from a distance, but they can still bring that spark of life to your paintings. Most of my skies contain a bird or two; without them they seem empty and deserted. (Notice when you go outdoors to sketch that even on the coldest—or the hottest—day of the year, birds make their way across the sky, either singly or in great, migrating flocks.)

Demonstrations

Since I am quite fond of animals and feel they are vital to any nature painter's repertoire, I've included more demonstrations with this chapter than usual. I wanted to show that there are many different ways to include life in your paintings.

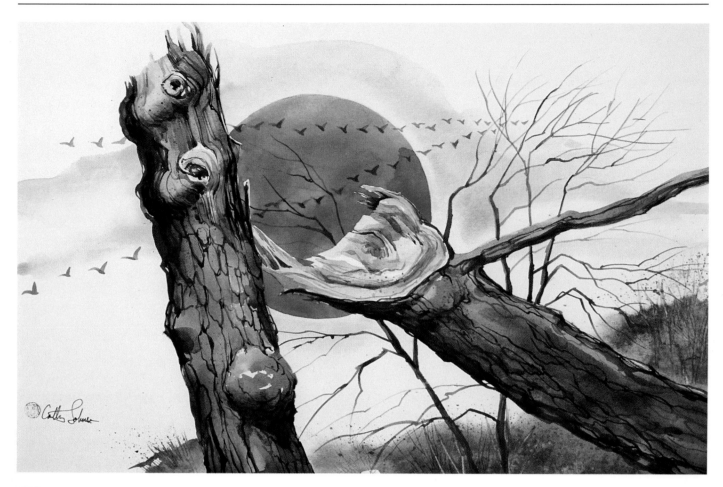

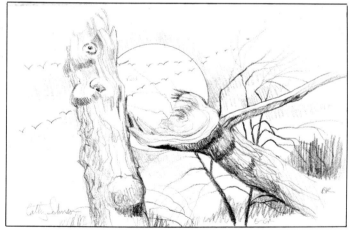

I used a "vee" of migrating Canada geese as a design element in this painting. A preliminary sketch helped me plan my composition and design; color notes organized my thinking.

This painting contains a number of triangles designed to lead your eye into and around the picture plane; the vee of the geese counters the directional thrust of the two stumps.

I almost lost my nerve with this painting. I had planned that red sun from the first, even in my preliminary sketch, but as I drew the large circle, painted around it, and almost completed the rest of the painting I got cold feet. My "red" sun was a pale subtle moon; and everything else a tapestry of blues, blue-grays, tans, and browns. Yes, I liked it—but perhaps I was just chicken. It was awfully subtle, so I worked up my nerve, mixed a nice big puddle of cadmium red medium and alizarin crimson, and decided to give it a try.

I first wanted to make sure I wouldn't have to throw the painting out afterwards; I painted a piece of scrap paper with my red mix to tell me if I really wanted to be that brave. I did.

Once I took that step, the rest was easy. I added a bit of red spatter here and there, red backlighting on the tree form for color unity, plus the geese—I'm glad I was bold.

ENDINGS
15″ × 22″

Sketch

Highlighting an Unseen Presence

One of my favorite themes is to paint where animals have been. This is like a secret shared, a mystery unfolded. A sketch done at a nearby lake helped me plan composition and value for Beaver Tree. These guys really are "busy as beavers"; many of the nearby trees have been felled (often overnight) and the limbs and brush neatly trimmed so beavers can build their dams and lodges, and stock their winter food. In my sketch, I was interested in the low-key background lighting with the strong sun hitting the pale, white trunk.

Stage One

In stage 1, I laid in the first washes with a strong medium value as a base wash. I painted around all the trunks and limbs rather than mask them out; I wasn't as concerned with accuracy here as I was with pattern and rhythm.

Stage Two

In stage 2 I've added some secondary washes in the lake to bring its value down still further; this wash is mainly thalo blue, about as strong as you can get. I've started to texture the grass a bit more, and have scratched out some light-struck grasses. I've also tried to give the impression of sharp beaver teeth marks on the trunk without compromising the strong light of the woods.

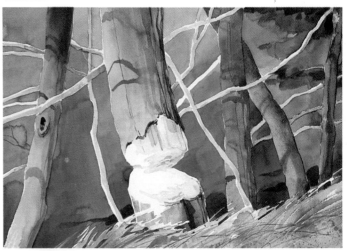

Stage One

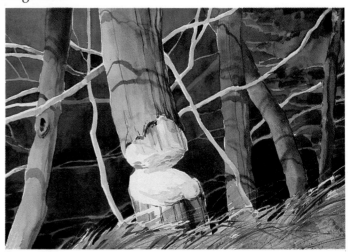

Stage Two

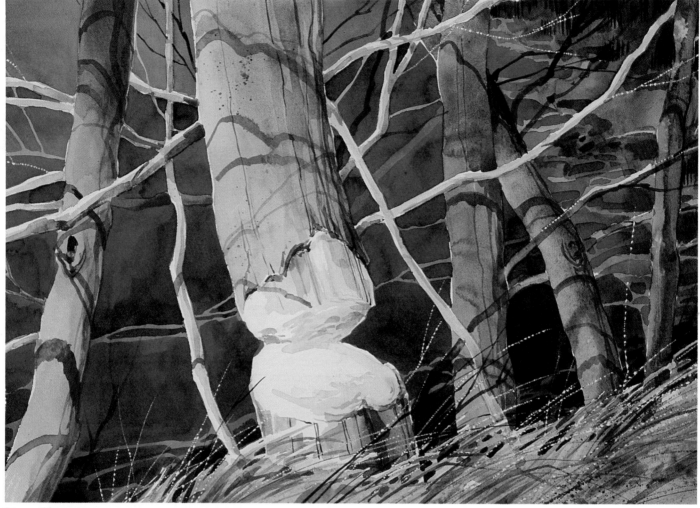

Stage Three

Detail

Stage Three

Finally I've added sharp accents, both light and dark (I added the lights by scraping with a sharp blade). I've refined the shadows and bark patterns on the tree as well. (See detail.)

BEAVER TREE
15" × 22"

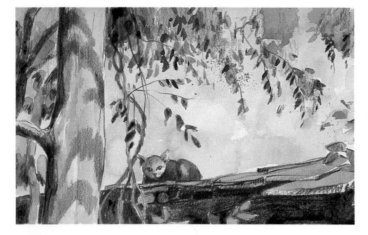

Stage One

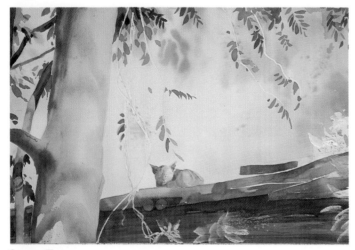

Stage Two

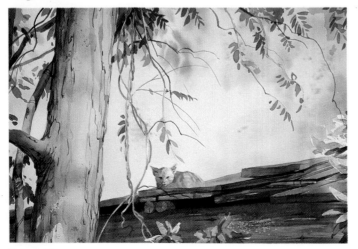

Stage Three

Bending the Rules of Composition

Here, I've tampered with the "rules" a bit by placing this kitten nearly in the horizontal middle. The tree on the left was so strong a statement that if I moved it any further left or allowed much more dead space on the right the whole thing would have tumbled off the left side of the page.

Stage One

I did a watercolor sketch first, to see if I really did have a subject (and if I could avoid a sort of kittenish cuteness), and although I managed to do a pretty lousy kitten, I liked the idea and format enough to explore it further.

Stage Two

I used liquid mask to protect the vines and leaves, but painted the wet-in-wet background of hazy spring greens right over where the kitten was to go. I simply blotted the wash back where I wanted the light side of his head to be.

The tree, a very warm sunlit mixture of cadmium orange, yellow ochre, and touches of ultramarine blue, is also painted partly wet-in-wet to allow the shadows to blend smoothly. We often tend to think of trees as gray, or, worse yet, a flat, dark brown; imagine how flat and boring this would look had I followed that formula. The light struck fire on the trunk, and I wanted to capture its high key and warmth. (Rain-wet trunks are often so dark they appear almost black, but that's another mood for another painting.) I laid the tree in after the yellow-green background dried to produce good clean edges.

Then using a large flat brush, I laid in the rough shakes of the roof with a strong mixture of ultramarine blue and burnt sienna. I also introduced an extra bit of warm burnt sienna as reflected light in the shadow area under the eaves.

Stage Three

The small sapling to the left of the tree had gotten too harsh, so I wet it down again, lifted some areas, and floated in other areas of fresh color for more subtle transitions. I used a small brush to suggest the bark and the twisted vines, then added a bit more foliage here and there to frame my subject. By the way, the "Jesse" of the painting's title was Jesse James. The little yellow cat perched on the roof of the original James log cabin near Kearney, Missouri.

JESSE'S KITTEN
15" × 22"
Courtesy of Bedyk Gallery, Kansas City

Birds at a Feeder

I keep my bird feeders full in the winter (and well into the spring and early summer) and am rewarded by a constant parade of visitors. I liked the contrast of the dun-colored sparrows with the natty little nuthatch and bright apple, so I decided to do a vignetted painting of the feeder scene.

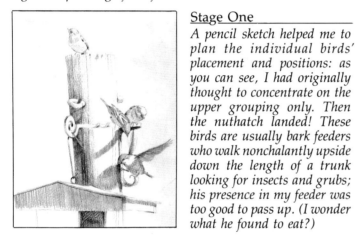

Stage One

A pencil sketch helped me to plan the individual birds' placement and positions: as you can see, I had originally thought to concentrate on the upper grouping only. Then the nuthatch landed! These birds are usually bark feeders who walk nonchalantly upside down the length of a trunk looking for insects and grubs; his presence in my feeder was too good to pass up. (I wonder what he found to eat?)

Stage Two

Here, I've just painted the pole, feeder, and wrought iron bracket it hangs from. These were fairly direct washes; I was mainly concerned with value and form at this point. My usual favorites, burnt sienna, burnt umber, and ultramarine, were the chosen pigments.

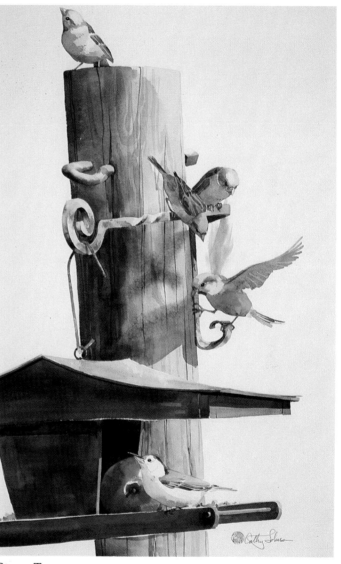

Stage Two

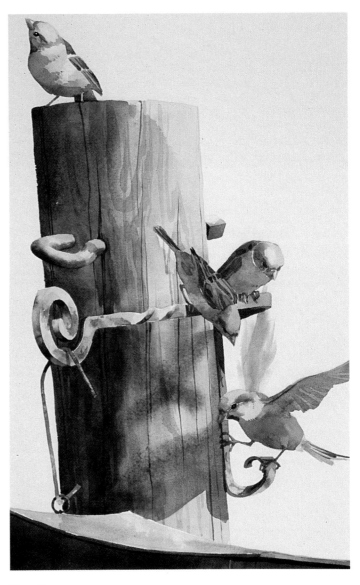

Stage Three

In stage 3, I added texture to the pole, painted in the small birds and painted that big red apple; notice the reflected light (alizarin crimson) on the nuthatch's breast feathers.

VISITORS
15" × 22"

Detail

The lowest sparrow had just landed; I suggested motion with a blurred upper wing, which was still flapping.

I liked the little fellow up top, staring off contemplatively; he gives a slight sense of dynamic tension to the composition: what's out there?

Learning from Mistakes

It isn't always necessary to really see your subject. I was sketching these rocks on the hill when a furry blur caught my attention, diving into the dark triangular den entrance under the rocks. He moved too quickly to identify, but it could have been a raccoon. (More than likely it was really a woodchuck, but I like raccoons.)

Stage One

I quickly sketched a curious coon in the margin to remind myself to include him in the finished painting. A small value sketch also helped clarify my thinking.

Stage Two

It was long enough between sketch and painting that I quite forgot the colors actually present; when I finally painted it, it was full summer, so I did a couple of color samples to help me decide on a color scheme.

Stage Three

All that preparation and I still blew it—maybe I was over-prepared? 'Coon #1 just fell flat; I included this painting because my students like to see my failures, too. He didn't work because I hadn't fully planned my value pattern. The 'coon should be the natural center of interest, but look at the painting—does your eye go to the raccoon or somewhere else first? (Actually, to about three competing areas—when I blow it, I really blow it.)

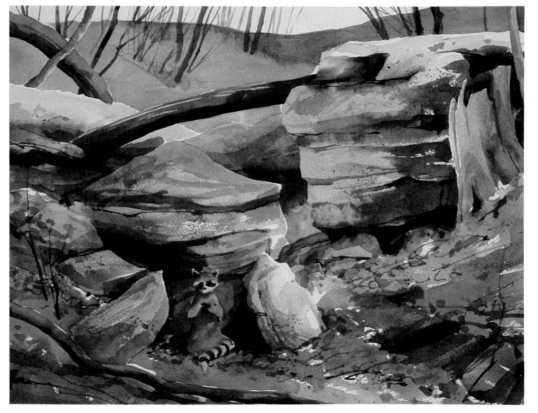

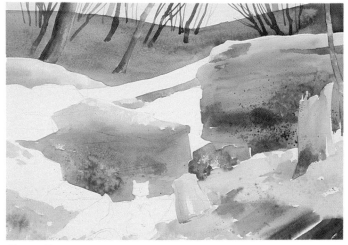

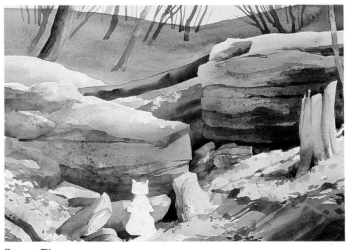

Stage Four

So, chastened, I started over. I replanned my values so a strong light would fall across the small animal, forcing your eye toward him. In fact, in stage 1, I had trouble keeping the sun-struck leaves light enough even though I could always have darkened them later if need be.

Stage Five

In this stage, I've added texture, shadow, and detail in the rocks, but still no 'coon.

ROCK 'COON
15" × 22"

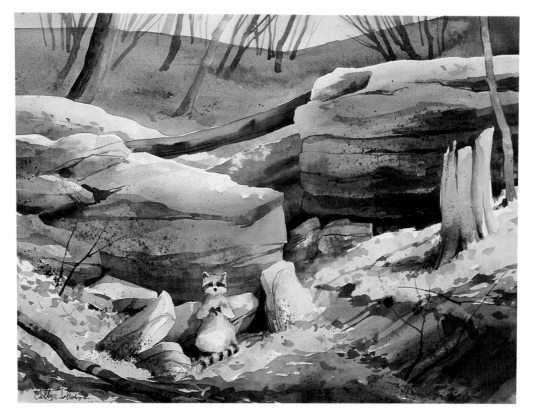

Stage Six

Finally I added the little bandit, keeping my washes as loose as possible. His face was the wrong shape, so I softened the cheeks with clear water and blotted them back. The sky still drew attention away from the little guy, so I toned it down with a light gray wash.

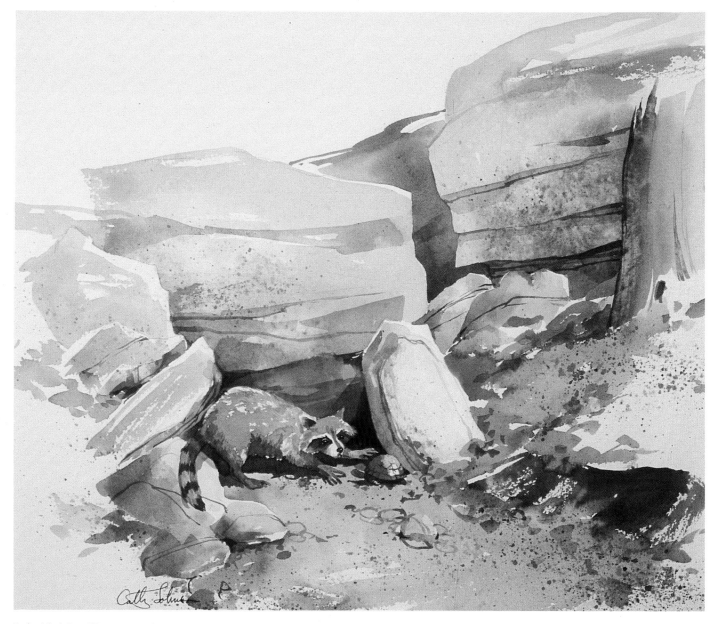

SURPRISE PACKAGE
15" × 22"

I decided I still wasn't through with this subject, though. I wanted to see how a vignetted handling would work, so I tried it one more time.

Here, I've left out all but the most pertinent information: the closest rocks, the stump on the right (which I lowered somewhat), the den hole, a suggestion of leaves, and the curious raccoon. Only this time, he's curious about a box turtle; I was tired of painting him sitting upright! I handled the rocks simply and kept them fairly high-key; a little detail work in the form of cracks and spattering was enough to say what I wanted to.

Again, the raccoon was drawn from my imagination and familiarity with 'coon anatomy. I think I like this painting best.

LINES AND SHAPES

Nature is a moving, growing tapestry of lines and shapes. Even in an intimate landscape we find counterpoints, rhythms, and repetitions. Some of nature's lines are vigorous, emphatic, like tree roots thrust into the sky as if surprised to be there. Other lines are sinuous, snaking like vines embracing a tree. Some forms bend and sway like dancers in the forest. Everywhere there is something to paint: a singular angle of a dead tree, the warty protuberances on a gall tree, or the beautiful circles and ellipses of cut wood.

Seeing

Learning to see these things is simply a matter of becoming aware of them. A student in one of my workshops complained that she couldn't find subject matter near her home; after three intensive days of *looking* and learning to see, she soon found subjects everywhere. Use the tricks discussed in Chapter 1 and interesting lines, shapes, and angles will appear as if by magic. You may find yourself drawn to a specific form or shape. Train your eye to look for that shape—a circle, a certain quirky angle—and you'll begin to discover it in places you never noticed before. "As ye seek, so shall ye find" is not bad advice for the watercolorist.

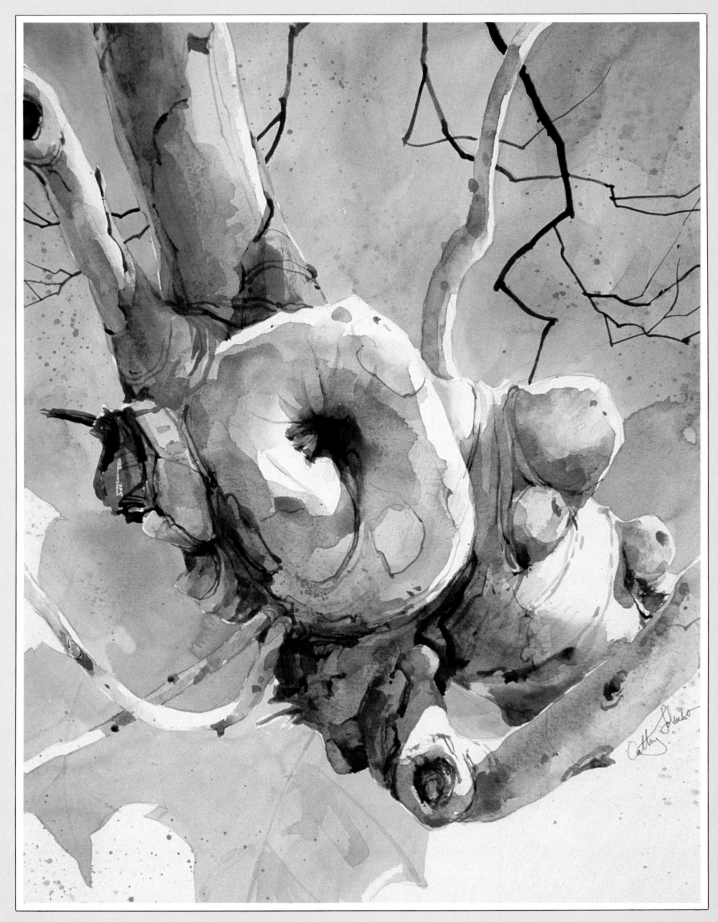

SYCAMORE *15″ × 22″*

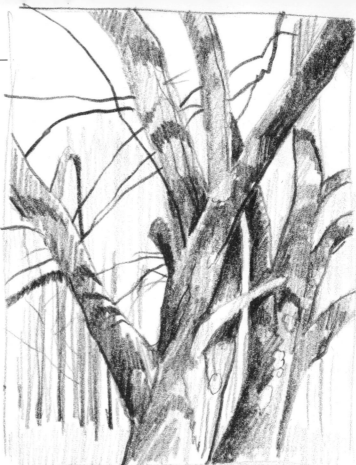

This fascinating old stump was covered with the warts of a hundred galls. Look for interesting shapes such as this to sketch in pencil or watercolor. These are details to be explored.

This Osage orange tree was alone in a forest of straight-trunked pines standing at attention; I loved the twisty curves of the hedge-apple's warm-colored limbs against the cool, dignified uprights of the evergreens.

You might find other contrasts by looking for light against dark, or natural against man-made.

This thumbnail sketch employs two contrasts. The decaying roof on the old cabin was dark against the pale sky; the tumbling, cascading vines softened only some of the dark geometric forms. I like the sense of drama and the counterpoint this juxtaposition allows.

I am especially drawn to angular and to calligraphic forms of nature. Vines and roots especially appeal to me (and if I choose to imagine a gnome's cottage beneath the roots, who is to know?). When looking for a painting subject I start by first reminding myself to look for these forms. My friend, an avid mushroom hunter, does the same thing each spring before she sets out to search for morels: first, she looks long and hard at a painting I did for her of her favorite fungus, then sets out with eyes "at the ready." If I am similarly prepared to find an interesting subject, I will find it.

Contrasts

Look for nature's contrasting forms to set up dynamic tension in your work. Perhaps you'll find curved lines against straight ones, as in my small sketch of an Osage orange tree. Other contrasts to look for are value, color, size, and shape. Use these things to add interest to your paintings.

Positive and Negative Shapes

Looking for good—and interesting—negative shapes can't be overstressed. Not only will adding them give you interesting compositions—and keep areas from becoming too boringly similar—they will help you draw more accurately. Betty Edwards, in her landmark book, *Drawing on the Right Side of the Brain,* uses the concept of negative space to help you *see* what you are looking at. Charles Reid, a leading watercolorist, has this concept down to a fine art—if you will pardon the pun.

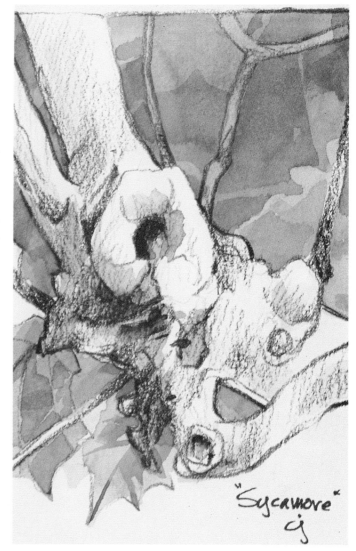

Enclosed forms often define your subject's boundaries. I was particularly interested in these small shapes when I spotted the end of this sycamore limb with its twisting branches. The forms and perspective were somewhat confusing from such a close angle, but looking first at the negative space that surrounded them helped me to draw what was before me. (Using a viewfinder helps isolate negative shapes, as well.) I liked the variety of shapes, large and small, linear, round and triangular. It inspired Sycamore, *the painting on page 117.*

119

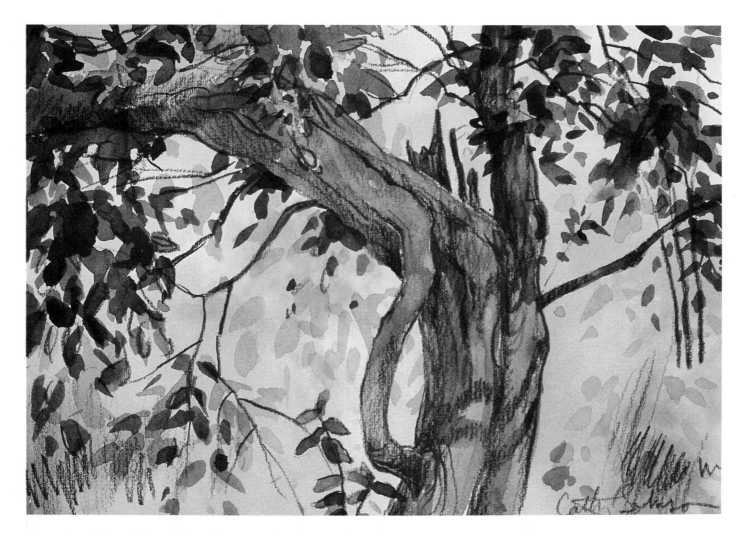

The enclosed shape explained the subject in my favorite tree, the Teacup Tree. *The impossible limb formation with no beginning or ending is like a Zen Koan; it makes you think. This small study (9″ × 12″) was done in full summer where cool and warm colors added to the contrasts. More subtle negative shapes surround the tree on both sides; a triangular shape full of sunlight throws the two main branches into sharp relief.*

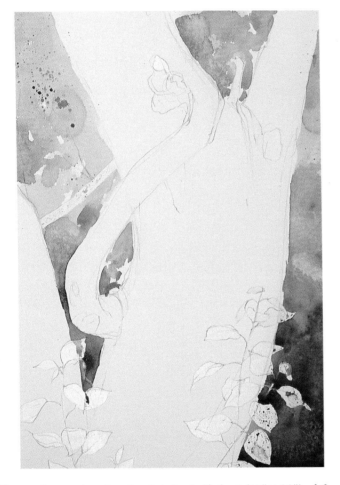

On another spring day, I painted a half-sheet (15" × 22") of the Teacup Tree. The first stage was a pencil drawing with a bit of liquid mask on the leaves against the trunk.

In the second step, above, you really can see the negative shapes; I've painted them first with rich mixtures of thalo green and cadmium yellow, with touches of burnt sienna. These forms were kept fairly loose and free. I mixed colors as much on the paper as on the palette, and a bit of salt and spatter gave all the texture I wanted for this step. I planned to downplay the background to focus attention on that incredible anomaly. I did, however, use contrasts of value and temperature to call attention to the tree trunk. Notice how the background goes from warm and light in value at the top of the page to cool and dark in the lower right corner; simple tricks like this add interest without detracting from the main subject.

I painted the trunk and limbs with mixtures of ultramarine blue, burnt and raw sienna, and burnt umber, manipulating the play of cools and warms to bring some areas forward (warm) and push others back (cool). I wanted to maintain the soft, overcast lighting of the hazy late-spring day, so I kept my shadows mostly soft and graded rather than hard edged as they would appear in direct sun.

In the last step, above, I removed the liquid mask and added the final details to the water sprouts at the base of the ancient apple tree, and the bark. I also added the suggestion of leaves.

TEACUP TREE
15" × 22"

121

Sinuous Forms

Nature abounds with these shapes. Look not only for vines, clinging snake-like or hanging like macramé, but for other shapes as well.

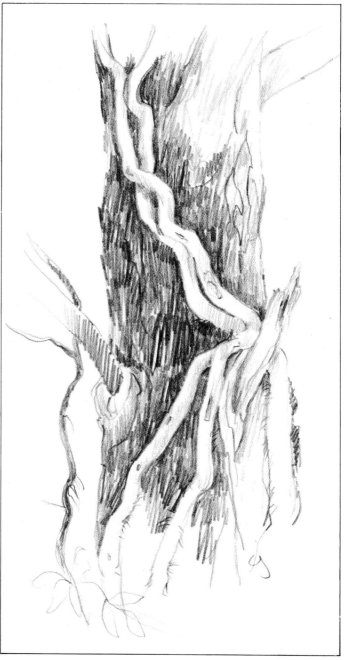

Try quick sketches of these graceful forms to train your eye. These tree rhythms caught my eye one day while walking along a path—I was amazed at how different they are in size and direction. Nature hates to repeat itself (think of snowflakes or fingerprints) so each form's uniqueness ensures an endless source for painting ideas.

Too many beginners resort to a kind of learned shorthand: a tree is one shape, a clump of weeds is another, a rock still another. But it's not as easy (or boring) as all that; shorthand has its uses in painting, but it cannot replace careful observation.

Clinging poison ivy vines with their hair-like aerial rootlets interested me enough to draw them in my field journal. Even if a painting never results from these sketches, keeping in training—eye and hand—is invaluable.

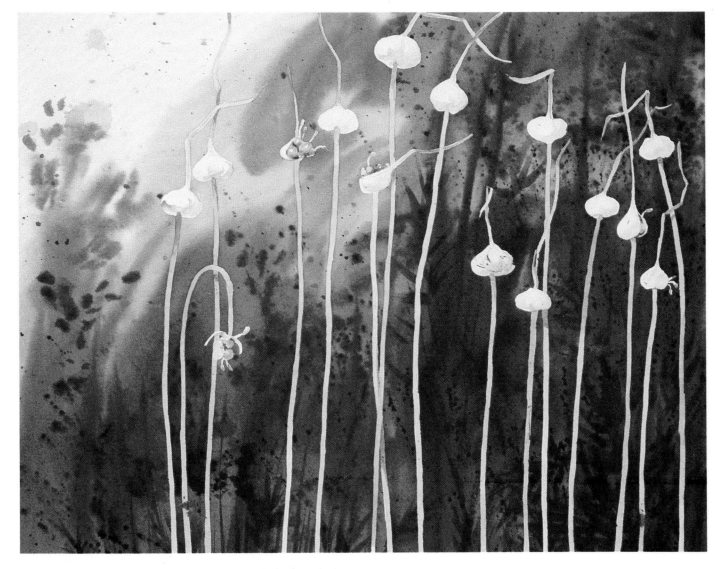

I painted these wild onions growing at the end of a friend's long gravel drive in the country; their gentle, curving shapes and syncopated rhythms were perfect for a watercolor study.

I used liquid mask to preserve their shapes so I could paint the background wet-in-wet. When it was completely dry, I carefully removed the mask and painted the delicate greens, reds, pinks, and maroons of the onions' seed heads.

WILD ONION
20″ × 22″

Many linear shapes and sinuous forms may be seen as "natural calligraphy."

This study of clinging and free-hanging vines around an ancient sycamore trunk was painted on a hot summer day with altogether too many obstacles already. Normally, when working on the spot, I wouldn't attempt liquid mask; it's just not part of my daypack "traveling studio." In this case, however, I knew what I planned to paint before I left home. I took liquid mask, a rubber cement pick-up, and a comfortable stool to sit on while working this rather complicated subject!

Long ago someone carved an initial into the tree's massive trunk; this road is known locally as "Lover's Lane" (every town has one.) Since my husband's name is Harris I modified the "M" I saw into an "H".

This painting is a half-sheet—larger than I normally work on the spot. Given the difficulties of 102° heat and passing (often curious) motorists, I was reasonably happy with the results.

LOVER'S LANE
15" × 22"

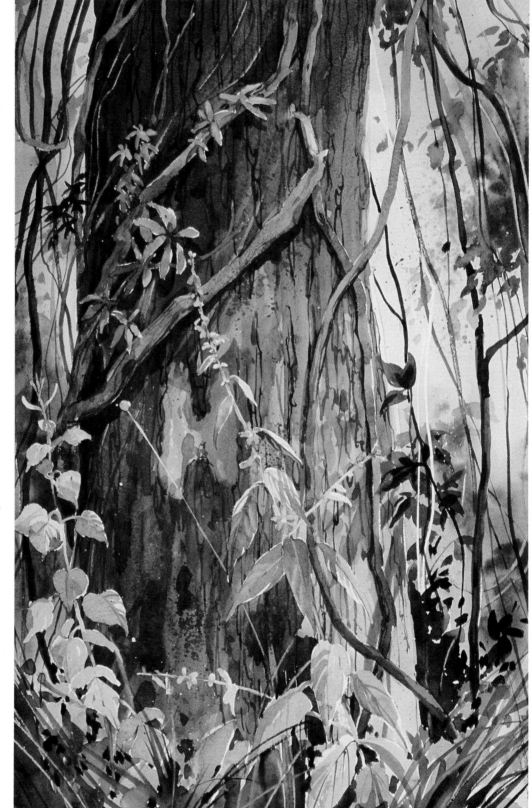

Nature's calligraphy is often easier to spot when winter simplifies the scene with a blanket of snow. These vari-colored twigs and sprouts had an interesting quality; the contrasts of small twig shapes and the straighter sprouts or wild berry canes made a nice, small composition. I painted this one in my studio from sketches and photo references. Liquid mask preserved the berry canes and bright leaves from the snow shadows; I wanted to paint them freely, wet-in-wet. Notice the color variation of the twigs and vines. This is what caught my attention in the first place: the winter colors. The subtleties were lost in my hastily-shot photos, but I remembered the wonderful variety well enough to reintroduce them in the painting. The finished work has an oddly oriental feeling—it seemed to call for the chop mark next to my signature.

SPROUTS AND SAPLINGS
9″ × 12″

Curves and Angles

Some subjects call for a slightly different emphasis. A combination of lines and angles may catch your eye; their mirroring shadows add a nice touch. You may want to try variations on a theme to see what best suits your subject and your feelings about it; or try a series of paintings on a single theme.

All studies of this linear quality needn't be busy or complicated, of course. A single vine, snaking in and out through your picture plane, may be subject enough. My small sketch done with colored pencils and watercolor washes is nearly that simple. Warms and cools make a nice counterpoint here with the vine itself as the subject along with its negative spaces and enclosed forms. I thought it was a successful sketch.

One windy fall day I sat on the dock by a lake looking for a subject to sketch; the lake was full of sailboats, but I was in the mood to capture something on a more intimate scale.

A quick look along the shoreline turned up this bit of driftwood—or should I say driftweed?—since it is really the root system of a particularly hearty and stocky weed.

I used my little sketcher's watercolor kit and a Notchy postcard for this small study, concerning myself again with negative shapes and what went on in them. The background wood of the old weathered fishing dock was beautifully textured and soft in variations of lovely blue-grays.

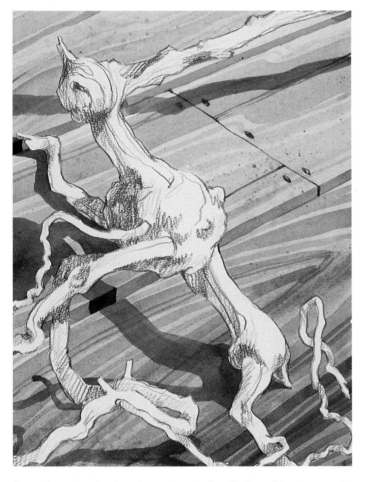

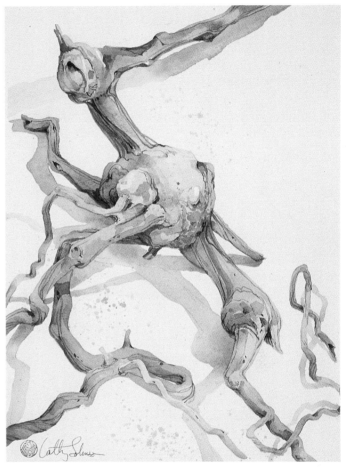

One advantage to choosing nature's details for subject matter is that sometimes I can simply pick them up and take them home with me for later studies. This piece of driftwood sat on my studio shelf for six months before I decided to try some variations.

The first is close to the original. I had thought at first to leave the positive shape completely white and without detail, painting only the weathered wood with its underlying wash graded from warm to cool and from light to dark. This would have turned the positive shape of the driftwood into a negative one, and it was an interesting effect. But the effect was too stark; perhaps I was overly fond of the original sketch. I decided to add colored pencil work for a mixed media treatment. I like the result, but felt it was *a rather predictable repetition of the sketch.*

DRIFTWEED
11" × 15"

I tried my second concept: painting the driftwood and its shadow against a white background. This time I was much happier with the finished painting.

I used all the sedimentary colors in my palette: burnt umber, burnt and raw sienna, yellow ochre, and the blues—ultramarine and cobalt. As they settled and dried they gave me interesting textures; notice, especially, the left side of the knobby ball of the root. I used a fine sable brush to draw in the details.

A mixture of cobalt and ultramarine blues made up the shadow; I liked the contrast of warm and cool here (as I often do). Notice the almost oriental feel here; I used my chop mark to emphasize it.

DRIFTWEED II
11" × 15"

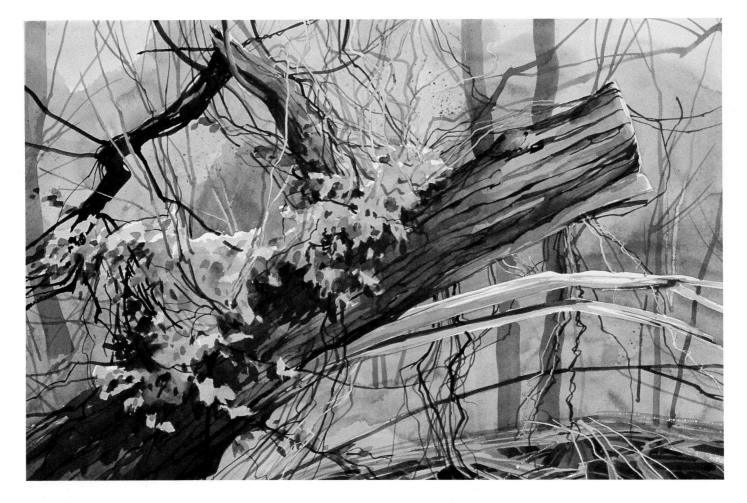

I used directional thrusts and repetition in this half-sheet water-color, Woods Monster. *I was attracted to "his" open maw, and let my imagination run wild.*

The strong diagonal of the sawed tree trunk rises up out of the forest like a sea monster from the ocean floor; I wanted to retain this effect. This could be a bit tricky without something to hold it in the picture plane, but I didn't want to dilute the effect with too much manipulation. The pale background trees at center right and the opposing diagonal branches in the upper right are all the counterpoint I wanted.

When the tree was cut, long slivers tore away from the trunk to form the "monster's" mouth and tongue; these, with the bent sapling below, echo the shape of the main trunk with slight variations for interest.

The wild vines that bind the "monster" were protected early on with liquid mask. They were like an ineffectual fisherman's net, unable to hold back the strong thrust of the log creature.

WOODS MONSTER
15" × 22"

Directional Thrusts and Repetitions

These can give your work drama and emphasis. Look for ways to use them playing against one another or using them to restate a theme or concept. *Sprouts and Saplings*, page 125, could be viewed in this way.

Try various abstract sketches to see what you might want to use in your painting. A series of thumbnail sketches no larger than 1" × 2" is enough to give you a sense of composition. Play around with the values to emphasize your directional thrusts. On this small scale, detail is impossible, so it can't distract you from capturing the strong elements of your composition.

The view from my workroom window early one cold winter morning, before the sun had risen sufficiently to melt the frost, offered me a challenge. The values were varied and lit by the warming light of the sun with shades of pale gold and blues; it looked as if someone had built up a corner of the window with stained glass.

FROST WINDOW
9" × 12"

Straight Lines

Not all of nature's lines and shapes are sinuous, curved, or rounded, of course. Look for these surprising straight lines: frost patterns, rock stratification, mud cracks, and some odd forms of plant life like horsetail or pipewort. These may look as though drawn with a ruler—but don't be tempted to do likewise. Rather, if you wish to do the underlying drawing as precisely as your subject seems to have been scribed by nature, fine; but *paint* freehand to avoid a too mechanical result.

Diagonal Thrust and Negative Shapes

The woods near my house are what is known as "old-growth" forest. That means they are a mix of ancient trees, young saplings, rotting logs, stumps, and exposed tree roots. I could paint a hundred pictures here (and probably have) yet never be bored.

This fallen giant near the crest of the hill seemed to be reaching for something in the air now—after decades of reaching into the soil for moisture and nutrients.

Stage One

I explored several formats for this work; the two most promising are shown here. I liked the horizontal format with its diagonal thrusts enough that it may become the subject of a later work, but for now I felt the more dramatic vertical format expressed the feeling I was after.

Stage Two

This subject is rich in negative shapes. To make sure I had varied them enough to maintain interest and believability, I did a felt-tip pen study of the negatives and was pleased with the results. I proceeded to transfer the sketch to my watercolor paper, using a modified grid system to make sure I didn't lose my interesting shapes. I liked my sketch, though, and hated to mark on it, so I did the grid on a piece of translucent paper taped to the sketch. This allowed me to see through to the sketch and keep my shapes intact.

Stage One

Stage Two

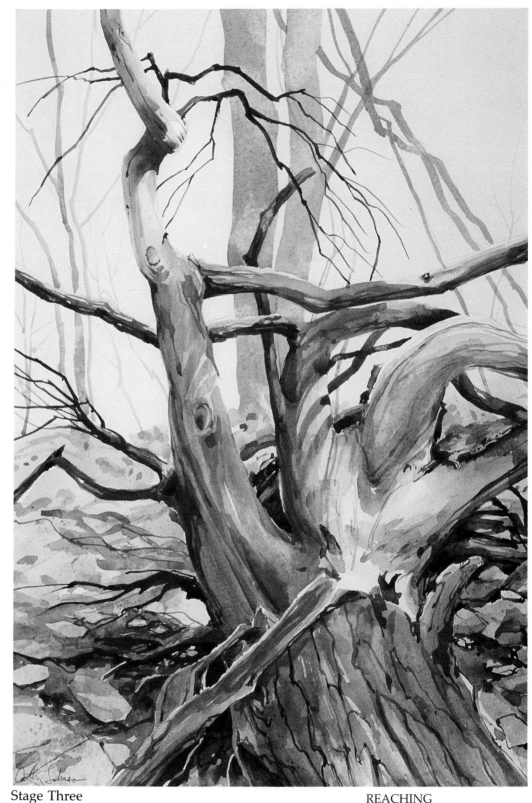

Stage Three

In the finished painting you see the contrasts of warm against cool in the wintry blues and rich browns. Notice how I have suggested the various textures of bare wood, bark, and rocky ground. Too much texture would have distracted from the wonderful interwoven shapes of the tree roots, so I used combinations of glazes, wet-in-wet, and calligraphy, and avoided drybrush work. Spatter was useful in the rocky areas, too. In forming the shadows on the upraised roots, I was careful to preserve the illusion of roundness by allowing my brush to follow the curve of these underground branches.

Stage Three

REACHING
15" × 22"

131

Man-Made Subjects

Just because we are focusing on nature's details doesn't mean we have to exclude the existence of *human* life—in fact, evidence of our presence adds a special poignancy to our works.

We find nature in our yards and gardens as well as the uninhabited forest or seashore. These small corners have a special charm, a homely appeal. Look around you; your own back yard may turn out to harbor a hundred subjects.

I think purists tend to forget that *we* are part of nature. We came from nature, return to nature, and in between are totally dependent on it. (Perhaps that's how we get ourselves into such predicaments as pollution, acid rain and the threat of nuclear winter—it's not only the purists among us who forget.)

Afternoon light on an old barn door is a detail of nature. So are the shadows on a weathered tree stump used as a chopping block; the weeds in a cracked pane of your coldframe; and snow mounded on a stone bench. I once painted my clothesline on the farm, with the clean linens billowing in front of the huge old maple tree that acted as a pole on one end.

I painted this almost-hidden bench on the spot early one morning last summer. I took a thermos of coffee, a peach, and a piece of hardtack in my daypack and enjoyed the early morning walkers and joggers as they passed me on the path. The rising sun hit the background with a pale gold, which I painted in an overall, wet-in-wet wash. The foreground was still in shadow; I used cool blues, greens, and gray-blues here. Rima's Bench *has the feel of a morning chill about it—and so did I!*

RIMA'S BENCH
9" × 12"

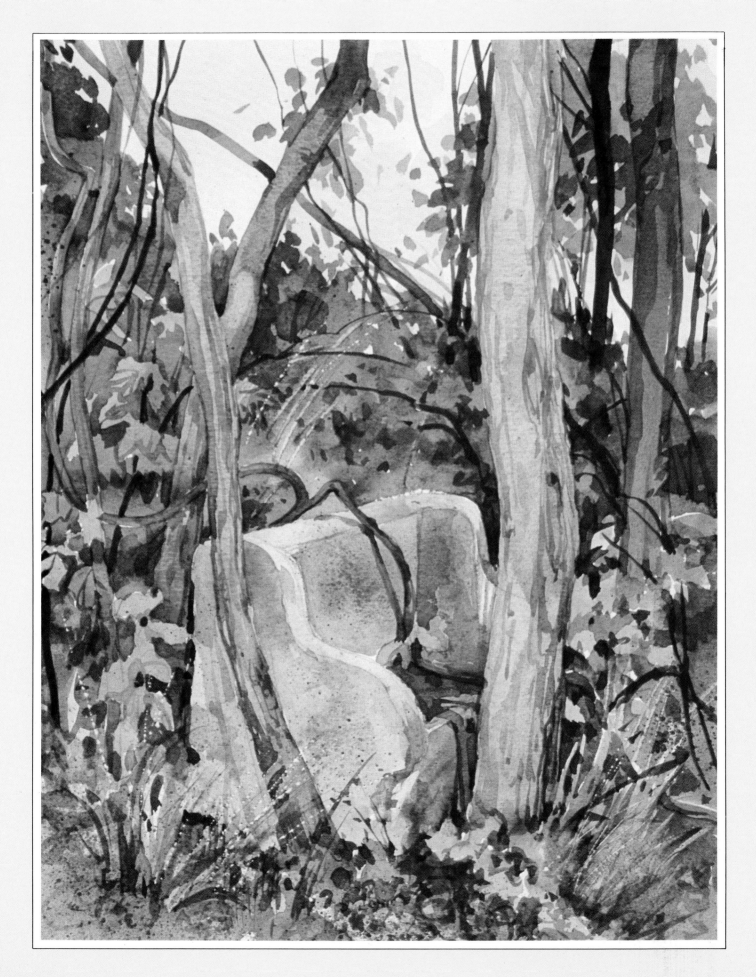

These subjects are fun—and they tell a story. They involve the viewer. In that sense they have something in common with book illustrations— they give us something recognizable to relate to, perhaps something that strikes an emotional chord. They may remind us of the past. We may feel, in looking at these subjects, the universality of life— our interconnectedness. When combined with natural subjects, they become strong emotional tools; but use them in a hackneyed, overdone way and you may end up with something that resembles a typical mass-produced print instead of an original painting. Use them *well* and you are really on to something.

Look around you for fresh ideas. Objects from the past do strike a chord, but look for a new way to express that feeling. Try an extreme close-up, or an oriental feeling with the subject isolated against the white of your paper. Milk cans with daisies, old buckets full of strawberries, even barns and mailboxes *are* valid subjects, but make them your own. Don't be influenced by how they've been painted (and painted and painted) before. Better yet, look for fresher subjects, at least when starting out. Once you've developed this new way of looking, you'll be able to paint literally *anything* without falling into the trap of sticky sentimentality or that done-to-death feeling. Old buckets and milk cans are fine, but first try, perhaps, a fat-cream separator, a grain scythe with its lovely linear shadows, a hand sickle or an ancient high-wheel cultivator—something fresh.

You've noticed, perhaps, that these are mainly rural subjects, but you can find suitable subjects anywhere. Look for something fresh, something that catches *your* eye, makes *you* stop in your tracks. Chances are, it will work well as a painting subject. I like tiny, hidden bridges, old park benches, bird baths, windows, and other architectural details. As you begin to look around more carefully, you will develop your own special subjects.

I used a graphite pencil to explore light and shadow possibilities in this midwinter sketch of Rima's bench, the subject of the painting on page 132.

On the Spot

For a change of pace, try working on the spot when painting man-made objects. To counteract the tendency of getting lost in all the confusing detail, try zeroing in on a single subject.

An old concrete bench lies hidden in the weeds at my park; trees have grown up all around it; it's a great subject to paint and sketch—it has almost become a part of the landscape.

Zeroing In

Zero in for a good look at the way man-made objects and nature interact. All sorts of details can make good subjects; a wildflower in the crack of a city sidewalk; birds perched on a garden chair; a pot of begonias; a plaza fountain sparkling with moving water. This is a good place to use some of the techniques we discussed in Chapter 1. Use a viewfinder to help isolate subjects. Let your curiosity take you back to childhood; get down on your hands and knees to discover these small treasures—never mind your dignity! It's amazing how many painting subjects are right under our noses, ignored as we go merrily on our way. What a pleasure to find that the world is such a full and varied place; why not share this vision with your viewers?

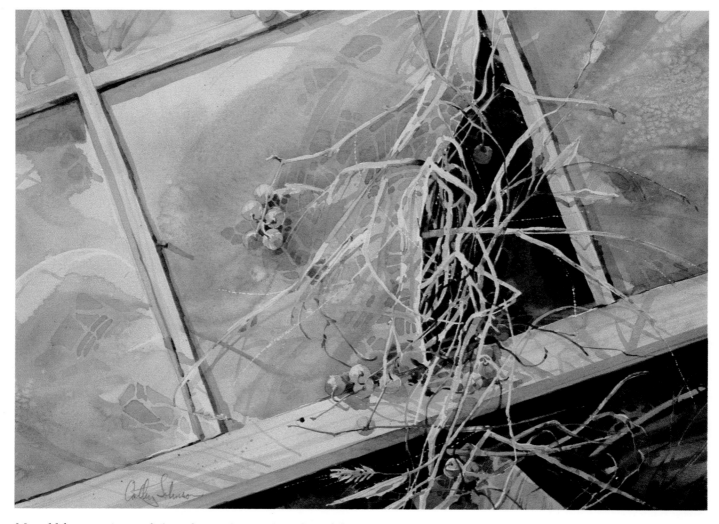

My cold frame sat unused since the previous spring. One of the panes had broken during a summer hailstorm; some seeds found their way inside and sprouted in the rich soil. I like the pattern formed by the pale weeds, their golden fruit, and the frosty window panes. A closely related, analogous color scheme of blues, blue-green, and pale yellows expressed it best.

You can find similarly interesting compositions if you look around closely. A basement window may reflect a spring hyacinth, or your birdbath may contrast with a twisting grapevine. Keep your eyes open for these man-made subjects amidst nature.

WINTER COLD FRAME
12″ × 16″
Collection of William Woods
College

Fence Posts

Miles and miles of fence not only mark our legal boundaries and corral our stock, they provide artists with a thousand compositions. In parts of Kansas, fence posts may be of weathered limestone; in other areas of the country, wood is more commonly used. The tightening farm economy is forcing many farmers into less than optimum practices and may cut down on this availability. Many farmers have removed their fences altogether and now till from roadbed to roadbed. Still, there should be enough old wood and stone posts left to provide plenty of practice.

Down on the Farm

Although we may not all have experienced rural life personally, many of our families have. At the least we may long for the (imagined!) simplicity of this way of life. (After seven long and arduous years as back-to-the-land types we gratefully moved back to *town*!) At any rate, there is an emotional bond with the land that few of us escape entirely, and that bond enables rural subjects to touch us in some way.

Our old farm held the lives and hopes of generations of people before us. Every corner seemed to hide a subject to paint. The strong abstract qualities of the barns and sheds fascinated me, and the wonderful clear light never failed to excite my creative urge.

Here, the old post is silhouetted against the distant lake; this area is now part of a state park. I decided to look for a different way to simplify and isolate my subject. (I chose another approach when I painted "Gate Post" in Chapter 3.) My small sketch helped me decide that I wanted a less important background, and a detailed foreground, but that I wanted to maintain a certain unity. The repeated color in the scene gave me a cue; the richly toned weeds and deep blue lake were reflected in the colors of the lichen and shadows of the fence post.

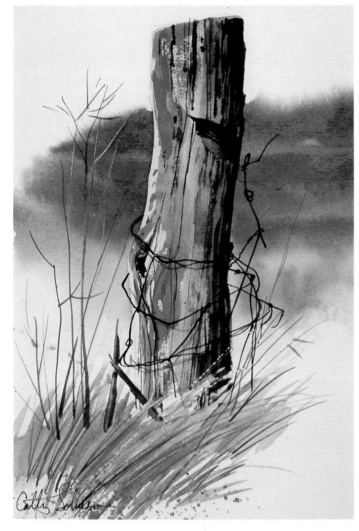

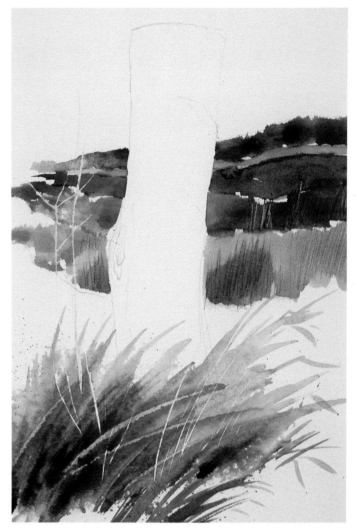

It worked best to paint this background wet-in-wet; I protected the post with drafting tape and cut around the contour I had drawn onto my watercolor paper, pulling the excess off. The tape let me lay in the colors loosely and let them blend without worrying about the post.

I painted the weathered post fairly directly, allowing the shadow tones of burnt umber and ultramarine blue to mix with the lighter side for a soft shadow. I mixed the lichen's color with burnt sienna and raw sienna and used it in both wet-in-wet and drybrush techniques. A fine brush loaded with a strong mixture of sepia, burnt sienna, and ultramarine blue made the wire, and I was careful to keep the interesting angularity attained over the years. Blotting here and there helped give it a bit of dimension.

WATKINS MILL POST
9" × 12"

My first attempt had gone all wrong. I hoped to avoid masking the post, so I tried painting the background directly, certain that the bands of color would blend sufficiently for a soft look. Wrong! Not only that, but my foreground grass got completely out of hand.

One of the most important things to learn is when to admit defeat and start over, and I was whipped. The lazy way out had only made more work in the long run.

I thought it was interesting to notice that the colors—although exactly the same pigments in each example—appear much brighter and cleaner in the wet-in-wet background.

You can see one of my favorite rural/architectural subjects in *Morning Light on Barn Door. Our biggest barn had a wonderful old porcelain knob that caught the sunlight. The odd assortment of chains and toggles holding it shut (except when March winds were at their worst) cast great shadows on the diagonal, whitewashed boards. I wish I still owned this one.*

I love the subtle blue-gray shadows. I mixed some nice combinations of ultramarine blue and burnt sienna for these, mostly painted with my favorite 1/2" flat.

Subjects like this require planning and careful drawing when you transfer the subject to your paper. The subject is so simple that the smallest mistake in delineating the chains or knobs would show up glaringly. Observation is the key, again. Draw what you see, not what you know. We often talk ourselves out of a great effect because we "know" white buildings are white (never mind the evidence of reflected color that our eyes present us) or that chains work in a particular way, with alternating links. I drew what was before me, going slow and ignoring preconceptions—trusting my vision.

Notice, too, that this painting would have been much less effective if any of the elements (knob, toggle, edge of the door) had taken dead center stage. The edge of the door comes dangerously close, but the slight angle throws it out of kilter just enough to keep it from getting boring.

Each element in the painting has a part to play. Here, the diagonals draw your eye into the center of interest; the chain's shadows repeat the angle. Even the hole where a missing board left a tiny dark triangle plays its part: try covering it with your hand and you'll see that the right side of the painting would lack something.

And no, I don't always consciously include this system of checks and balances—as you paint, you almost develop a second sense without thinking about it. I guarantee it.

MORNING LIGHT ON
BARN DOOR
15" × 22"
Collection of Dr. and Mrs. John Schutz

The wonderful diagonal slash of that red axe handle caught my eye on this winter morning. My husband had been splitting wood for the cookstove and left his new axe imbedded in the old elm log. The vignetted background drew attention to the axe and Harris's chopping block.

Again, most of this was done with my ½" flat brush—you can see the interesting effects in the negative spaces that define the whitewashed gate and the cement retaining wall of the root cellar. A bit of scraping and spatter provided all the detail I wanted.

WINTER WARMTH
15" × 22"
Collection of the Artist.

You may not want man-made objects to take center stage in your paintings. They can still appear—with good effect—in the background, as shown in my sketch, Ironweed and Wild Plum. This is another gray colored pencil sketch with quick watercolor washes—a satisfying effect, for me. I could have even left the objects as simple silhouetted shapes; you would still have had the sense of place.

IRONWEED AND WILD PLUM

Stone Fences

In many parts of the East, picturesque stone fences mark boundaries; in the Midwest they're relatively uncommon, but the stonemasons weren't entirely unemployed. You may find stone walls in old neighborhoods (or affluent new ones.) Older parks in towns and cities often boast stone benches, picnic tables, arches or buildings, as well as stone walls. They're just as interesting to paint and also make a nice rugged counterpoint to nature's details.

a quick "mask" for spattering. (yes, I *do* get dotted fingers!)

I used my fingers for an impromptu mask to protect the snow from random droplets. Hold your hand over the area you want to protect; your fingers will act as a mask. And, yes, you will get mottled hands!

The warm-colored stones contrast nicely with the cold blues of the recent snowfall. I used the old John Pike trick again here to avoid too much blue-blue in the snowy areas: I first wet the paper with clear water, then dropped in small amounts of the three primaries in the form of alizarin crimson, cadmium yellow light, and thalo blue. I stirred them around a bit with my brush tip and tilted the paper this way and that to allow them to blend, then let them dry thoroughly before doing much more than the long soft shadows in the foreground.

I protected the closest trees with liquid mask, but simply painted around the snowy mounds on the bench as I laid in mixed and mottled washes of burnt sienna, ultramarine blue, cobalt blue, and sap green (for lichen and moss).

I painted the deeper blue shadows of the hill beyond next; notice how the overlapping forms give a sense of depth. The bare trees on the far hills were mostly wet-in-wet mixtures of burnt sienna,

DRUID'S BENCH
15″ × 22″

brown madder alizarin, and cobalt blue—a little scraping done while the area was still damp suggests the texture of trees.

I added soft, blended shadows to the bench's snowcaps with cobalt blue. Edges softened by touching them with a brush dampened with clear water.

Ancient Cemeteries

These fascinating places are for those among us who are not squeamish (and don't read Stephen King!) They tell much about the history of an area and the families who lived there. We can understand much about our changing world by the size and style of the weathered markers, and by the inscriptions they bear. Some are funny; others touch the reader, bringing a lump to the throat. In Missouri, as in many parts of the country, we can even read in them the history of the Civil War. They make powerful painting subjects. One such painting in a recent show got more comments than any other single work I've done!

The title of this piece didn't refer so much to the spiritual as the practical. This tiny rural cemetery was a landmark on the way home to our old farm. Still, the dark cedars with their bare limbs and subdued colors touched me on a deeper level as well. A quick sketch confirmed the drama of this day caught between late winter and early spring.

I used a rich mix of thalo green, thalo blue, and sepia for the cedar's foliage.

HEADING HOME
15" × 22"
Collection of the Artist

Contrasting Patterns of Man-made Shapes

The old cattle loader's strong abstract shapes and pattern of light and dark attracted me. The summer sun reflecting on the boards gave them beautiful warm and cool subtleties I was anxious to capture.

This place was special to me—I used to sit in the nearby barn doorway, dreaming and petting my sweet baby goat. I had helped birth her, and she thought I was her "other mother." She often draped herself over my lap like a cat—until she got too big.

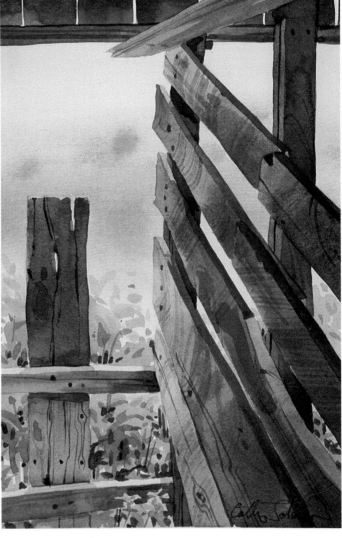

Stage One

After exploring both a vertical and horizontal format in my preliminary sketches, I decided I liked the more focused approach the vertical format allowed. The reflected lights on the rugged boards presented a challenge I couldn't resist.

Stage Two

After planning out my composition and format, I roughly sketched in the patterns of vertical, horizontal, and diagonal boards, being careful to maintain their warped weathered shapes. I didn't want to get too mechanical here, so I avoided using a ruler except along the edge of the roof overhang.

I painted the background wet-in-wet with a rich mixture of thalo blue, cadmium yellow light, and a touch of manganese in the far hills. The granular texture of that pigment gives just the right texture to read as distant foliage. I let this area blend into the foreground and kept the tops of the two horizontal boards as white paper.

Ultramarine blue and burnt and raw sienna in varied mixtures made the boards' slightly graded washes. You can't see the pale straw underfoot, but you can guess it's there from the warm light reflected back onto the upright board.

LOADER
9" × 12"
Collection of the Artist

FOUND STILL LIFES

Even on an intimate scale, painting nature can sometimes be intimidating and confusing. Some of us would rather paint still lifes; it's a respected tradition which gives a sense of order and calm. So, why not combine the details of nature with the discipline of still life and look for "found" still lifes? Potted plants in a greenhouse; your own herb garden; the axe by your wood pile; the random arrangement of old junk overgrown with wildflowers and vines by a small-town gas station; a corner of your porch; the philodendron on your windowsill—all these may provide intriguing subjects to form your still life.

Found still lifes are everywhere; your own backyard is a natural place to begin your search. I like the homely, comfortable feel of these paintings; they touch a chord, elicit a response.

When I lived in the country I was often distracted by the beauty of life itself. I was as likely to paint my speckled blue colander of freshly shelled peas as I was to get them into the freezer. One of my favorite paintings from that period featured sparkling jars of canned tomatoes cooling on my old wood stove. That's not nature, you say? You bet it is! Those paintings represented hours spent outdoors, tending and weeding the garden, leaning on my hoe and watching the natural world all around this small plot of earth.

This area of my farm's backyard begged me to paint it over and over. My old enameled canner, drifted in heavy snow and raked with morning light, was something I couldn't resist. The subtle blues, blue-grays, and golds were suddenly exciting and special—though I had passed this old table on my way to the woodshed a hundred times.
DETAIL OF EARLY MORNING COLD
15" × 22"

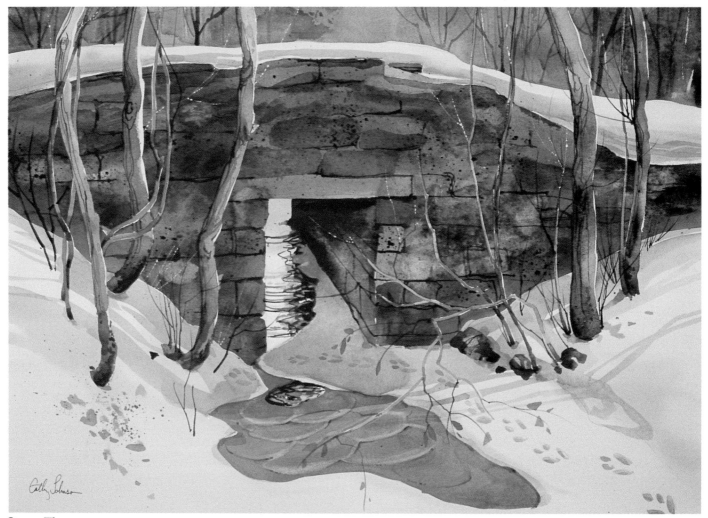

Stage Three

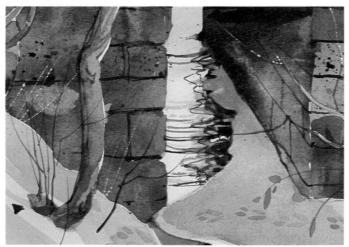

Detail

Stage Three

When this dried, and after removing the liquid mask, I painted the trees and vines, letting a bit of sap green act as the moss "socks" the trees wore. I added a bit more spatter, some animal tracks for a sense of life, a leaf here and there, and a little scraping of light-struck twigs—the painting was finished. I tried to keep some color unity throughout by repeating colors more than once; I like the effect.

Detail

In the close-up, you can see some detail in the stones and water. I wanted to suggest rather than spell it all out. You just know that a squirrel ran up a tree and scampered off across the road.

THE SECRET BRIDGE
15" × 22"
Private Collection

Contrasting Values

A late winter walk turned up this lovely little bridge, hidden from the road. You don't even know you're driving over it unless the tiny stream is in flood and roars through the narrow opening.

Sketch

I had taken only a felt-tip pen with me; it was too cold for more than a quick sketch. But when I got home I quickly added the penciled halftones to remind myself of the values. That bit of open water under the bridge was like a bright eye—I wanted to remember that the lightest lights and darkest darks were here.

Stage One

In stage 1, I painted the background and shadowed snow all in one sitting; the bit of warmth reflected in the open water was done wet-in-wet. Remember that although watercolor is a transparent medium, you can layer it. I didn't worry that my reflected light bled into the areas that would later become the stone bridge.

The patch of open water had begun to solidify into ice in the foreground; you can see the mushy texture and curved lines of its freezing in the gray-blue "puddle" up front.

Stage Two

The trees were protected with liquid mask, so I was free to loosely lay in the bridge's stones, letting pigments blend; then spray, spatter, and blot for effect. I introduced plenty of color here—actually, if you went to see the "real" bridge you'd find it a dull, overall gray-green, almost hidden under brush and weeds. I was standing above the creek on a little rise; that's why the angle of the bridge is so acute.

I added more trees to the background, and a little fine detail to the stonework. I used a small brush to paint the darker reflections with a rich mixture of ultramarine blue and sepia umber.

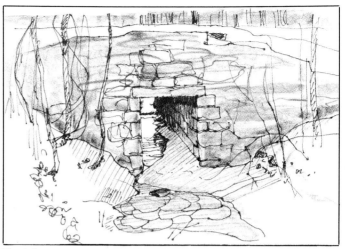

Sketch

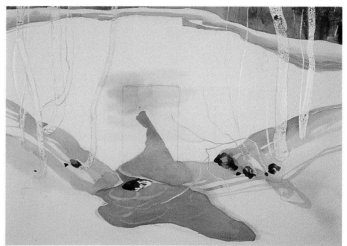

Stage One

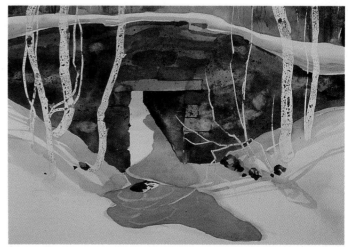

Stage Two

Contrasting Textures of Man-made Objects

This old cattle waterer was at the base of the hill where we gathered deadwood for our wood stove. I liked its rich color and interesting texture, as well as the wooden uprights (although I have no idea what they were for!)

Stage One

Stage 1 shows that I protected the uprights with liquid mask and covered a few weeds and grass blades, too. I added the warm glow in the sky to give a bit of interest.

Stage Two

In stage 2 I used warmer colors to model the closer boards; a stronger mix of ultramarine blue and burnt umber gives a sense of distance—however small—and depth to the wooden construction. The big old raucous crow came last; I located his wing covert by scraping through the damp black wash with the end of my aquarelle brush. (Actually, as mentioned, I seldom use black except for an animal's eye. This was a strong mixture of ultramarine blue and sepia umber.)

CROW BATH *15" × 22"*
Private Collection

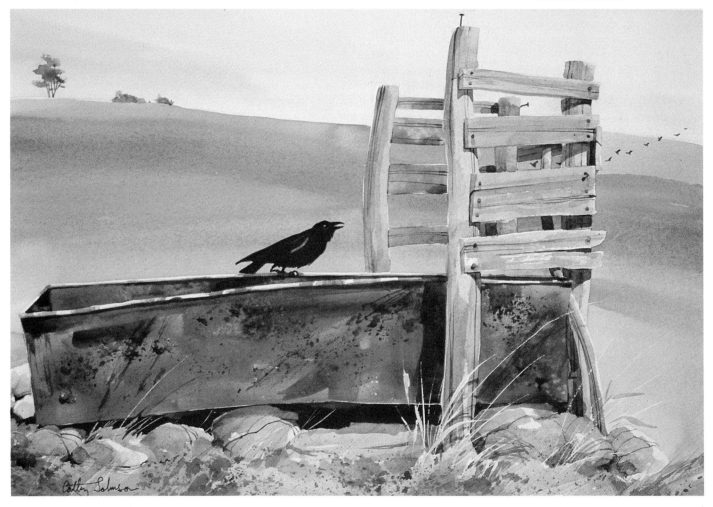

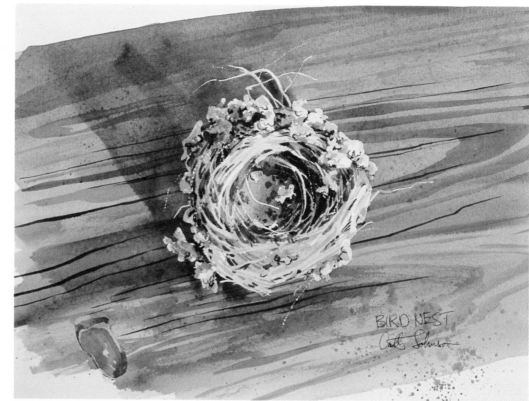

You may wish to turn this kind of attention on a single object; I did this when I painted the tiny bird's nest we found on a camping trip. After the nesting season this small woven cup of grasses, twigs, soft green moss, and blue-green lichen was deserted. Against the weathered wood of the picnic table it was subject enough.

BIRD NEST
10" × 14"

Found still lifes, in their way, can be fresher than carefully arranged studio set-ups of flowers and fruit. Unless you've trained yourself to see painting possibilities in the commonplace, like Charles Reid, or have developed an understated but classic simplicity, like Thomas Aquinas Daly, you may fall into the trap of painting still lifes that are just an extension of a classroom exercise. We need to develop fresh eyes and a sleuth's ability to ferret out painting subjects from the ordinary pieces of life all around us. Found still lifes aren't arranged or manipulated. They just happen. They become harmoniously entwined with nature and seem to remind us of our interdependence on the natural world.

Think of Georgia O'Keeffe's paintings. By focusing her creative attention on commonplace objects—the skull of a cow, a pelvis bone, or a flower—she gave them dignity and meaning. Or, more accurately, she *recognized* their dignity and meaning and helped us to see it as well.

Nature at Home

As an exercise, go outside with your viewfinder. Scan the things around you, no matter how familiar they are; take nothing for granted. Get as close as you like, but look for these small, unmanaged still lifes. Your birdbath with the watering bucket nearby, a crack in the sidewalk where you've left your gardening hand tools, the basement window's wrought iron grate with miniature weeds softening and accentuating it. What do *you* see? Try a series of quick sketches to see what you may find. Try vertical and horizontal sketches; add or subtract elements to your found still life if you wish. A vase of flowers set on the picnic table by your outdoor dining utensils would be a pleasing possibility, and one that still qualifies—in my book, anyway—as a found still life.

I liked the way this bent pitchfork accentuated the woodshed's weathered wall. Its subtle planes against those of the barn in the background formed the basis for this small sketch, left.

Another time, it was the slanting light slightly later in the morning that prompted a simpler, warmer handling of the scene. In the painting below, I've only suggested the shed; I've allowed the details to fade off in a kind of vignette on the right, with the focus on the hanging Indian corn and that wonderful neutral shadow.

WOODSHED
15" × 22"

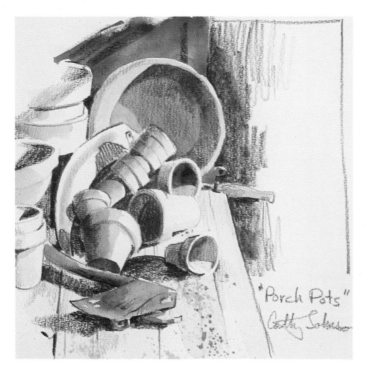

"Porch Pots"

I see these clay pots on my woodbox almost every day. The reflected light, direct sun, and cast shadows presented a real challenge to my ability to see. Variable values and reflected lights cast back into shadows can be confusing—"where is that light coming from, anyway?" I needed to carefully analyze my subject to capture all the nuances; squinting my eyes to simplify what I saw before me was a good starting point. Keeping in mind the logic of all those circles and ovals and their effect on each other was a big help as well. Try quick sketches like this one as you search for possibilities in the backyard or garden.

PORCH POTS *9" × 12"*

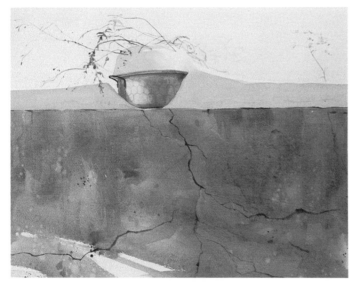

A simple subject may prove to be quite challenging. This old aluminum cook pot was full of wildflowers in the summer, which, in winter, became dried out and angular. The unique chickenwire patterning on the pot presented an enjoyable challenge to paint.

I used sedimentary pigments to capture the root cellar's granular, crumbling cement wall—with ultramarine blue and burnt umber the predominant choices. Notice the negative (clear water) and positive (pigment) spatter used to texture the wall. I painted the crack in with a strong mixture of ultramarine blue and sepia umber.

Ultramarine was my basic pigment choice for the snow shadows, as well. These I carefully modeled with clear water as they turned toward the light.

I painted the weeds with a small brush, using the warmth of burnt umber and burnt sienna to provide tension in an otherwise very cool painting.

SNOW SOUFFLE *11" × 14"*

Collection of Dr. and Mrs. John P. Schutz

The Backyard Environment

Nature has a way of magically changing the commonplace, like an alchemist turning dross to gold. The slanting light of early morning suddenly changes something we've seen every day, in less felicitous lighting, to a must-paint possibility. Fresh snowfall softens and transforms an ordinary view into a classic winter scene.

Life itself in any backyard provides literally hundreds of vignettes to paint. A friend painted the strong summer sunlight shining through canvas patio chairs, or the overdone dinner rolls she left out for the birds. Different times of the day suddenly present possibilities you had overlooked before. Being ready, being *open* to the possibilities is the key to a "fresh" painting.

Unconsciously we often paint the light rather than the object we see, as in Chapter 2. What excites us is the change and drama the lighting adds to objects we see every day. Try to get out earlier than usual, or make your rounds as evening begins to throw dramatic shadows over familiar objects. Go out on a foggy morning, or catch the buttery rays of the day's last light. See what happens in the rain! I guarantee you'll find something familiar that's worth painting.

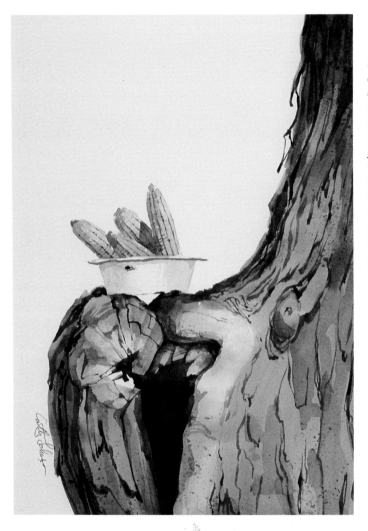

If you've exhausted the possibilities in your own backyard—
after you've painted everything there in every conceivable light
and season—branch out. Found still lifes may be as close as your
neighbor's yard (ask permission to work here, or you may be
hauled off for trespassing!) or the local park. This small painting
was done at a nearby farmstead. Mr. Cowsert put out ear corn
for a rakish collection of bold furry-tailed bandits in an old
enameled pan. The odd-shaped tree and the bright colors of both
the pan and the corn made the subject irresistible. I couldn't help
but notice the possibilities for a yin/yang symbol handling of the
vignetted tree form against a white background, especially since
I had just seen a television special on Oriental philosophy. The
pan of corn seemed like a well-placed offering to the nature gods!

MR. COWSERT'S
SQUIRRELS
10" × 14"

Nature abounds even in our homes; we've brought it indoors in
hundreds of ways. Look indoors for a wide variety of subject
matter. Even a homely onion makes an interesting subject. I was
intrigued with this one's forms and shadows and papery
covering—it may yet become a painting. Charles DeMuth did
many wonderful watercolors of subjects no more exalted than
this.

Painting Nature's Humble Beauties

I painted this, as you might have guessed, on Ash Wednesday. I spotted these pink geraniums in an old greenhouse in my town; since I had the day off, I asked permission to paint there, on the spot.

Stage One

A small pencil sketch helped simplify my thinking. I liked the somewhat abstract composition—the contrast of the rough stone wall with the soft pinks and bright greens of the plants interested me. I wanted to paint the wall as freely as possible, so I used a liquid mask to protect the plant forms. I gave careful attention to keeping these shapes varied and natural.

I then painted the wall loosely, using a combination of sedimentary pigments to give texture without overworking it. I introduced a bit of sap green into the wet wash to suggest moss. Notice how the direction of the strokes gives the feeling of slanting shadows.

When this completely dried, I removed the liquid mask and painted the flower shapes and their leaves. I tried to keep everything as fresh as possible, with very little working back into this area when dry. I let the pigment blend, wet-in-wet, to suggest form and depth.

The large potted fern on the left I painted wet-in-wet as well, then the background was cut in and punched out with a very dark shadow wash, giving it a lacy feel.

Stage Two

Only a bit of detail work went into the weathered wood of the greenhouse plant bench; too much would have distracted attention from the flowers. I spread the hairs on a large watercolor brush and barely wet them with pigment; then I applied them in a variety of ways to suggest the woodgrain and the semicircular marks of the saw blade that cut the timbers for the bench. This painting was chosen to hang in the 1975 Watercolor USA exhibition, so I was glad I had taken the time to paint it again.

ASH WEDNESDAY GERANIUMS *15" × 22"*

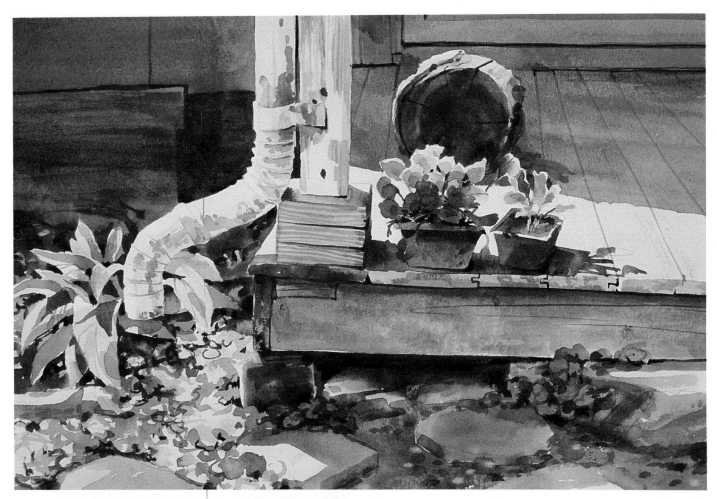

Painting Afternoon Sunlight

The light is really the subject here—it catches and backlights the cabbage and broccoli sets that didn't quite make it into the garden (that accounts for their interesting color variation, by the way—they should have been planted while still fresh and green.)

I built up this painting in a series of careful washes, allowing them to dry thoroughly in between. I used very little wet-in-wet or texturing. You can see in the nearest porch board that I've textured slightly by pressing the side of my hand into the damp wash. (Yes, this was on purpose!)

Detail

The log on the porch just caught the light on top. I wanted to give a sense of roundness to its side as it curved away from the light, yet still retain that feeling of strong sunlight, so I kept most of the washes fairly high-key.

Plant leaves have a row of cells along their outer edges that often catch the light when it comes from behind. I captured that effect by keeping these small washes back from the outer edges of the leaves where they are in strong sun.

BACK DOOR PLANTS
11" × 14"

Using Color Boldly

This one almost doesn't qualify as a still life: the wind keeps it from being very still. But I loved the rainbow effects of sunlight on the multi-hued sock, and the reflected lights on my white porch, so it was worth a shot.

Stage One

I carefully drew the wind sock to give the illusion of motion; the streamers flowed gracefully in the breeze. The porch post was really trickier to draw, and I thought about drawing one side only on a piece of tracing paper, then flipping it to transfer, to make sure both sides matched, but instead decided to go with negative shapes to help me "see." I drew the pencil lines on either side of the post (visible in the slide), then drew the negative shapes between that line and each side of the post. I didn't want mechanical perfection, I wanted a sense of reality. And I got close enough not to distract the viewer with obvious mistakes in drafting.

I painted the preliminary washes directly with a ³/₄" flat brush. I took advantage of their natural tendency to puddle, and used the shape of the brush itself to describe the fabric "tails." By manipulating the brush this way and that, I avoided a too squared and flat effect.

I used fresh pigment to keep the colors as unsullied as possible, and mixed primaries to get the strong secondary hues. Cadmium yellow medium was my yellow, alizarin crimson the red, and thalo blue the strong, pure blue. I mixed the orange using cadmium yellow and alizarin crimson, but branched out a bit for the green and purple to get better, cleaner hues. Cadmium yellow pale mixed with thalo made a better green, and ultramarine blue mixed with my alizarin crimson made a much richer purple than did the thalo blue. I was quite satisfied with the effects.

Here and there the sunlight was strong enough to let some of the colored streamers show through from behind the others; I introduced a bit of green to the shadow areas of the yellow strip, and a little red to the green areas. I fell in love with the effect and was almost tempted to stop there.

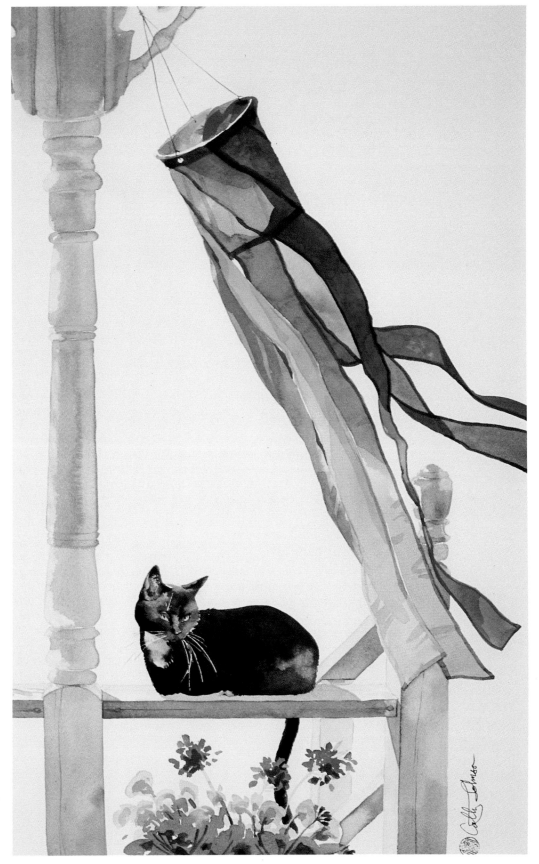

Stage Two

The shadows on the sock were a real challenge—would I dare to go bold enough? I would. I used each color mixed with its complement for most of the shadows. Notice especially the yellow streamer. Yellow is a tough color to shadow believably, so I almost took the coward's way out by using brown. After painting a test swatch, I decided that a complement mixed with lavender and burnt umber was definitely more atmospheric than the dead brown. When in doubt, experiment; you waste only a few moments and a scrap of paper instead of your whole painting!

I didn't want to compromise the bright freshness of my colors with a painted background and chose to leave it as a vignette against a clean white.

I was satisfied enough with the finished effect of this one that it has become a part of my permanent collection. On those days when my paints fight me and everything seems to go wrong, it's nice to look through the ones that did work and say to myself, "See, I can paint."

WIND SOCK
15" × 22"
Collection of Harris Johnson

AFTERWORD

We've traveled hidden forest paths together, and poked our noses into the tiny details that make nature tick. We've discovered wildflowers and weeds, birds and animals; we've looked at nature through an artist's microscope. Together we've wandered through backyards, parks, and gardens—and we've found something to sketch or paint wherever we've gone.

It's *like* that in learning to see. Places we've taken for granted before suddenly are touched with magic. Light falls on them in a new way, or we see them in a different season or time—we look with new eyes. And we wonder why we never stopped here to paint before. This loveliness, this excitement is everywhere—we only need to look for it.

I hope you've enjoyed the adventure—I have. Once your eyes are opened to the beauty just beyond your doorstep you'll never be at a loss for subject matter again. This miniature world is just waiting to be discovered by someone with an artist's eye, an artist's curiosity, an artist's gift for interpretation. Who knows? You may find more than you bargained for.

An old Navaho prayer sums it up:
In beauty I walk.
Beauty before me,
Beauty behind me,
Beauty below me,
Beauty above me.
May it be beautiful all around me;
In beauty it is finished.
In beauty it is finished.

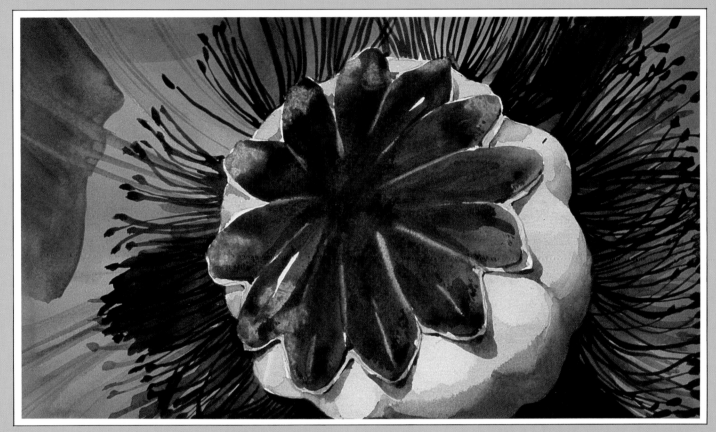

CENTER OF THE UNIVERSE
10" × 14"

INDEX

Other Art Books from North Light

Graphics/Business of Art

An Artist's Guide to Living By Your Brush Alone, by Edna Wagner Piersol $9.95 (paper)

Artist's Market: Where & How to Sell Your Graphic Art, (Annual Directory) $18.95 (cloth)

Basic Graphic Design & Paste-Up, by Jack Warren $12.95 (paper)

Color Harmony: A Guide to Creative Color Combinations, by Hideaki Chijiiwa $14.95 (paper)

Complete Airbrush & Photoretouching Manual, by Peter Owen & John Sutcliffe $23.95 (cloth)

The Complete Guide to Greeting Card Design & Illustration, by Eva Szela $24.95 (cloth)

Design Rendering Techniques, by Dick Powell $27.95 (cloth)

Dynamic Airbrush, by David Miller & James Effler $29.95 (cloth)

Getting It Printed, by Beach, Shepro & Russon $29.50 (paper)

The Graphic Artist's Guide to Marketing & Self Promotion, by Sally Prince Davis $15.95 (paper)

The Graphic Arts Studio Manual, by Bert Braham $22.95 (cloth)

How to Draw & Sell Cartoons, by Ross Thomson & Bill Hewison $15.95 (cloth)

How to Draw & Sell Comic Strips, by Alan McKenzie $18.95 (cloth)

How to Understand & Use Design & Layout, by Alan Swann $22.95 (cloth)

Illustration & Drawing: Styles & Techniques, by Terry Presnall $22.95 (cloth)

Marker Rendering Techniques, by Dick Powell & Patricia Monahan $32.95 (cloth)

The North Light Art Competition Handbook, by John M. Angelini $9.95 (paper)

Presentation Techniques for the Graphic Artist, by Jenny Mulherin $24.95 (cloth)

Studio Secrets for the Graphic Artist, by Graham et al $27.50 (cloth)

Type: Design, Color, Character & Use, by Michael Beaumont $24.95 (cloth)

Watercolor

Getting Started in Watercolor, by John Blockley $17.95 (paper)

Make Your Watercolors Sing, by LaVere Hutchings $22.95 (cloth)

Painting Nature's Details in Watercolor, by Cathy Johnson $24.95 (cloth)

Watercolor Interpretations, by John Blockley $19.95 (paper)

Watercolor—The Creative Experience, by Barbara Nechis $16.95 (paper)

Watercolor Tricks & Techniques, by Cathy Johnson $24.95 (cloth)

Watercolor Workbook, by Bud Biggs & Lois Marshall $18.95 (paper)

Watercolor: You Can Do It!, by Tony Couch $24.95 (cloth)

Mixed Media

Catching Light in Your Paintings, by Charles Sovek $16.95 (paper)

Colored Pencil Drawing Techniques, by Iain Hutton-Jamieson $22.95 (cloth)

Creative Drawing & Painting, by Brian Bagnall $29.95 (cloth)

Drawing & Painting with Ink, by Fritz Henning $24.95 (cloth)

Exploring Color, by Nita Leland $26.95 (cloth)

Keys to Drawing, by Bert Dodson $21.95 (cloth)

The North Light Handbook of Artist's Materials, by Ian Hebblewhite $24.95 (cloth)

The North Light Illustrated Book of Painting Techniques, by Elizabeth Tate $26.95 (cloth)

Painting Seascapes in Sharp Focus, by Lin Seslar $24.95 (cloth)

Painting with Acrylics, by Jenny Rodwell $19.95 (cloth)

Pastel Painting Techniques, by Guy Roddon $23.95 (cloth)

The Pencil, by Paul Calle $16.95 (paper)

Putting People in Your Paintings, by J. Everett Draper $22.50 (cloth)

Tonal Values: How to See Them, How to Paint Them, by Angela Gair $24.95 (cloth)

You Can Learn Lettering & Calligraphy, by Gail & Christopher Lawther $15.95 (cloth)

To order directly from the publisher, include $2.00 postage and handling for one book, 50¢ for each additional book. Allow 30 days for delivery.

North Light Books
1507 Dana Avenue, Cincinnati, Ohio 45207
Credit card orders call TOLL-FREE
1-800-543-4644 (Outside Ohio)
1-800-551-0884 (Ohio only)
Prices subject to change without notice.